"A timely and insightful exploration into one of the most important intersections today between cities, architecture and global culture. Stimulating and provocative."
>> Prof. Iain Borden, *University College London, United Kingdom*

"Urban culture has always been marked by fear and enthrallment, mutability and meaning, rich and poor, but the specificity of these relations is ever changing. These wonderfully diverse and interdisciplinary essays, focusing especially on the visual culture of contemporary global cities, usefully present and take stock of these old themes in the garb of our time."
>> Prof. Thomas Bender, *New York University, USA*

Globalization, Violence, and the Visual Culture of Cities

What connects garbage dumps in New York, bomb sites in Baghdad, and skyscrapers in São Paulo? How is contemporary visual culture – extending from art and architecture to film and digital media – responding to new forms of violence associated with global and globalizing cities? Addressing such questions, this book is the first interdisciplinary volume to examine the complex relationship between globalization, violence, and the visual culture of cities.

Violence – in both material and cultural forms – has been a prominent and endemic feature of urban life in the global metropolitan era. Focusing on visual culture and offering a strong humanities perspective that is currently lacking in existing scholarship, this book seeks to understand how the violent effects of globalization have been represented, theorized, and experienced across a wide range of cultural contexts and urban locations in Asia, Europe, North and South America, and the Middle East. Organized around three interrelated themes – fear, memory, and spectacle – essay topics range from military targeting in Baghdad, carceral urbanism in São Paulo, and the Paris *banlieue* riots, to the security aesthetics of G8 summits, the architecture of urban paranoia, and the cultural afterlife of the Twin Towers.

Globalization, Violence, and the Visual Culture of Cities offers fresh insight into the problems and potential of cities around the world, including Beijing, Berlin, London, New York, Paris, and São Paulo. With specially commissioned essays from the fields of cultural theory, architecture, film, photography, and urban geography, this innovative volume will be a valuable resource for students, scholars, and researchers across the humanities and social sciences.

Christoph Lindner is Professor and Chair of English Literature at the University of Amsterdam and Research Affiliate at the University of London Institute in Paris. His book publications include *Revisioning 007* (2009), *Urban Space and Cityscapes* (2006), and *Fictions of Commodity Culture* (2003).

'Questioning Cities'
Edited by Gary Bridge, *University of Bristol, UK* and
Sophie Watson, *The Open University, UK*

The 'Questioning Cities' series brings together an unusual mix of urban scholars under the title. Rather than taking a broadly economic approach, planning approach, or more socio-cultural approach, it aims to include titles from a multi-disciplinary field of those interested in critical urban analysis. The series thus includes authors who draw on contemporary social, urban and critical theory to explore different aspects of the city. It is not therefore a series made up of books which are largely case studies of different cities and predominantly descriptive. It seeks instead to extend current debates, through, in most cases, excellent empirical work, and to develop sophisticated understandings of the city from a number of disciplines including geography, sociology, politics, planning, cultural studies, philosophy, and literature. The series also aims to be thoroughly international where possible, to be innovative, to surprise, and to challenge received wisdom in urban studies. Overall it will encourage a multi-disciplinary and international dialogue always bearing in mind that simple description or empirical observation which is not located within a broader theoretical framework would not – for this series, at least – be enough.

Published:

Global Metropolitan
John Rennie Short

Reason in the City of Difference
Gary Bridge

In the Nature of Cities
Urban political ecology and the politics of urban metabolism
Erik Swyngedouw, Maria Kaika, Nik Heynen

Ordinary Cities
Between modernity and development
Jennifer Robinson

Urban Space and Cityscapes
Christoph Lindner

City Publics
The (dis)enchantments of urban encounters
Sophie Watson

Small Cities
Urban experience beyond the metropolis
David Bell and Mark Jayne

Cities and Race
America's new black ghetto
David Wilson

Cities in Globalization
Practices, policies and theories
*Peter J. Taylor, Ben Derudder,
Piet Saey and Frank Witlox*

**Cities, Nationalism, and
Democratization**
Scott A. Bollens

Life in the Megalopolis
Lucia Sa

Searching for the Just City
*Peter Marcuse, James Connelly,
Johannes Novy, Ingrid Olivio,
James Potter and Justin Steil*

**Globalization, Violence, and the
Visual Culture of Cities**
Christoph Lindner

Forthcoming:

Urban Assemblages
How actor network theory changes
urban studies
Ignacio Farias and Thomas Bender

Globalization, Violence, and the Visual Culture of Cities

Edited by

Christoph Lindner

Routledge
Taylor & Francis Group
LONDON AND NEW YORK

HT119 .G64 2010

0134112232084

Globalization, violence,
and the visual culture
c2010.

2009 11 16

First published 2010
by Routledge
2 Park Square, Milton Park, Abingdon, Oxon OX14 4RN

Routledge is an imprint of the Taylor & Francis Group, an informa business

© 2010 Christoph Lindner

Typeset in Times by
RefineCatch Limited, Bungay, Suffolk
Printed and bound by
MPG Books Group, UK

All rights reserved. No part of this book may be reprinted or
reproduced or utilized in any form or by any electronic,
mechanical, or other means, now known or hereafter
invented, including photocopying and recording, or in any
information storage or retrieval system, without permission in
writing from the publishers.

British Library Cataloguing in Publication Data
A catalogue record for this book is available from the British Library

Library of Congress Cataloging in Publication Data
Lindner, Christoph
Globalization, violence and the visual culture of cities / Christoph Lindner.
 p. cm.
 Includes bibliographical references and index.
 1. City and town life–Case studies. 2. Cities and towns–Case
studies. 3. Globalization–Social aspects–Case studies. 4. Violence–Case
studies. 5. Visual communication–Social aspects–Case studies. 6. Social
problems–Case studies. 7. Sociology, Urban–Case studies. 8. Intellectual
life–Case studies. I. Title.
HT119.L557 2009
307.76—dc22
2009005062

ISBN10: 0–415–48214–3 (hbk)
ISBN10: 0–203–88507–4 (ebk)

ISBN13: 978–0–415–48214–1 (hbk)
ISBN13: 978–0–203–88507–9 (ebk)

Contents

List of Figures xi
List of Contributors xiv
Foreword xv
NEZAR ALSAYYAD

Acknowledgements xvii

1 **Globalization and violence** 1
 CHRISTOPH LINDNER

PART I
Fear 15

2 **Architecture and economies of violence**
 São Paulo as case study 17
 RICHARD J. WILLIAMS

3 **Drugs and assassins in the city of flows** 32
 GEOFFREY KANTARIS

4 **Temporary discomfort**
 Jules Spinatsch's documentation of global summits 49
 HUGH CAMPBELL

5 **American military imaginaries and Iraqi cities**
 The visual economies of globalizing war 67
 DEREK GREGORY

PART II
Memory 85

6 Globalization and the remembrance of violence
Visual culture, space, and time in Berlin 87
SIMON WARD

7 Trash aesthetics
New York, globalization, and garbage 107
CHRISTOPH LINDNER

8 Global Beijing
'The World' is a violent place 122
STEPHANIE HEMELRYK DONALD

PART III
Spectacle 135

9 The poetics of scale in urban photography 137
SHIRLEY JORDAN

10 Globalization and cultural capital
Symbolic violence in recent filmic images of Paris 150
RUTH CRUICKSHANK

11 Conspiracy, surveillance, and the spatial turn in the Bourne Trilogy 161
SUE HARRIS

Bibliography 172
Index 181

Figures

1.1	'Mixtacity': giant hands	3
1.2	'Mixtacity': sugar-cube skyline	4
1.3	'Mixtacity': cookiescape	4
1.4	'Mixtacity': bobbins and blades	5
1.5	London Underground poster: slums	6
1.6	London Underground poster: growth	7
1.7	London Underground poster: pollution	7
1.8	Tate Modern: 'Global Cities' exhibition	9
2.1	View of São Paulo, looking southwards from the Edificio Itália	21
2.2	Vilanova Artigas, FAU-USP building (1961–9)	24
2.3	Vilanova Artigas, FAU-USP building (1961–9), detail of column	25
2.4	Paulo Mendes de Rocha, MuBE (1987)	26
2.5	Paulo Mendes de Rocha, MuBE (1987), detail of interior water garden	27
2.6	Alphaville (SP), view of business centre with walled residential compound in foreground	28
2.7	Alphaville (SP), sign advertising CCTV use in commercial centre	29
3.1	Living at the speed of light: Judy (Marta Correa) stares at the Christmas lights reflected in the windscreen of her client's car in *La vendedora de rosas*	36
3.2	'All that is solid melts into air': *dissolvency* in *Sumas y restas*	40
3.3	The shooting of a screen: Alexis (Anderson Ballesteros) in *La virgen de los sicarios*	41
3.4	The camera-gun: Buscapé (Alexandre Rodrigues) 'shoots' the gang of traffickers in *Cidade de Deus*	44

xii *Figures*

3.5	Megapolitan *flânerie*: surveying the city through a car window in *O invasor*	46
4.1	Jules Spinatsch, Hotspot No. 3, World Economic Forum (WEF), Davos-CH, 2001	51
4.2	Jules Spinatsch, Empty pool, sea, and sportsground, G8 Summit, Genoa-IT, 2001	53
4.3	Jules Spinatsch, Antilogo No. 1, G8 Summit, Geneva-CH, 2003	54
4.4	Jules Spinatsch, Antilogo No. 8, G8 Summit, Geneva-CH, 2003	55
4.5	Jules Spinatsch, Discontinuous Panorama C240700	56
4.6	Jules Spinatsch, Discontinuous Panorama B251356	58
4.7	Jules Spinatsch, Discontinuous Panorama A240635	60
4.8	Jules Spinatsch, Heisenberg's Offside	62
4.9	David Hockney, 'Luncheon at the British Embassy, Tokyo, Feb. 16, 1983', 1983	65
4.10	Rotterdam: Schouwburgplein at night	66
5.1	Virtual Fallujah: US Marines training at Twentynine Palms, California, 6 March 2007	78
5.2	Checkpoint simulation	79
5.3	US military plot of ethno-sectarian murders and executions in Baghdad, July–August 2006	84
6.1	Hotel Esplanade, Potsdamer Platz	91
6.2	S-Bahn sign, Potsdamer Platz	92
6.3	Traffic signal-box, Potsdamer Platz	93
6.4	Fragment of Berlin Wall, Potsdamer Platz, 2003	94
6.5	Fragments of Wall, Potsdamer Platz, 2008	95
6.6	Fragments of Wall and souvenir seller in Soviet army uniform, Potsdamer Platz, 2008	95
6.7	Fragments of Wall below the Beisheim-Center, Potsdamer Platz, 2006	96
6.8	Image of ruins at the Brandenburg Gate, 2005	98
6.9	Holocaust Memorial, 2005	100
6.10	Christian Boltanski, *The Missing House* (2008)	102
6.11	Palace of the Republic, 2007	104
6.12	Buddy Bear Pariser Platz	105
7.1	Aerial view of Fresh Kills Landfill, 2001	108
7.2	Rendering of Lifescape from the southeast	114
7.3	The High Line, NYC: sectional view	115
7.4	Gansevoort Entry: Slow Stair and Vegetal Balcony	116
7.5	Lighting concept, High Line level	116

7.6	Rendering of park interior	117
7.7	Rendering of the creek landing esplanade with market roof	118
7.8	Rendering of floating gardens and old landfill machinery exhibit	118
7.9	Rendering of 9/11 earthwork monument	119
7.10	Location and orientation of earthwork monument	119
7.11	Earthwork: 360-degree view of the region	120
8.1	The Suzhou Qiao underground train station, Beijing, 2007	125
8.2	Publicity still for *The World*, Xiaotao in the corridor	127
8.3	Still from *The World*, on the building site	133

Contributors

Nezar AlSayyad is Professor of Architecture, City Planning, Urban Design, and Urban History in the College of Environmental Design at the University of California, Berkeley.

Richard J. Williams is Senior Lecturer in the School of Arts, Culture, and Environment at the University of Edinburgh.

Geoffrey Kantaris is Senior Lecturer in the Department of Spanish and Portuguese and Director of the Centre of Latin American Studies at the University of Cambridge.

Hugh Campbell is Professor of Architecture in the School of Architecture, Landscape, and Civil Engineering at University College Dublin.

Derek Gregory is Professor in the Department of Geography at the University of British Columbia at Vancouver.

Simon Ward is Lecturer in German in the School of Language and Literature at the University of Aberdeen.

Christoph Lindner is Professor and Chair of English Literature at the University of Amsterdam.

Stephanie Hemelryk Donald is Professor of Chinese Media Studies at the University of Sydney.

Shirley Jordan is Reader in French in the School of Languages, Linguistics, and Film at Queen Mary, University of London.

Ruth Cruickshank is Lecturer in French in the School of Modern Languages, Literatures, and Cultures at Royal Holloway, University of London.

Sue Harris is Reader in French Cinema Studies in the School of Languages, Linguistics, and Film at Queen Mary, University of London.

Foreword

Nezar AlSayyad

Globalization, violence, and visual culture have always been three very important and sometimes separate domains in urban studies. While there has been some work on violence and globalization on the one hand, and some work on the representation of violence in the visual sphere on the other hand, little attempt has been made to link together these three domains of study or to theorize from one to the other. This book does just that, and it does it well. In a very interesting and methodical fashion, Christoph Lindner has assembled a book of three well-balanced parts, with each part focusing on one theme; fear, memory, and spectacle. Each part attempts to tackle the links between globalization, violence, and the emerging visual culture of cities in view of the chosen theme. In each part, several dimensions of visual culture, from photography to film and from architecture to landscape, are explored. And in each part, there are examples of urbanisms from everywhere, from the *banlieues* of Paris to the walled neighbourhoods of Baghdad, and from Berlin to São Paulo before returning us back to the heart of empire.

We should remember that globalization is a paradox. It promises all the possibility of being part of an interconnected globe and yet it is marked by great inequalities often resulting in a hardening of national, ethnic, and religious identities. It promises that we will all know and possibly visually witness what is happening everywhere in the globe and yet it is marked by a persistent distance from what we perceive to be so near and so familiar. Globalization's reality is indeed virtual. Some may argue that cities, particularly megacities in this globalizing era, are and will always be violent places. Their size, their densities, their disparities of wealth inevitably contribute to making them spaces of greed and injustice and the concomitant violence that ensues. It is this violence that necessitates the urban institutions whose reason for being is bringing a sense of order.

The chapters of this book clearly illustrate that violence, at least in the cities discussed, comes not from this inherent urban condition but rather from past grievances associated with colonialism, imperialism, racism, and other human failings. They also demonstrate at a level beyond the individual chapters how fear creates memory, and how memory becomes the source of new fears. Here spectacle often results when those who are neither the subject of

this fear nor the agents of this memory are provided with the opportunity to witness either or both in action.

But it is also important to put the visual culture of cities in its proper context, for these concerns are not only about what we see, but how we live. As we grapple with the geopolitics of the world-system, we must take note of the everyday practices of everyday spaces. Alongside the momentous eruptions of violence at the beginning of this century that now circulate through our global vectors of media, we are now part of a world where thousands of people have to contend with this everyday violence. This violence is manifest in the everyday spaces and the visual culture of our cities. As there is an increase in social inequalities, so urban space and visual culture will continue to be remade through the micro-geography of fortification. Our cities are today cities of walls, where a great deal of effort is spent on policing, surveilling, and gating. We must not forget that this too is a transaction of violence, a structural violence that breeds poverty that must then be managed by techniques of counter-violence.

Acknowledgements

This book developed from an interdisciplinary symposium on the topic of globalization and violence which was held in 2008 at the University of London Institute in Paris (ULIP). All of the authors included in this volume spoke at the event and participated in the lively and productive discussions that took place in Paris. Since the symposium had virtually no funding, the event itself was made possible almost entirely through the generosity of the speakers and our institutional host, ULIP. I am therefore grateful to the authors not just for contributing their work to the present volume but also for travelling to Paris from near and far to attend the original symposium. Andrew Hussey, Dean of ULIP, was enormously supportive of this project in both practical and intellectual ways, and he deserves credit for co-hatching the plan with me over drinks in a seedy blues bar in Chicago.

For permission to reprint material, the editor, authors, and publishers are grateful to the following: Nigel Coates, Angus Hyland/Pentagram, and Patricia Poon for images in Chapter 1; Nirvana Films/Wanda Distribución, La Ducha Fría Producciones, Vértigo Films, O2 Filmes/Miramax, and Europa Filmes for images in Chapter 3; Jules Spinatsch and Galerie Luciano Fasciati, David Hockney, and West 8 Urban Design and Landscape Architecture for images in Chapter 4; *Radical Philosophy*, where an earlier version of Chapter 5 was published in 2008 under the title 'The Rush to the Intimate: Counter-insurgency and the Cultural Turn in Late Modern War'; Charlotte Govaert, Andreas Steinhoff and Miguel Parra (www.pbase.com/miguelp) for images in Chapter 6; Wiley-Blackwell Publishing and the *Journal of American Culture*, where an earlier version of Chapter 7 was published in 2008 under the title 'New York Undead'; Field Operations and the New York City Department of City Planning for images in Chapter 7; and Phototime and X Stream Pictures for images in Chapter 8.

Every effort has been made to contact copyright holders for their permission to reprint material in this book. The publishers would be grateful to hear from any copyright holder who is not acknowledged here and will undertake to rectify any errors or omissions in future editions of this book.

<div style="text-align: right">Christoph Lindner</div>

1 Globalization and violence

Christoph Lindner

VISUAL CULTURE AND GLOBAL CITIES

From the Paris *banlieue* riots, the London transport bombings, and the Mumbai hotel sieges, to the architectural excesses of global Beijing, the spatial estrangements of vertical New York, and the aesthetic defacements of post-unification Berlin, violence – in both material and cultural forms – has been a prominent and endemic feature of urban life in the global metropolitan era. This interdisciplinary volume addresses the broader cultural significance of globalization by examining treatments of urban violence in contemporary visual culture, including architecture, film, photography, and urban planning and design.

The recent 'global turn' in cultural theory and critical urban studies has highlighted the growing impact of globalization on the life and development of cities, from new trends in architecture and design, to new patterns of migrancy and diaspora, to new techno-informational networks of communication and power. At a time when more than half the world's population lives in cities (for the first time in human history), the relationship between global processes and local conditions is one that positively demands increased scrutiny. Yet, while much work has been done on the economic, social, and political dimensions of global cities, relatively less attention has been paid to their cultural dimensions, although studies such as Shiel and Fitzmaurice's *Cinema and the City* (2001) and Linda Krause and Patrice Petro's *Global Cities* (2003) have made important inroads in this area by specifically analysing the phenomenon of the global city in light of contemporary developments in film and digital culture. Indeed, the contributions to both of these volumes, which collectively address the identity formation of cities and the effects of globalization on urban societies, demonstrate the valuable insights that can be gained by reading global cities through their visual cultures. Maintaining a focus on visual culture, and offering a strong humanities perspective that is too often lacking in existing scholarship, this book seeks to understand how the violent effects of globalization have been represented, theorized, and imagined across a wide range of cultural contexts and urban locations in Asia, Europe, Latin America, the Middle East, and the United States.

2 *Christoph Lindner*

EXHIBITING THE GLOBAL CITY

The relationship between globalization and the visual culture of cities was the subject of a major exhibition at London's Tate Modern Gallery in 2007. Entitled 'Global Cities', and drawing on data and materials presented at an even larger exhibit on the same topic that ran the previous year at the Venice Architecture Biennale, the Tate Modern exhibition sought to place the phenomenon of the global city on display for public consumption. Because it not only staged a literal presentation of the broad subject of this book, but in doing so engaged with some of the central concerns of the following chapters – including, albeit in a largely oblique way, the theme of violence – the 'Global Cities' event is worth examining in some detail here.

A significant part of the challenge of mounting the 'Global Cities' exhibition in London was finding a space large enough to house it. As a reconfigured power station in a central urban location, the Tate Modern offered a uniquely suitable space. In fact, the process of redesigning the gallery's cavernous Turbine Hall to accommodate the event became a subject of exhibition in its own right. The gallery and its website featured substantial visual documentation about constructing the space, including a very popular short digital film showing the entire process of transformation in fast motion.

The exhibition itself focused on ten megacities – Cairo, Istanbul, Johannesburg, London, Los Angeles, Mexico City, Mumbai, São Paulo, Shanghai, and Tokyo – and was organized around five interpretive frameworks: size, speed, form, density, and diversity. Working within (and across) these frameworks, the installations featured informational and statistical graphics about global cities, combined – and frequently blended – with original artwork drawn from the fields of photography, digital video, architecture, and urban planning and design. In addition to displaying work by well-known artists and architects – such as photographer Andreas Gursky, sculptor and videographer Eva Koch, and architect Rem Koolhaas – 'Global Cities' also presented work by a range of new and emerging artists from around the world, particularly from developing and non-Western nations.

Among the more imaginative and visually compelling installations was a specially commissioned project, called 'Mixtacity', by British architect Nigel Coates. The idea behind 'Mixtacity' was to explore the potential of London's Thames Gateway, which has been declared a national priority for urban regeneration, to accommodate the complex range of cultures, ethnic ties, and lifestyle choices of its future inhabitants. Coates' approach was to create an elaborate planning model driven not by political or economic determinism, but by artistic spirit and, in particular, playfulness. The result, as one reviewer described it, was 'a wild, allusive, collagist vision of what the Thames Gateway might become, . . . a model estuary townscape made up of biscuits, sugar lumps, cotton bobbins, tacky souvenirs, replica guns, and giant human hands' (Pearman 2007). In the eclectic list of *objets trouvés* and consumer detritus forming the phantasmagoric architectural landscape of 'Mixtacity', I would

also call attention to the razor blades, digital cameras, chess pieces, and toothpicks littered across this urban junkyard/funfair.

Given this book's overarching interest in the effects of globalization on the 'urban imaginary' – what is best understood in Edward Soja's terms as the 'mental or cognitive mappings of urban reality and the interpretive grids' through which we experience and understand the space of cities (Soja 2000: 324) – it is worth lingering a moment over Coates' installation and reflecting on its commentary on the future of London. In my reading of 'Mixtacity', the sugar-lump skyline, urban cookiescape, and playful use of tourist trinkets, sugary food, and found objects, suggest a double critique of the post-millennial city. First, 'Mixtacity' registers in outrageously exaggerated terms the ongoing transformation of London and its environs into an urban playground and disposable consumerscape – a trend that is already particularly pronounced in the inner-city Docklands end of the Thames Gateway. More specifically, in light of the elaborate Olympic preparations taking place in 2007, 'Mixtacity' registers an anxiety over London turning into some kind of delirious Olympic candyland. Second, 'Mixtacity' functions as a lighthearted – but nonetheless poignant – statement about the need for urban planning to embrace heterogeneity and pluralism if it is to reflect London's growing cosmopolitan identity, what Coates describes as its 'seething, scintillating mix of cultures' (in Sandhu 2007).

With these ideas in mind, I would suggest that there is a certain residual violence present beneath the candy coating of 'Mixtacity' that derives from the aesthetic and semantic tensions created by its lurid, surreal reimagining of the Thames Gateway in terms of playfulness and consumability. In particular, the juxtaposition of incongruous everyday objects such as cotton

Figure 1.1 'Mixtacity': giant hands (courtesy of Nigel Coates).

Figure 1.2 'Mixtacity': sugar-cube skyline (courtesy of Nigel Coates).

Figure 1.3 'Mixtacity': cookiescape (courtesy of Patricia Poon).

Figure 1.4 'Mixtacity': bobbins and blades (courtesy of Nigel Coates).

bobbins and razor blades creates a tension not just between soft and hard, blunt and sharp, but between safety and danger, comfort and menace. Elsewhere in the edible dreamscape of 'Mixtacity', the precariously stacked biscuit high-rises conjure an architectural future that is at once delectable and celebratory yet vulnerable and impermanent. The digital cameras scattered across the landscape evoke the introspective realm of memory and nostalgia, and also the scopophilic technologies of simulation and surveillance. The imbalances of scale disorient and unnerve almost as much as they liberate and inspire: enormous ornamented hands sprout grotesquely from the ground, a giant teddy-bear doll in a wedding gown looms Godzilla-like on the horizon, a massive translucent phallus protrudes into the sky, and a monstrously sized overturned Martini glass punctuates the skyline. To my mind, therefore, 'Mixtacity' is about more than the cosmopolitan possibilities and consumerist orientation of global cities like London. The installation is also an expression of the peculiar co-minglings of ecstasy and angst that, as this book goes on to discuss, have become an integral part of life in the twenty-first-century megalopolis.

To comment more broadly on the significance of the 'Global Cities' exhibition, however, I want to step back from Coates' work and address how the event was advertised in London. As part of the marketing strategy, the Tate Modern put out a series of three advertising posters, which were plastered in Tube stations across London. Each of the three posters communicated a fact

about contemporary cities. The first poster was about poverty: 'One out of three city dwellers currently lives in a slum'. The second poster was about growth: '95% of urban growth in the next 20 years will be in Africa and Asia'. And the third poster was about pollution: 'Cities produce 75% of the world's carbon dioxide emissions'.

These posters are interesting because they did not promote the exhibition in terms of artistic or cultural value: the urban graphics underlying the text – which included powerful images of poverty, congestion, and runaway development – were deliberately dulled by a semi-opaque layer of colour, causing them to fade into the background. Instead, the posters employed discursive shock tactics to promote the event, functioning as a sort of wake-up call to a new and possibly frightening urban reality. More than that, the posters identified the subject of the exhibition – global cities – as a problem; one, moreover, that is currently spiralling out of control. The subtext here was that the exhibition could help to allay the very anxieties it created and, in this respect, the Tate Modern tapped into the way global cities have become a source of both fear and enthralment in the popular imagination – a development that is also of direct concern for this book, informing chapters on topics as diverse as Beijing's accelerated globalization programme, hyper-mobility and surveillance in the Bourne film trilogy, and the post-9/11 skyline of New York.

The 'Global Cities' posters raise a number of questions that the exhibition explicitly articulated in a series of enormous banners and signs that were

Figure 1.5 London Underground poster: slums (courtesy of Angus Hyland/ Pentagram).

Globalization and violence 7

Figure 1.6 London Underground poster: growth (courtesy of Angus Hyland/ Pentagram).

Figure 1.7 London Underground poster: pollution (courtesy of Angus Hyland/ Pentagram).

spread throughout the gallery. The visual effect was that these questions *literally* overhung the exhibition. The questions were:

- Does the shape of cities affect the future of our planet?
- Can cities be improved by design?
- Can cities promote social justice and greater equality?

The exhibition's answer to all of these questions was emphatically 'yes' – although, as this book reveals, the real answer is much more elusive and complex. The point I want to make here, however, is that these questions – like the entire exhibition – stress the centrality of cities to our global future and, even more important, stress that visual culture has an important role to play in shaping that future. This is precisely the position of this book, even if it does offer a more tempered outlook than the Tate Modern. I emphasize this last point because, as the following chapters explore, while the globalization of cities certainly has the potential to foster cultural innovation, it too frequently tends towards a homogenization and suppression of difference that can lead to violence in an alarming number of ways.

FEAR, MEMORY, AND SPECTACLE

Cutting across disciplinary and geographic boundaries, the chapters in this book are organized according to three broad, interconnecting themes – fear, memory, and spectacle – and range from the examination of military targeting in Baghdad, carceral urbanism in São Paulo, and the poetics of scale in urban photography, to the analysis of the security aesthetics of G8 summits, the architecture of urban paranoia, and the cultural afterlife of the Twin Towers. The first part of the book, 'Fear', focuses on cultures of fear, paranoia, and panic that have been generated by the global metropolitan condition. The second part, 'Memory', addresses the role of memory and monuments in negotiating cultural responses to sites of urban scarring, mourning, and trauma. The third part, 'Spectacle', considers the ways in which urban violence can become a source of spectacle in visual representations of globalized cityspace. What links all the chapters is a shared concern not just over globalization's transformation of the shape and appearance of cities, but also, and perhaps more importantly, over globalization's profound reshaping of our cultural imagination.

In the opening chapter of Part I, 'Fear', Richard Williams examines the relationship between architecture and economies of violence in the Brazilian city of São Paulo, one of the most violent cities on earth and a place so besieged by crime that, throughout the early 2000s, the phrase 'undeclared civil war' was routinely used by the media to describe its condition. Williams' main interest is in the way cultures of fear in São Paulo have informed the design of the built environment in the era of globalization, extending from the brutalism of the city's modernist tower blocks to more recent

Figure 1.8 Tate Modern: 'Global Cities' exhibition (courtesy of Tristam Sparks).

developments such as the massive gated community of Alphaville – a secured suburban enclave containing its own skyscrapers, hotels, police force, and video surveillance system. For Williams, who reads the sprawl and spectacle of São Paulo in light of Mike Davis' (1992) insights into the fortress mentality of Los Angeles, Alphaville not only marks a militarization of urban space but also represents a concrete manifestation of the middle-class city's fear of violence.

Maintaining the focus on Latin America, but shifting attention from architecture to film, Geoffrey Kantaris' chapter cruises the urban ganglands of Colombia and Brazil, where the globalized narcotics industry and the violence associated with it have become dominant concerns in the cinematography of both countries. Drawing on Manuel Castells' (1998) thinking about the 'space of flows' and the 'negative globalization' of poverty and social exclusion, Kantaris argues that in recent years Latin American filmmaking has mounted a vigorous critical response to the violent restructuring of urban social relations brought about by the illegal flow of drugs and money. In the process, he explores how films like *Our Lady of the Assassins* (2000), *City of God* (2002), and *Maria Full of Grace* (2004) register the emergence of a 'culture of death' in which the human body becomes the ultimate disposable consumer good in a capitalist circulatory flow driven by runaway consumption, ever accelerating turnover, rapid obsolescence, and manipulated desire.

Hugh Campbell's chapter considers the relationship between globalization and the fear of violence in the work of Swiss photographer Jules Spinatsch, whose 2005 book *Temporary Discomfort* explores the security aesthetics produced in locations such as New York, Evian, Geneva, and Davos by meetings of the G8 and World Economic Forum. Through innovative photographic techniques that create vast panoramic collages of the meeting sites, Spinatsch's images show how, despite the tense climate of anticipation surrounding these events, there is often very little to see and record except for the security itself. Connecting Spinatsch's work to earlier attempts by artists like Eadweard Muybridge and David Hockney to extend the spatio-temporal range of photography, Campbell argues that the insight of *Temporary Discomfort* lies in its novel vision of urban spaces emptied in anticipation of violence and marked by a deflatory absence of incident or conflict. The removal of the 'real' action of the G8 and World Economic Forum meetings beyond public view and behind impenetrable security – an evacuation of content so effectively illustrated by Spinatsch's work – comments on the lack of transparency and access that too often accompanies political decision-making on global economic issues.

In the final chapter of Part I, Derek Gregory examines the US military's changing conceptions of Iraqi cities during the 'war on terror'. He begins by retracing the genealogy of the city-as-target to show how its imaginative geographies of abstract spaces and hollowed-out cities were reactivated during the early phase of the ground war and counter-insurgency in Iraq. He then discusses how, as it became clear the insurgency could not be defeated by military violence alone, the US military replaced its visual imaginary of deserted urban spaces with one that strategically 're-peopled' Iraqi cities through an emergent focus on military–civilian interactions. Gregory's main concern in this chapter is how the resulting 'cultural turn' in the US military's approach to counter-insurgency and urban warfare has been codified by US Army and Marine Corps doctrines. He also pays particular attention to the translation of these doctrines into pre-deployment training, including war games, simulations, and 'virtual reality' representations of Iraqi cities. Among Gregory's important insights is the disturbing revelation that, far from breaking with the traditional Western discourse on otherness, the cultural turn in the American military imaginary is, in fact, consistent with the Orientalism that has underwritten the 'war on terror' since its inception.

Part II, 'Memory', opens with Simon Ward's chapter on what is perhaps the most visibly violated urban environment of twentieth-century Europe: the city of Berlin. In 'Globalization and the Remembrance of Violence', Ward examines the way that the Second World War, as a form of globalized violence, manifests itself in the urban environment of contemporary Berlin, and how visual culture attempts to make the memory of that violence visible in the urban environment through a process of defacement. As his discussion illustrates, the aesthetic strategies employed have been complicated by an influx of multinational corporate capital that has led to the violation of

pre-existing spaces, principally at Potsdamer Platz, where the amnesiac architecture of globalization has worked to erase the traces of time. Ward argues that this process is countered by two forms of remembrance that act as a counter to the homogenizing effects of globalization. On the one hand, he suggests, there is 'monumental memory', which plays on the aesthetic power of images, as illustrated by photographic installations at the Brandenburg Gate, Christo's *Wrapped Reichstag*, Norman Foster's new Reichstag cupola and Peter Eisenman's Holocaust Memorial. On the other hand, he goes on to argue, there is 'critical memory', which seeks to instrumentalize the aesthetic qualities of material space. For Ward, this is illustrated by the work of Shimon Attie, Christian Boltanski, Daniel Libeskind, and Hito Steyerl. His conclusion is that, in the marketing strategies of the would-be global city of Berlin, exchange value is fast supplanting memory value.

My chapter, 'Trash Aesthetics', is about the mutability of urban landscape and the radical impermanence of the city. It is also about globalization, violence, and cultural memory. Engaging with these issues as they relate to post-9/11 New York City, the focus is an urban landscape architecture project titled Lifescape. Under construction since 2008, Lifescape is an ambitious, long-term plan to transform the Fresh Kills Landfill on Staten Island into a public park and recreation area. There are two reasons for this interest in a project to rehabilitate a garbage dump. First, Lifescape marks a significant effort to reclaim and reimagine a derelict landscape that is connected in both material and symbolic ways to the lived space of the global city. Second, following the events of 9/11, the wreckage from Ground Zero was transported to the Fresh Kills Landfill. Through an analysis of Lifescape's transformative vision and, in particular, its plans for a 9/11 earthwork monument, the chapter considers the ways in which the Twin Towers, as the world's most notorious and conflicted architectural symbols of globalization, continue to haunt the contemporary imagination. My argument is that Lifescape works simultaneously to reveal and conceal the mutability of urban landscape, attesting not only to the extraordinary versatility of urban space but also to the imaginative ways in which such space can be recycled, renewed, and remade.

In 'Global Beijing', Stephanie Hemelryk Donald takes the events surrounding the 2007 Suzhou Qiao tragedy, in which six migrant workers were trapped and killed in the works of a new underground train link in Beijing, as a point of departure for discussing the relationship between globalization and violence in urban China. Donald then goes on to consider the Suzhou Qiao tragedy and memorial effort in relation to Jia Zhangke's 2004 film *The World*, which tells the story of a young migrant worker who dies in a construction accident while building a Beijing amusement park. Her aim in this chapter is to situate violence as integral to the construction of new modern spaces in China's accelerated globalization programme. In doing so, she highlights the level of violence made possible by new, or newly configured, class distinctions in China. What her discussion illustrates is that the violence

of development, the emasculation of the poor, and the non-spaces which they are forced to occupy are at the core of both Jia's fictional work and the real story of contemporary urban China.

Part III, 'Spectacle', opens with a chapter on experimental city photography. In 'The Poetics of Scale in Urban Photography', Shirley Jordan considers the place of the individual in postmodern urban landscapes by examining the work of contemporary artists such as Andreas Gursky, Naoya Hatakeyama, Denis Darzacq, and Raymond Depardon. In particular, she explores two tendencies in recent urban photography that are connected to issues of spectacle and scale: images that focus on the monumental and images that seek out interstitial fragments. One of Jordan's far-reaching ideas, developed in relation to Depardon's postmodern urban walking experiment *Villes/Cities/Städte*, is that, despite contemporary photography's nostalgic allusions to *flânerie*, this mode of knowing the city (which belongs more to urban modernity than to urban postmodernity) has been replaced by a new trope – specific to the present era of globalization – which she calls 'urban skimming'. For Jordan, what is ultimately at stake in urban photography's 'poetics of scale' is a shared understanding of 'human scale' and the violence done to it in the emerging cityscapes of the global era.

Ruth Cruickshank's chapter examines three recent internationally acclaimed films – *La Haine* (1995), *Le Fabuleux Destin d'Amélie Poulain* (2001), and *Caché* (2005) – to consider the relationship between cultural mobility and symbolic violence in Paris. Drawing in particular on Pierre Bourdieu's (1977 with Passeron and 1984) work on both symbolic violence and the creation of distinction through cultural capital, Cruickshank begins by establishing how the economic and cultural apartheid between the peripheral *banlieues* and the bourgeois centre differentiates Paris from other postcolonial global cities. She then identifies how representations of spatial and symbolic exclusion in these films are predicated not only on global market economics, but also on France's involvement in an earlier phase of globalization: colonialism. After examining the films' motifs of incarceration and their mapping of physical mobility onto the spatial and symbolic geography of the city, Cruickshank focuses on interior spaces and the ways in which they reflect an internalized form of symbolic violence that is inherent in the (post)colonial condition. She concludes by identifying how the selected films risk sedimenting a symbolically violent image of Paris in which the *banlieue* and its inhabitants continue to be disempowered.

In the final chapter of the book, Sue Harris offers a case study of the commercially and critically successful Jason Bourne film trilogy, a series of big-budget conspiracy thrillers based on the bestselling novels by Robert Ludlum. A central concern for Harris is how the films set new spatial agendas for twenty-first-century blockbuster cinema in which distinct city-spaces are 'flattened' into undifferentiated and indistinguishable canvases for the spectacular display of violence. Key to her reading of the films is the idea that the character of Jason Bourne represents the focus of both the process and the

condition of globalization. Pursuing this line of thinking, Harris also investigates the films' structural reliance on the transnational mobility of people, capital, technology, and information, as well as the films' dramatization of the geographical reach, technological capability, and violent potential of globalized systems. The conclusion reached here is that the Bourne trilogy's investigation of the global reach of malevolent forces resonates not only with a generalized tide of unease underpinning the contemporary experience of globalized security systems, but also with distinctly post-9/11 fears about the random eruption of violence in world cities.

CITY OF PANIC

Surveying the contemporary urban scene in *City of Panic*, French philosopher Paul Virilio suggests that what the global city creates in its inhabitants – mainly through spatial incarceration and the mass-mediated looping of terror – is nothing short of a 'raging mass psychosis of the besieged' (Virilio 2005: 85). Together, the chapters in this book show that, while global cities are frequently marked by cultures of fear and panic, Virilio's view of the global metropolitan condition as some kind of mental derangement is both a distortion and an exaggeration. As urban geographer Nigel Thrift has similarly remarked, Virilio's account of panic urbanism dramatically overstates the case, leading to a nightmarish vision of the contemporary city as a 'phenomenology of despair' that has 'reached the edge of urban evolution' with 'nowhere left to go' (Thrift 2005: 340). A more measured and useful version of Virilio's concept of a siege psychosis can be found in Mike Davis' (1992) much earlier work on the fortress mentality of twentieth-century Los Angeles. Indeed, this fortress mentality and its attendant practices are addressed, both explicitly and implicitly, by the many chapters in this book dealing with the spatial segregation and reordering of cities. The point I want to make in light of Virilio's alarmist comments, however, is that what the following pages explore are the many ways in which cultural production can engage – but also break away from – the paranoid, carceral urbanism of globalization.

Part I
Fear

2 Architecture and economies of violence
São Paulo as case study

Richard J. Williams

INTRODUCTION: ECONOMIES OF VIOLENCE

It has become a commonplace that any economy may include both real and imaginary elements, and that the boundary between the two is often difficult to draw. The imaginary may well inform the real, or in some cases displace it. This is nothing new, and may be observed in many different locations. It defines postmodern accounts of arguments about the changing nature of the global economy, specifically the shift in developed world economies from economies based around the manufactured goods, to services, made up of, in large part, the representation of those things. The chief exponent of this world-view, the French philosopher Jean Baudrillard, saw the world increasingly tilted towards representations, hence the high value he ascribes to the sign (Baudrillard 1988). The first Gulf War, he argued, didn't happen but was a media event (Baudrillard 1995).[1] So it is with most economies of urban violence, the subject of this chapter. Here the real and the imaginary find themselves linked in the most profound and sometimes surprising ways; imaginary violence has a striking capacity to inform the look of cities. As Geoffrey Kantaris observes elsewhere in this volume, cinematic violence may feed into reactionary fantasies, which in turn affects real behaviour (see Chapter 3). Numerous studies of Los Angeles in the 1980s and 1990s describe the de facto militarization of an otherwise liberal urban landscape, with armed patrols, hi-tech surveillance, and defensive mechanisms appropriate to wartime conditions – all out of largely imaginary fears. This was Mike Davis' hyperbolic, but still striking, argument in *City of Quartz* (Davis 1992). LA had become, in his words, a 'fortress', protected against all manner of enemies. As *Ecology of Fear*, Davis later treatment of LA made clear, however, the imaginary violence was increasingly detached from the real, cinematic, and literary representations it. The militarization of southern California, in other words, was as much a response to the possibility of an invasion by Martians as it was a response to high rates of burglary. In situations such as this, imaginary violence can go on to dominate the real if it is in effect a city's defining culture. In New York, under mayors Rudy Giuliani and Mike Bloomberg, real violence declined to the point at

which the city was among the safest in the US.[2] Meanwhile the most powerful cultural representations of the city, notably in film, were dominated by acts of imaginary or symbolic violence. It could be argued, therefore, not entirely in jest, that New York's economy of violence has become increasingly post-industrial, played out less on the streets and more on the cinema screen.

Economies of violence can have a profound effect on architecture, a form of representation as much as film. The economy of violence may be distorting enough for a city to wish to cultivate a *look* of violence in its buildings. Precisely how this might occur is my main topic here. I explore these issues in relation to São Paulo, Brazil's largest city, with 11 million inhabitants in the city proper and some 20 million inhabitants in the metropolitan hinterland. A city with a relatively low profile in Anglophone literatures on urban matters, it nevertheless makes an excellent case study. Like a southern hemisphere New York (which it physically resembles), its entire cultural identity is bound up with questions of violence. The way business and social relations are conducted in the city, the way its population moves about its surface, and most of all where and how its citizens live, are all conditioned by an expectation of violence. This expectation has been highly cultivated, and however clichéd or inaccurate, it has become one of the defining characteristics of its culture, from its newspapers, to its novels, to its music, to its films, to (my focus here) its architecture. Everything is conditioned by the possibility of violence. The narrator of Teixeira Coelho's brilliant comic novela *Niemeyer: Um Romance* (2001) has a neurotic dread of the city he inhabits, returning time and again to his *expectativa de ser assassinado a qualquer instante*, or his 'belief that he will be killed at any minute' (Coelho 2001: 56).[3] Its droll recurrence on every other page indicates that humour may be the best way of getting past this most horrible of fears.

São Paulo's economy of violence has excesses of both real and imaginary violence. Its real-world violence has been in recent years of the most extreme kind. The city's murder rate hit a peak in 2004 of 37 murders per 100,000 per year, twice the average for Brazil and approximately four times the rate for New York City during the same period (Goertzel and Kahn 2007). Through the early 2000s, the phrase 'undeclared civil war' was a widely used journalistic shorthand for the state of urban Brazil (Goertzel and Kahn 2007). In May 2006, a series of astonishing events gave this view credence. A series of coordinated attacks by a criminal gang, the Primeiro Comando da Capital (PCC or First Capital Command), paralysed police stations throughout the city, local buses were set on fire, blocking the city's main highways, and police officers were killed. The city was brought to a total standstill for two days, after which the police staged a series of revenge attacks. The combined death toll for the two days was 172 according to CNN, although much higher in other anecdotal accounts. In an extraordinary piece on the violence for the Buenos Aires newspaper *La Nación*, Coelho wrote of fear, but also of an unprecedented silence. The events produced a silence of an

all-encompassing kind that the author had only experienced once before, in the middle of the Amazon jungle.

A number of aspects of this story are worth drawing out. First, this was self-generated violence, coordinated and produced by and within the city itself. Second, this was violence on a colossal scale by any standards, bringing this city, the world's third largest, to a dramatic, albeit temporary halt. Third, it was visually spectacular, and became a representation of itself almost immediately. The PCC's tactics, especially the burning of buses, were televisual events of the first order, as was the police response. It is no surprise therefore to find it already forming the narrative (and visual) background to a major movie, *Linha de Passe* (dir. Walter Salles, 2008) given its European premiere at the Cannes Film Festival in 2008. Finally, it was a classic São Paulo tale in that it retold the narrative that civilization ultimately begets uncivilization. São Paulo's economy of violence, it could be said, transforms real events into representations with remarkable speed, very often through the medium of film. *Linha de Passe* is one example in what is effectively a tradition; the best-known example distributed internationally was *Carandiru* (dir. H. Babenco, 2003), an account of a real prison riot that took place in 1992, and led to the founding of the PCC. Although not set in São Paulo, the following two films should also be seen in the same context: *Cidade de Deus* (dir. Fernando Meirelles, 2002), a history of a Rio *favela* based on an autobiographical novel by Paulo Lins, and *Ônibus 174* (dir. José Padilha, 2002), a documentary of a Rio bus-jacking which took place in 2000. There is in São Paulo, and more generally in Brazil, a powerful industry able to convert real violence into cultural product in a remarkably short space of time.

ARCHITECTURE AND ECONOMIES OF VIOLENCE

However, I want to emphasize architecture, because it is here perhaps that São Paulo's economy of violence is most distinctive. The work of Davis on Los Angeles has helped open up a general category of understanding, whereby otherwise innocuous architectural forms can be understood to signify violence, repressed or otherwise. After Davis, a well-cared-for suburban villa can signify participation in the city's economy of violence. There is in Davis a plethora of micro-architectural examples of the city's economy of violence, from the warning signs already mentioned, to the 'bum-proof' benches in bus shelters, fiendishly designed to prevent their use as an impromptu bed, to the increasing presence of CCTV cameras, to larger examples of surveillance and deterrence, most, if not all, associated with shopping. Davis is arguably as much a participant in the 'ecology of fear' as the things he ostensibly criticizes, but nonetheless his work is useful in expanding the category of violence in relation to architecture. What he has shown, to my mind compellingly, is how complicit architecture can be in the economy of violence: buildings are among the most overt representations we have of our fears about urban life (see Williams 2004).

Davis has a Brazilian counterpart in the form of Teresa P. R. Caldeira, a Brazilian anthropologist whose *City of Walls* appeared in English in 2000 and is now one of the better-known academic works in English about São Paulo. A more sophisticated work theoretically than anything produced by Davis, and grounded in a much more thorough body of research, Caldeira's work nonetheless shares with Davis a somewhat pessimistic attitude towards the city, and a belief that small architectural signs are among the best indicators of the condition of a city. Like Davis, too, she is preoccupied with the participation of architecture in what I call here the economy of violence. Her research focuses on the decline of the São Paulo's public realm during the 1980s, concentrating on the once respectable lower-middle-class neighbourhood of Moóca, which can be found some 10km to the northeast of the historic centre of the city (Centro). She describes in detail the architectural signs of the area's slide: pavements (sidewalks) degrade along with public plazas; metal grilles appear on virtually all domestic buildings to deter intruders; graffiti appears everywhere; metal roller shutters appear on commercial storefronts; public streets are closed by legal or quasi-legal means to create defensible private realms; modernist apartment houses, built on *pilotis* and meant to be open at ground level, are fenced in. It becomes unfeasible to take an evening stroll. At the same time she describes the beneficiaries of flight from Moóca, the new, self-contained, air-conditioned and secure shopping malls of the smarter suburbs, and gated communities (*condomínios fechados*) such as Alphaville far outside the city proper – I will say more about Alphaville in due course. Caldeira's methods – the observation of microscopic architectural change, and of residents changing behaviours in their environment – has close parallels with the work of her partner, the architecturally trained anthropologist James Holston, who produced a widely acclaimed, although flawed, study of Brasília in 1989. Both Caldeira and Holston share a fundamentally pessimistic view of the city and the place of architecture within it. When architecture is not registering some slow act of violence done to the city, it is an active participant in that violence, a tool of oppression used by those in authority.

I will return to Caldeira shortly. However, let us start a detailed discussion of São Paulo's architecture by considering a *view*. São Paulo has a remarkable urban landscape that to many observers suggests violence. Since the mid-1960s and the development engendered by the so-called economic 'miracle', the perceived violence of its landscape has something to do with its immense concentration of high-rises (according to the authoritative architecture website Emporis, the world's third largest concentration after New York and Hong Kong). But there is something more impressive – or terrifying – about São Paulo for the first-time visitor, because unlike those other high-rise cities, this one appears to have no end. The buildings rise up in seemingly endless waves, apparently unbounded. This impression is qualified on clear days when the Serra da Cantareira comes into view in the northwest, but most days the city is all that can be seen.

Figure 2.1 View of São Paulo, looking southwards from the Edifício Itália (photo by Richard J. Williams).

The idea that the landscape might be of itself violent is nothing new. Something about its form in 1942 led the Austrian poet Stefan Zweig to say, 'no city in Brazil, and very few in the whole world can be compared in the violence of development with this most ambitious and dynamic of towns' (Zweig 1942: 211). In 1936, the French anthropologist Claude Lévi-Strauss noted some similar impressions as he took up a position at the newly formed University of São Paulo. He remarked, like Zweig, that something about its pace of development led to its having a more or less permanently ruined condition. It never looked new, even though it was always in the process of coming into being. It was always half-destroyed as if it had just emerged from a war. He wrote of his shock at the city's premature ageing:

> I was staggered to discover that so many of their districts were already fifty years old and that they should display the signs of decrepitude with such a lack of shame, when the one adornment they could lay claim to was that of youth, a quality as transitory for them as for living creatures. Rusty old iron, red trams with the appearance of fire engines, mahogany bars with polished brass rails; brick built warehouses in deserted streets, where there was only the wind to sweep away the rubbish; rustic parish churches standing at the foot of offices and stock exchanges built in cathedral style; mazes of seedy buildings looming over intersecting

valleys of trenches, swing-bridges and footbridges; a town being piled ever higher, since the vestiges of old buildings are constantly used as a basis for the new.

(Lévi-Strauss 1976: 96)

What Lévi-Strauss observed is not entirely unique to São Paulo, for his comments might be profitably compared with those of Alexis de Tocqueville or Friedrich Engels on early nineteenth-century Manchester, a city whose very progressive quality seemed to render it as ruin. But São Paulo is a good contemporary case, and something about this imagination of it as a ruined landscape in the aftermath of an act of violence persists strongly to the present, even when the facts contradict it. Take Anselm Kiefer's monumental painting *Lilith*, for example, one of a series of works the artist made in response to São Paulo in 1989 on the occasion of his invitation to the art Bienal that year. The scene is an adaptation of the view from the Edifício Itália, and is one of the city's iconic monuments. From the top of this forty-six-storey tower, you look towards the great ridge of high-rises on the Avenida Paulista, across canyons of slabs and point blocks. There is some of the city's best architecture here, including Niemeyer's serpentine Edifício Copan (not represented), and some of the inner city's most gracious neighbourhoods, such as Higienopolis.

The city as depicted here consists exclusively of modernist towers, undistinguished and hard to separate from each other. They form a dense array from which everything else is excluded; there is barely space to breathe. The city is drawn roughly in acrylic and emulsion paint, and the surface is scratched and gouged, physically attacked. Across it are scattered haphazardly a set of crude materials, all of which have about them the feeling of decay – chalk, ashes, human hair. Now the original view from the Edifício Itália has some ruinous moments (Centro has seen better days) but it is by no means the chaos Kiefer depicts. His visual trope – supported by the title, *Lilith*, an evil Hebrew deity who rains destruction from above – is that of the city destroyed by aerial bombardment, Dresden, Hamburg, or Nagasaki. São Paulo, it barely needs to be said, may have suffered at the hands of the PCC, but it has never been the object of such monumental aerial destruction. And yet something about the place invites this imagery and it receives it without complaint.

Let us focus our gaze slightly now, and move from a view, to a building type, or more accurately an architectural style. If the wider landscape of São Paulo is widely perceived in terms of violence, the characteristic style it developed in the 1960s provides further support, in terms of both inflicting violence on the city, while at the same time providing some respite from it. This style is Brutalism, a 1950s variant of Modernism associated with Le Corbusier in Paris, and Peter and Alison Smithson in London. Unlike the first flowering of Modernism, Brutalism accepted the existing built environment as found, whatever its condition, and advocated the use of poor or

rough materials. Its appearance in Brazil in the early 1960s had local peculiarities. Its main practitioners (Vilanova Artigas, Paulo Mendes da Rocha, and Lina Bo Bardi) were for the most part unhappy about both the term and international comparisons. This was the case with Artigas in particular, whose public statements had a distinctly xenophobic dimension. A key member of the Brazilian communist party (PCB) which had been outlawed by the military in 1964, Artigas was suspicious of any international involvement in Brazil and presented his architecture as a peculiarly local response to local conditions (see Williams 2007b).

Nevertheless, São Paulo Brutalism has in common with European variants an understanding of the existing built environment as essentially hard, with which an accommodation must be reached. In England, it was the ruined landscape of post-war London, whose reconstruction would take decades. In Brazil, it was São Paulo, where voracious development had produced strangely similar results. In both cases, there was a tendency toward inward-looking architecture, in which the building turned its back on the public realm and in effect offered a sanctuary from it. In the case of Brazil, as Guilherme Wisnik has described, the architecture from the outside might be a set of 'blind facades'. But inside, it might bring in some of the 'attributes of the external environment – water, gardens, and sunlight – thus internalizing a sense of the country's natural landscape' (Wisnik in Forty and Andreoli 2004: 42). Such building therefore might outwardly have a profoundly defensive, bunker-like appearance, profoundly discouraging to the outsider; but inwardly, it might be rich and subtle. The school of architecture at the University of São Paulo (FAU-USP) more or less invented this style, and its headquarters is itself a key example of it. Designed by Artigas with the engineer Carlos Cascaldi in 1961, completed in 1969, it occupies an island site in the expansive campus of USP on the south side of the city. The faculty's removal to the site itself signifies a turning away from the city, and city life – its main site previously had been on the Rua Maranhão in the gracious neighbourhood of Higienópolis.

The new building consists of a giant concrete bunker of three storeys and 18,000m^2, raised on columns of a famous design, tapering in the middle. Its roof has huge beams spanning up to 22m. Its untreated concrete surfaces are exceedingly rough, with the traces of formwork clearly visible. The whole thing is a heavy, awkward, defensive-looking object, superficially more akin to a military installation than a teaching building. Inside, however, there is a surprising delicacy, and the building quickly becomes something like a sanctuary. The landscaping on the south side is rich and lush, and more or less extends into the building, which is entirely open at ground level; there are no doors, just an occasionally manned security post. Then inside, FAU-USP opens up into a huge, airy atrium whose scale recalls a public plaza (and has frequently been used for meetings on a public scale). Hanging off this atrium are various delicate features – a well-used library with views into the atrium and out to the garden, with a small terrace recalling the format of the

Figure 2.2 Vilanova Artigas, FAU-USP building (1961–9) (photo by Richard J. Williams).

traditional *fazenda*. In summary, this is a building that is profoundly defensive on the outside, whose entire form speaks of the need for defence against the violence of the city. It reproduces the best forms of the city – its plazas, its gardens, its libraries, and its café society – in its sanctuary-like interior.

FAU-USP coincides with an immense period of reconstruction in São Paulo, during which the city was rebuilt in the image of the automobile, a direct representation of the development of the motor industry in the country which, through investment by Ford, Fiat, and VW, became one of the world's major concentrations. The city was violently restructured via a set of urban motorways threaded through the urban landscape. The so-called *minhocão*, inaugurated in 1970, is the most dramatic of these, insinuating itself along an existing boulevard in the west of the city at what amounts to third- or fourth-floor level. The consequences for the life of the existing street were severe. The popular name of the new motorway – 'big worm', after a mythical monster of the Amazon region – alludes to both the motorway's form and the violence of its insertion into the city. Although the presence of the *minhocão* has inevitably been accompanied by many forms of adaptation to its presence, and the motorway itself has provided shelter and space for numerous forms of light industry, it nevertheless can be said to be part of the city's economy of violence. It is worth adding, furthermore, that it was planned and

Figure 2.3 Vilanova Artigas, FAU-USP building (1961–9), detail of column (photo by Richard J. Williams).

inaugurated by a military regime at the height of its power. As much as it was anxious to encourage economic development, the regime was also keen to show the extent of its power, and its programme of highway building – like that of Baron Haussmann, the prefect of the Seine in Paris 1853–70 – was designed as an expression of state power as much as anything else, an act of symbolic state violence. FAU-USP, and the associated works of architecture in the Brutalist style of the late 1960s and early 1970s, are inseparable from these infrastructural works of the state. They may paradoxically start from a political position that was diametrically opposed to that of the state, but they exist in and help reinforce the same economy of violence.

Something similar can be seen in a very late flowering of Brutalism in the city, the Museum of Brazilian Sculpture (MuBE) by Paulo Mendes da Rocha, designed in 1987. Like FAU-USP two decades previously, this is explicitly a retreat from the city. Set on a street corner originally designated for commercial development in the upscale neighbourhood of Jardins, it appears from the street as a rather scruffy, mostly concrete square dotted with sculptures. Up close, it becomes apparent that this is in fact a building, but an extremely reticent one, sunk mostly into the ground. A giant concrete beam provides shade and defines the extent of the structure. Mostly this is a subterranean museum. It would in fact make a good air-raid shelter, except for the fact that the bunker-like main spaces are punctuated with some exquisitely

Figure 2.4 Paulo Mendes de Rocha, MuBE (1987) (photo by Richard J. Williams).

designed voids, including a delightful, sunny water garden with carefully chosen native flora. This tiny intervention again reproduces the most civilized qualities of the city in a protected form – so protected, in fact, that museum visitors can only look on it from outside. The remainder of MuBE is harsh, made more so since its inauguration by the superficial decay of the concrete surfaces, now stained with rust. It is a successful space in many ways, but a hard one that responds to the architectural violence of the city with a tough, well-defended space that seems designed to repel rather than invite the visitor. This toughness has been continued well up until the present day in Mendes da Rocha's building for the Galeria Leme, a contemporary private art space in a tough corner of the suburb of Butantá, adjoining the southern side of the Marginal Pinheiros motorway. A completely blank, concrete façade on the outside conceals a carefully detailed, churchlike interior with a small, sunny garden-like space, a quiet retreat that has nothing to do with the harsh exterior world (see Williams 2007a).

ALPHAVILLE

Now, for the most part, the things I have described so far have been metaphorically rather than actually violent – they are representations of a vaguely understood economy of violence, less a response to actual conditions of violence. Alphaville, a new city thirty kilometres to the west of São Paulo

Figure 2.5 Paulo Mendes de Rocha, MuBE (1987), detail of interior water garden (photo by Richard J. Williams).

would fall into this latter category (Carvalho et al. 1997). Adjacent to the established city of Baueri, but physically separated from it by a six metre steel fence, it is by land area one of the largest gated communities in the world, and has a resident population of 15,000, swelling to 30,000 during the daytime. It has its own police force, miles of huge new houses in a variety of historical styles from New England to Art Deco to Second Empire French, and a city centre, similar in scale to Los Angeles's revitalized downtown, with a cluster of thirty-storey towers. Adjoining the business centre is an area of small-scale retail and commerce, built along lines that correspond to the so-called New Urbanism, a form of building found in Celebration (Florida, USA) and Poundbury (UK) which seeks to revive old-fashioned notions of civility along with historical architectural styles. Alphaville, like those places, has all the infrastructure to create the illusion of a healthy civic life: schools, health care centres, streets, squares, and parks, all organized within walking distance of each other. The commercial centre is genuinely impressive: bustling and not at all contrived.

The general character of the city is wealthy, white, middle-class, and in physical appearance it is closely related to small cities in North America. It is, in purely physical and commercial terms, an impressive achievement, a huge and immersive environment of the highest standards. Its very existence, however, is the direct result of the fear of violence. Its location, by road between

28 *Richard J. Williams*

Figure 2.6 Alphaville (SP), view of business centre with walled residential compound in foreground (photo by Richard J. Williams).

one and three hours from the centre of São Paulo, is a positive attraction, despite the inconvenience – a de facto barrier between the residents and the city. It sells itself primarily on its ability to provide a secure environment for families; in the city itself, walls and checkpoints are all-pervasive as one moves between the relatively open commercial zones, to the resolutely closed residential ones. Even in the open zones, signs warn (or reassure) the visitor that the entire area is under CCTV surveillance. All this makes for an environment that appears relatively secure by Brazilian standards, achieving levels of control and stability normally associated with an enclosed shopping mall.

There is, to invoke a Freudian metaphor, a good deal of repression in this particular local economy. Violence may not be actually present, but everything about the nature of the built environment and its management – the gates, the walls, the guards, the cameras – speaks of a fear of violence. In a bizarrely Freudian episode in the late 1980s, everything Alphaville sought to

Figure 2.7 Alphaville (SP), sign advertising CCTV use in commercial centre (photo by Richard J. Williams).

repress returned with a vengeance from within. Its bored youth took to stealing cars, drugs, rape, and murder. Statistics for car accidents alone within the community walls are staggering: between 1989 and 1991 there were six deaths and over 1,000 injuries caused by no less than 646 car accidents. The fear of violence, exacerbated by events such as these, would seem to be accompanied by an unusually large demand for mental health services. Alphaville had in 2005, according to its directory of local services, no less than ninety-six psychologists or psychotherapists – on the evidence of the *Páginas Amarelas*, roughly 3,000 times the number of analysts per head of population in Alphaville than in São Paulo in total. This is no more than an association, it must be stressed. However, it would be no surprise to find that, given the intimate relationship between the very existence of Alphaville and the fear of urban violence, many of the conversations in these therapeutic sessions had violence as a key term.

A CHANGING ECONOMY OF VIOLENCE

My argument at the outset was that São Paulo's economy of violence was composed of both real and represented violence, and that the two, although historically related, could exist independently of each other. A de facto industry has propagated the idea that São Paulo was in a state of civil war, generally concluding that nothing can be done until Brazil's underlying inequality of wealth is redressed. However, the recent history of crime in São Paulo makes the situation much more complicated. In 2000, the homicide rate for São Paulo state was approximately 37 per 100,000 inhabitants, or 8,000 per year, roughly twice the average for Brazil, and higher than the rate for any comparable US city (Goertzel and Kahn 2007).[4] In 2006, the São Paulo state murder rate had declined to 15 per 100,000, with first indications for 2007 of a further decline to 11 or 12 per 100,000. The São Paulo decline was strongly concentrated in the city, so meaningful – and striking – comparisons can now be made. São Paulo in 2007 compares reasonably well with NYC (7 per 100,000), a city that has had among the most marked declines in violent crime in the developed world. As Goertzel and Kahn (2007) have suggested, São Paulo's results have to do with a variety of factors, mainly sophisticated policing, enforcement of gun crime laws, better rates of crime resolution, and, crucially, much higher rates of incarceration.

Whatever the reasons for this striking fall in São Paulo's crime rates, it is hard to argue with the conclusion that we are now in a changed situation. But what has changed, and how, is harder to say. One scenario is that with increased prosperity and relative economic stability the factors that led to violence in the first place have decreased. Another, for which there is much anecdotal evidence, is that more and more aggressive policing has led to the change. The latter, it is true, might be described as the Alphavillization of São Paulo – that is, its interpretation as secure reserve in which a high level of surveillance is accepted and even encouraged. There is plenty of evidence for this in the forms of development and socialization that have appeared since 2006. Superficially the city is better for it – there is more life on the street, more places to eat and drink, less of an urgency to return to one's secure apartment block. But it may have come at the cost of increased surveillance, in which architecture is a key factor.

NOTES

1 Baudrillard made a career out of this hyperbolic perspective, but it is prefigured in many respects by Freud's worldview in which *neurotic* symptoms – that is symptoms with no connection to an observable reality – increasingly displace realistic ones. This is well represented in his classic account of the economy of anxiety (see Freud 1977).
2 New York City rated tenth among metropolitan cities for crime in 2006 (FBI statistics for 2006; see http://www.fbi.gov/ucr/cius2006/index.html, accessed 8 June 2008). There were any number of films during this period that represented the city

in violent terms. As the locus of street violence, *Gangs of New York* (dir. M. Scorsese, 2002) is a good example. New York was also destroyed several times in neo-biblical disasters: see *Independence Day* (dir. R. Emmerich, 1996) or *AI* (dir. S. Spielberg, 2001).
3 The novella is tangentially about architecture: the main character is a writer engaged on a stalled biography of Oscar Niemeyer.
4 Certain US cities have had historically higher murder rates; for example, Washington DC (63 per 100,000) and Birmingham, AL (44 per 100,000), but these are much smaller cities and cannot be strictly compared.

3 Drugs and assassins in the city of flows

Geoffrey Kantaris

INTRODUCTION

The cinematography of a number of Latin American countries over the last couple of decades has become deeply imbricated with the violent effects and aftershocks of a set of global forces which have profoundly restructured the social relations of the polis. These forces are often represented in cinema as the flipside of glossy corporate globalization or the inevitable corollary of 'wild' (unregulated) neoliberal capitalism, a 'negative globalization' of the type analysed by Manuel Castells in the third volume of his trilogy on the Information Age, *End of Millennium* (1998). This is the negative globalization of poverty and social exclusion in the 'globally connected but locally disconnected' megalopolis (Castells 1996: 404), but it is also the globalization of crime via the hugely profitable illegal drugs industry which has so profoundly marked many Latin American societies, particularly in the two countries which furnish the films to be analysed here in detail: Colombia and Brazil. My focus will be on the processes of representation which link these raw social conditions to a broader social imaginary, for which I take cinema, caught as it is today between a largely national literary culture and a globalized televisual culture, to be a paradigmatic case. Of course, no study of cultural forms in Latin America can afford to remain on the terrain of narrow aesthetic debate given the traditional imbrication of social and political power with the 'lettered city' in Latin America (Rama 1984; Franco 2002). But the relationship of the local to the global is not only a matter of economics; it is also a relationship that is profoundly mediated by social and increasingly global imaginaries of which televisual culture still takes pride of place despite the internet boom. Hence we should not forget that representational processes do not merely reflect social processes but are largely constitutive of deterritorializing forces, a point I shall be making in more detail later.

The Colombian city of Medellín went through a profound set of transformations during the 1980s as huge quantities of drugs and money flowed through the city, placing it at the centre of a highly successful globalized narcotics industry. A similar process occurred a few years later in Brazil's

megapolitan conurbations, Rio de Janeiro and São Paulo, as the drugs trade began to search for 'internal' Latin American markets, one effect of which was to accentuate a pre-existing tendency in both cities towards ghettoization, or the violent segmentation of urban space. The cinematography of each country has mounted a vigorous critical response to the processes of social transformation and immiseration that ensue, although both countries also produce films which trade in urban fear through the familiar formula of displacing social misery onto crime. In Colombia, a trilogy of films by Víctor Gaviria, of which I shall here consider *La vendedora de rosas* (*The Rose Seller*, 1998) and *Sumas y restas* (*Additions and Subtractions*, 2004), provide a highly subtle, almost Balzatian, exploration of the violent restructurings of the 1980s from the perspective of the city's displaced populations, while the global film industry also registers this violence through films such as *La virgen de los sicarios* (*Our Lady of the Assassins*; Schroeder 2000) and *María, llena eres de gracia* (*Maria, Full of Grace*; Marston 2004). Internationally popular Brazilian film focuses on the extremes of social violence, notoriously in *Cidade de Deus* (*City of God*; Meirelles and Lund 2002), and with a more subtle focus on imaginaries of fear in the globalized megalopolis in *O invasor* (*The Trespasser*; Brant 2002). In these films, the globalized 'space of flows' finds its corollary in the illusion of easy money as the congealed form of social violence. Of particular notoriety is the emergence of a 'culture of death' in both countries, in which modes of capitalist consumption, the tendency towards faster and faster turnover, rapid obsolescence, and the manipulation of consumption through libidinal addiction come to be applied not only to whole communities, as the drugs mafia take advantage of high rates of unemployment amongst working-class youths to employ a whole army of cheap assassins, but also to the human body itself, which becomes a shockingly consumable item.

Although I am here examining the cases of Colombia and Brazil, the special case of Mexico deserves mention, since in recent years it has become paradigmatic of a number of these processes due in part to its status as the poorest member of the North American Free Trade Association. Consequently, it has found itself at the sharp end of corporate globalization with a proliferation of high-brand-name sweatshops, deunionized free-trade labour, an enormous diaspora, and a perhaps not coincidental rise in crime, corruption, and illegal drugs (more than 2,500 people were killed in drug-related crimes in Mexico in 2007 (Kennedy 2008)). I am not examining Mexican cinema here because the globalization of its drugs trade, largely due to the displacement of certain operations from Colombia, is relatively recent, and although the country has an exciting and in many ways paradigmatic urban cinema of which *Amores perros* (*Love's a Bitch*; González Iñárritu 2000) is but the tip of the iceberg, it has not yet begun to register the links between the spreading narcotics industry and urban violence with the same intensity as that registered in Colombian and, more recently, Brazilian, cinema.

CINEMA AND GLOBALIZATION IN LATIN AMERICA

Before examining the films in detail, it is necessary to make a few theoretical remarks on what it means to be discussing visual culture in the era of globalization. Cinema has traditionally been understood within the study of Latin American culture as a technology for the formation of modern *national* imaginaries, as a suturing of collective identities and traditional oral cultures to the mass media industries of the modern nation-state, an idea derived almost exclusively from the classical cinema of Mexico, Brazil, and Argentina. Yet a focus on cinema as a mirror of the process of national identity formation in various Latin American countries, as 'tribal or national dreaming and not as thinking about the global and the complex', to cite Mexican anthropologist Néstor García Canclini (1995: 180), cannot take us beyond a paradigm in which emergent audiovisual cultures act as imagined communities, transparently extending the reach of traditionally elitist national print cultures to include new populations – the working classes, migrants, the unemployed – within its fold. But the community walls of the old 'lettered city' could never simply be expanded without calling into question its foundations, which is why, historically, the questioning of its boundaries – whether through populist political movements or simply the massification of the city – is concomitant in Latin America with high levels of political violence, often generated from within an elite sector whose hold on power is at least phantasmatically threatened by any broadening of the populace's right to the city. This process is still profoundly registered in today's cinema.

Yet mechanically or electronically reproduced forms of visual culture are also a series of technologies. If we view technology merely as instrumental, it is easy to construe it as a transparent relay for the replay of tribal identities, a mirror which may reflect and interpellate, provide a space for more or less complex specular and illusory identity processes, but which remains, essentially, an inert canvas or screen. But mass-media and televisual technologies in their broadest sense insert themselves *structurally* within social formations from the earliest days of cinema onwards, mediating equally the relationship of Mexican peasant migrants to their burgeoning metropolis and that of working-class audiences throughout Latin America to transregional forms of urbanization. And as Colombian media theorist Jesús Martín Barbero writes, 'the very *place* of culture changes when the technological mediation of communication stops being merely instrumental and thickens its textures, condenses, and becomes structural' (Martín Barbero 2005: 24; my translation).

Few studies of Latin American cinema have attempted to come to terms with what is meant by such geological shifts in the very *place* of culture, let alone with the structural involvement of cinema in the largely urban processes, which *dissolve* traditional conceptions of place. It may be argued that these shifts are properly attributable to the era of television, and it is true that in contemporary times television takes over this role and massively extends it. But cinema, television, and their subsequent incarnations in video and digital

technologies all belong to what Régis Debray (1996) terms the videosphere. Jonathan Beller goes so far as to argue that 'a social relation which emerged as "the cinema" is today characteristic of sociality generally[;] cinematic spectatorship . . . surreptitiously became the formal paradigm and structural template for social, that is, becoming-global, organization generally' (Beller 2002: 60–1). Of course, if television, video, and electronic cultures have taken over the spectacle and surveillance functions demanded of image production and consumption in capitalist societies everywhere – as much in Latin American societies as elsewhere – then cinema is now left to occupy something of a bridging function between the aesthetic as traditionally conceived and the technological, and in spatial terms between the nostalgia for place, locatedness, the dream of the tribe, and the forces of displacement and disembedding, the powerful urban processes with which cinema's deterritorializing image economy was complicit from the very beginning.

COLOMBIA

In analysing the response of Colombian cinematography to the urban dislocations outlined above, it would be impossible not to consider the extraordinary project undertaken by Colombian filmmaker Víctor Gaviria in his trilogy of films charting, in almost Balzatian mode, the violent social changes that occurred from the 1980s onwards in Colombia's burgeoning second city and erstwhile drugs capital, Medellín. This violent restructuring of Medellín society occurred as a result of the huge influx of easy money from the growing international cocaine trade. The rise of a drugs mafia almost overnight pulled the city, together with its large marginalized population of migrant refugees from political violence in the countryside, into the swirling vortex of a globalized trade capable of destabilizing all of the basic social structures of the nation, from street level all the way to the upper echelons of power.

One of the things that is distinctive about Gaviria's films is his consistent employment of non-professional actors who come from a similar environment and living conditions to those portrayed in the films. Initially influenced by neo-realism in the first film of the trilogy, *Rodrigo D. No futuro* (1989), the title of which pays homage to Vittorio de Sica's *Umberto D.*, the films go on to develop a subtle imaginary dimension based on the representational paradox of filming invisibility, of that which cannot be caught in the visible frame. The first two films focus on the lives of those who are essentially invisible within the social and political discourses of the nation: the cynically termed 'disposables' or throwaway people, many of them children or young teenagers growing up on the streets, and many not surviving beyond their teens. The boys become, quite literally, cannon-fodder for the drug barons, as well as falling into a vicious gang culture, while the girls who may start by selling roses in the street-side discothèques, end up selling themselves. These children live highly accelerated lives, turning night into day, with all temporal depth – history, genealogy – flattened into a hard pavement or transformed

into the speed-rush of displacement and self-consumption. They inhabit the present in fast-forward, yet are haunted by temporal and spatial ghosts. As the director says of them, using a temporal paradox, 'people don't realize that these street children live out just a handful of highly compressed days, of singular, eclipsed days, during their long nights on the streets. These are night-time days, whose secret light only they can see' (Gaviria 1998a: 40; my translation).

A perfect example of the kind of retroparadoxes that emerge from this new global deployment of time dissolved into speed as some ultimate form of spatialization is to be found in the sequence from the second film in the trilogy, *La vendedora de rosas* (*The Rose Seller*, 1998), which deals most explicitly with prostitution. Judy, who is slightly older than the other street girls who are the protagonists of the film, has taken to charging her boyfriends for sexual petting, and in this sequence we see her in a kind of speed-rush as the camera is mounted on a fast-moving car framing Judy standing through the sun roof. She whistles and shouts to other cars as she and a boy (who is driving the car) speed along the course of the river through the night-time city, past the dazzling lights of traffic and Christmas decorations. Then, slumped in the front seat against the windscreen, staring up at the garish but beautiful Christmas lights that pass overhead (Figure 3.1), she negotiates

Figure 3.1 Living at the speed of light: Judy (Marta Correa) stares at the Christmas lights reflected in the windscreen of her client's car in *La vendedora de rosas* (courtesy of Nirvana Films/Wanda Distribución).

sex with the boy for 15,000 pesos: 'But you won't put it in, will you?', she says; 'What will we do then?' asks the boy; 'Just touch each other and suck my tits'. Emptied of all emotion, reduced to a commodity, she tries to fend off the inevitable, losing herself in the rush of speed and light. This sense of rapid effervescence is typical of the lives of the girls portrayed in this film: there is much play on imagery of fire (and fireworks), representing the rapid consumption and burnout of the teenagers' lives, many of whom die before reaching full adulthood.

Paradoxically, given the accelerated lives of the street children, it is in fact history, memory, and genealogy – tokens which seem to point to the existence of great submersed forms whose dimensions we can hardly intuit from the ripples they leave on the surface – which are precisely the focus of Gaviria's visual practice, as if it were possible to illuminate these depth formations from below, reading off temporal depth from the spatial projections so produced. Engaging very precisely in a 'contradictory' attempt to represent those lives excluded from the globalized televisual gaze, Gaviria tentatively projects these shadows by reintroducing the mode – and the power – of negativity and contradiction.

We can see this at work in a sequence from the middle of the film, which gives an urban spatial metaphor – or atrocious reality rather than metaphor – for temporal loss. After spending all night on the streets, Mónica, the film's principal protagonist, has gone to her aunt's house, from where she had run away after the death of her grandmother, and where the grandmother had once had her own little room, to find a pair of shoes that her grandmother had left her, since her own are worn out. She stares at the plank door that had once led to her grandmother's room, through which a strange light is filtering. She opens it to find an empty plot of land strewn with rubble, with two fragments of adjoining walls that had once been the corner of a room. 'They came and nearly knocked down the whole house', her aunt explains, while the camera focuses on Mónica's disconsolate gaze. She picks her way gingerly across the plot of land while the frame cuts to a low-level medium shot of her legs and worn-out shoes. Indeed, many shots in this film are low-level, framing shoes or pavements, perhaps emphasizing the idea that the city is experienced as a space of transit, confounding our gaze with the flotsam and jetsam, the leftovers of consumption. Above all, such a procedure avoids the visual fetishism of height, of the omniscient gaze with which the city is conventionally represented. Here, the rubble from the demolition – the reality of life in the shantytowns around so many cities in Latin America – becomes a potent spatial metaphor for temporal loss. The film lends a particular importance to the setting of the demolished room, Mónica's only connection to place and locatedness, because it is to this place that she will return, tired and lonely, at the end of the film, and where she sees the final vision of her dead grandmother just before her own untimely death.

Temporal depth is here quite literally converted into empty space, and not

merely in the theoretical sense that Marc Augé (1992) and others give to such processes in the First World. If, as Fredric Jameson says, in our era time can no longer be perceived as a depth formation, something that accrues slowly in great geological strata, but is now 'a function of speed, and evidently perceptible only in terms of its rate, or velocity as such' (Jameson 1994: 8), then the effects of this global acceleration are perhaps most acutely felt by those locked in the peripheral eddies of this spinning vortex. As Gaviria himself suggests, in relation to the truncated lives of the boys he filmed in the first of the trilogy, many of whom met violent deaths even during the film's post-production, 'time has been paralysed in a consumable present, in the imminence of consumption. The present in which the product lives sealed in its empty packaging, . . . at any moment will be eaten, consumed, and then will become a piece of junk in the rubbish heap . . . The past and the future have been abolished . . . In Medellín, No Future is strewn about everywhere' (Gaviria 1989a: 4; my translation).

Gaviria's most recent film, *Sumas y restas* (*Addictions and Subtractions*, 2004) winds us back to the beginning of Medellín's crisis in the 1980s and is an examination of the rise of the drug barons, their henchmen, and the way the temptation of drugs money came to suck in a whole generation of citizens. Its protagonist is a construction engineer from an established entrepreneurial family in Medellín, Santiago Restrepo, who finds himself gradually pulled into the world of the drug traffickers and the allure of easy money that they offered. Attracted by the apparent freedom of his childhood friend, El Duende, who has made a lot of money from small-time trafficking, Santiago begins to accept inflated design and construction contracts from Gerardo, a friend of El Duende's and owner of a cocaine production facility. Santi begins to lust after money and drugs, spending more and more time with Gerardo's group and slowly abandoning his family. But he commits a fatal error in not attending the funeral of Gerardo's brother, and from that moment on his life slowly unravels, leaving him in ruin and mortal danger. This film is more allegorical than the others by Gaviria, and its non-professional actors no longer represent an invisible world of untranslatable cultural density, but instead the prototype of an all-too-visible logic: that of the market elevated to the level of euphoria, a 'utopia' of deregulation and impunity of which contemporary IMF economists would have been proud. It is the same logic which swept through much of Latin America during its lost decade and which is now as much linked to the aforementioned negative globalization (the destabilization of national economies, the rise in international debt often due to corruption, the globalization of crime) as it is to the official climate of free-market economics, privatization, and the substitution of the state by the market.

If 'violence in Colombia has always been an economic force', in the words of ex-minister Fabio Giraldo (Giraldo Isaza and López 1991: 273), then drug trafficking was the catalyst which distilled this potency into its 'purest' form of expression – violence as the intimate logic of consumption – and put it into

circulation from the streets of Medellín all the way to the streets of Miami. And circulation is indeed one of the film's strongest metaphors, from the vortex of its title sequence (an overhead shot of a plastic barrel full of liquid precursors of cocaine being stirred into a whirlpool) to the crazy gyrations of the drug barons' cars driven at high speed through the streets of Medellín under the dual effect of cocaine and alcohol. These gyrations seem to translate a deeper form of circulation, one which threatens to erase all traces of the real. This idea is summed up in the description which one of the characters, an accountant to petty drug baron Gerardo, gives us of the process of laundering money through the banking system, accompanied by a multitude of circular hand gestures:

> You won't believe it! The bank manager said to me, 'just get hold of a couple of ID cards', so we brought some in from a pair of cow herds in Ayapé, and she goes and opens these two accounts for me. Then she starts moving the money around from one account to another until there's not a trace of it left. She's a real pro, I can tell you! I guarantee there'll be no trouble on that score.

But perhaps the most powerful metaphor in this film, beyond the images of circulation, is, to coin a neologism, '*dissolvency*', in the literal sense of dissolving, in the moral sense of dissolution, and in the cinematographic sense of the dissolve between two shots or the fade to black, a technique used very noticeably throughout the film. One particular sequence from the film, or rather an image, becomes almost iconographic in this sense, because it inaugurates a whole series of social and economic dissolutions. Almost at the beginning of the film, we see one of the drug dealers, El Duende, sitting at a table in a Spanish restaurant together with two other dealers. He tells them that he has three hundred 'little packages' for them to sell, and that he has a sample to show them. He takes them through to his 'office', a small cleaning room at the back of the restaurant, where he fills a glass with a transparent liquid, takes out the little package of cocaine, and begins to dissolve the white powder in the liquid. The camera shows in extreme close-up the pure globules of cocaine powder slowly sinking to the bottom of the glass, floating up again and dissolving in white clouds (Figure 3.2). This image then dissolves to a travelling shot of the garage where a lorry belonging to drug baron Gerardo is being repaired in a vacant city lot. We realize that we are now fully installed in the space of flows: flows of money, flows of substances, networks of transport, emptied-out spaces, construction lots, and communications systems. These are the haunting deterritorialized spaces of globalization, the dislocated peripheries where, in Marx's famous phrase, 'all that is solid melts into air'.

Colombia's precarious situation in the midst of these highly destabilizing global flows of substances and dollars, of violence, displacement, and mass migrations, has also attracted the attention of foreign filmmakers. The two

Figure 3.2 'All that is solid melts into air': *dissolvency* in *Sumas y restas* (courtesy of La Ducha Fría Producciones).

main examples of fiction films here are Swiss Hollywood filmmaker Barbet Schroeder, who was himself born in Colombia and who made *La virgen de los sicarios* (*Our Lady of the Assassins*, 2000), an adaptation of a Colombian novel by Fernando Vallejo about Medellín's gangs and hired assassins; and US independent filmmaker Joshua Marsden, who made *María, llena eres de gracia* (*Maria Full of Grace*, 2004), about the phenomenon of drug mules, in this case young women who ingest sealed capsules of drugs in order to smuggle them into the USA inside their stomachs. Both are Spanish-language films, although Marsden's had to be shot mostly in Ecuador and New York, despite having a Colombian cast, because the insurance would not cover using his equipment in Colombia other than in Bogotá. Both films tell of human bodies shockingly reduced to consumable items, but I only have space for one, somewhat allegorical, example from the former film.

The protagonist of *La virgen de los sicarios*, the disillusioned and cynical writer Fernando, has returned to Medellín after many years of self-imposed exile. In a gay brothel, he hooks up with teenage assassin Alexis, who accompanies him on his nostalgic trips around a city which has changed utterly in forty years. Apart from sleeping with Alexis, he also buys him presents: the electronic commodities and fashion items he lusts after. In a key sequence towards the beginning of the film, we see Alexis watching television and listening to hard rock simultaneously in Fernando's apartment,

when the latter, a lover of classical music, arrives back from the street. On the screen, the former President of Colombia, César Gaviria, is giving a speech about the privatization of public utilities, an initiative, he says, that 'will benefit all Colombians'. Fernando tells Alexis to turn off the television, but Alexis stands up abruptly, goes into a back room, and comes back out with a revolver in his hand. He takes aim at Fernando, who backs off in fear, but suddenly, he turns around, points at the television, and fires at Gaviria's image on screen (Figure 3.3). The television explodes and, as Fernando bursts out in laughter, Alexis picks up the hi-fi and lobs it out of the third-floor window. Here, the act of shooting at a screen renders literal, in a somewhat dramatic manner, the relationship between the televisual regimes of media-driven global capitalism, the loss of temporal depth in consumer culture, and the reification of human bodies as throwaway objects of consumption, what Martín Barbero calls 'the tight symmetry between the expansion/explosion of the city and the growth/densification of the media and electronic networks' (Martín Barbero 2001: 132; my translation). It is highly significant that the shooting of a screen should in this film inaugurate a whole series of ever-more-arbitrary shootings which Alexis will carry out in his desire to please Fernando. By directly linking the global ideology of privatization, commodity fetishism, and mediatization to the literal trade in life and death on the streets of Medellín, this film – or at least its script and the book on which it is based – is elaborating a critique of the global production of violence in complicity with the televisual regimes of postmodernity.

Figure 3.3 The shooting of a screen: Alexis (Anderson Ballesteros) in *La virgen de los sicarios* (courtesy of Vértigo Films).

BRAZIL

In 2001, Brazil's most wanted drug trafficker, Fernandinho Beira Mar, was caught in the jungles of Colombia after his light aeroplane was forced to make an emergency landing. He is believed to have been dealing with the principal Colombian guerrilla movement, the FARC or the Revolutionary Armed Forces of Colombia, to oversee the trading of cocaine for a supply of weapons via arms dealers in Surinam as well as to seek their protection from the Brazilian authorities, although the FARC denied this (Associated Press 2001). On his capture, he named Brazilian politicians, businessmen, and police officers as having links to the drugs trade. Put behind bars, he continued to run a formidable criminal organization, the Red Command, using his mobile phone, relatives, lawyers, and other contacts, and was blamed for commandeering the street violence that virtually shut down Rio de Janeiro in 2003, after which he was transferred to a new maximum-security prison (Reuters 2007). However, in November 2007, his newly-wed wife was arrested on suspicion of continuing to run the Red Command, relaying his orders from behind bars. Cash to the value of US$200,000 was found in her apartment. Meanwhile, the powerful prison-based criminal gang that monopolizes the São Paulo drugs trade, the First Capital Command, brought the city virtually to its knees in May 2006 with hostage taking and riots in the prisons, coordinated with multiple attacks on police stations killing some thirty-two policemen and prison guards, the burning of eighty public transport buses and an attack on a metro station (Logan 2006). As is well-known, several of the shantytowns in both megalopolises had become no-go areas for the police in 2006–7, while recent reports suggest that high rates of violent crime remain an intractable problem despite the economic upturn of 2008 (Reuters 2008).

Bursting onto the international circuits in 2002, Fernando Meirelles and Kátia Lund's film *Cidade de Deus* (*City of God*), based on the homonymous 'true-story' novel by Paulo Lins, portrays with a somewhat controversial *Goodfellas*-type aesthetic the growth of the planned housing development, Cidade de Deus, originally established to relocate victims of flooding and homeless people removed from demolished shanty areas in central Rio de Janeiro, into a lawless *favela* dominated by rival drug gangs. Young black slum inhabitant Buscapé (whose name is translated as 'Rocket' in the English subtitles) grows up observing the changes, muggings, brutal acts of violence, revenge killings, rapes, and massacres, commenting on them at key points in the film for the benefit of the cinema audience. This film, like Gaviria's, uses a number of non-professional slum dwellers in its cast, although its stylized and highly edited cinematography, with use of narrative-style voiceover, self-conscious story-telling, and Hollywood-style spectacularization of gunfighting, would seem to obviate whatever realistic intentions might have lain behind this aesthetic choice. The contrast between the film's virtuoso cinematography, its narrative conventionality (the use of the motif of the 'survivor'

who tells his story in the first person using chronological flashback), and its engagement with the violent lives of the marginalized, created a fair amount of controversy amongst Brazilian critics upon the its initial release (e.g. Bentes 2002; Eduardo 2002). It was accused of representing a 'cosmetic of hunger' rather than the angry, revolutionary 'aesthetic of hunger' called for by legendary Brazilian filmmaker Glauber Rocha in his famous 1965 manifesto. However, despite the film's tendency to represent life in the *favela* as self-contained, and the petty (but violent) drug wars of the 1980s as territorial in-fighting amongst the *favelados*, unconnected to any kind of external chain of supply and demand, there is potential for reading within the film a more radical, if perhaps unintentional, critique of the representational practices which mediate the production of such violently segmented urban spaces.

Such a reading, I would like to suggest, revolves around Buscapé's developing interest in photography and, later, photographic journalism, which infuses the film's story-telling mode. While this interest somewhat stereotypically provides him with the keys to escape from the chaos of the *favela* and therefore situates the filmic point-of-view in a spatial and temporal 'outside', it also provides the film with a narrative device by which flashbacks can be signalled through temporal freeze-frames, engaging that sense of violently arrested flow which still photography almost always produces within the cinematic frame. In one of the film's most iconic sequences – given a special status because it is repeated at the beginning and the end and thus frames the entire film in flashback mode – a racy montage of shots follows the flight of a chicken through the streets of the *favela* as it is being chased by one of the gun-toting bands of young drug traffickers. The sense of rhythm and flow in this sequence, constructed through highly mobile shots and swift cutting, as well as a rhythmic musical soundtrack, immediately marks the camera as complicit with a sense of speed-up and velocity which disrupts and dissolves the lived spaces of this already marginal urban space. However, this sense of rhythm and flow comes to an abrupt stop as Buscapé, who had been walking along a parallel street with a friend, suddenly finds himself facing the chicken, now perfectly still, and the group of drug traffickers and hoodlums whom he thinks are going to kill him because of the publication in a national newspaper of one of the photographs he had taken of their leader, Zé Pequeno (Li'l Ze). They order him to catch the chicken, at which point a group of armed police officers arrive at the other end of the street, trapping Buscapé in the middle as both groups raise their weapons. The police, seeing how heavily armed the drug traffickers are, back off, and Zé Pequeno then triumphantly orders Buscapé to take a photograph of the group brandishing their weapons. Buscapé lifts his camera nervously, but at the precise moment that he presses the shutter release, a shot is fired from the other end of the street and one of the group he is photographing falls down dead (Figure 3.4). A rival group of traffickers has arrived, and so begins an all-out massacre between the two groups.

Figure 3.4 The camera-gun: Buscapé (Alexandre Rodrigues) 'shoots' the gang of traffickers in *Cidade de Deus* (courtesy of O2 Filmes/Miramax).

Once more, as in *La virgen de los sicarios*, we see in this sequence the conflation between visual technology and violence, in this case between a camera and a gun. In previous sequences, the still camera had literally frozen the flow of the film for an instant, arresting temporal flow together with the flow of images in order to mark points of temporal transition within the film's narrative. Here, the little death that is each photograph, the unconscious 'still' behind the filmic flow, is both literalized and rendered shockingly allegorical. Buscapé, as the spectator's proxy, can no longer be a mere observer. His/our implication with the mass media and their technologies of vision must now bear at least symbolic responsibility for another kind of death: the violence and death on which the 'city of flows' is predicated, at least in the intermedial and peripheral zones of the megalopolis. This self-conscious thematizing of the role played by the mass media in the violent segmentation of space perhaps provides the potential for a radical critique, à la Henri Lefebvre, of the complicity between the mass media – including cinema – and violent urban processes: 'the optical and visual world ... detaches the pure form from its impure content – from lived time, everyday time, and from bodies with their opacity and solidity, their warmth, their life and their death. *After its fashion, the image kills*' (Lefebvre 1991: 97; my emphasis). The self-reflexivity that emerges here, at the end of the film, can perhaps serve to mitigate, if only slightly, the film's tendency to indulge in a displacement which is all too common a gesture in dominant visual culture: the displacement of social misery onto a highly libidinalized portrayal of crime and violence.

There is also a gendered dimension to some of these portrayals. Various contemporary urban films from Latin America – such as *Amores perros, La virgen de los sicarios*, and *Cidade de Deus* – contain in some form or other a projection of urban space through more or less stereotypical representations of a highly performative masculinity whose outward appearance is aggression and violence and whose culture is often represented as a demonic version of hard rock or punk. The interstitial spaces occupied by urban criminal

gangs, a corrupt police force, voyeurs, stalkers, and female prostitutes are all deeply libidinalized, and often do little more than mirror the social libidinalization of urban space reinforced generally through the mass media. From within the wealthy gated condominiums of the typical Latin American megalopolis, petty urban violence has a powerful imaginary dimension, which, through a fantasy of transgression and dissolution of boundaries creates and reinforces violent social distinctions. The effects of filmic violence are thus difficult to separate from reactionary fantasies of otherness, which are apt to trigger a defensive posture in the spectator.

At first site – as announced by its fear-provoking title – the Brazilian film *O invasor* (literally 'The Invader', but translated as *The Trespasser*, 2002), directed by Beto Brant and based on a novel by Marçal Aquino (who was also the scriptwriter), appears to reinforce this condensation of fetishism, anxiety, and libidinalization surrounding social otherness. The invader in this case is an assassin from the megapolitan underworld hired by two partners in a construction company in order to kill the third partner after a row which threatens to split apart the business. The assassin, Anisio, kills the third partner and his wife, leaving an orphaned daughter, but then he begins to blackmail the remaining two partners, Iván and Gilberto (or Giba), working his way into their lives and into the daily affairs of the company, while seducing, without her realizing that he is the murderer of her parents, the teenage orphan Marina. The actor who represents this invading role is Brazil's most famous punk musician, Paulo Miklos, who is the author of a number of the hard-rock tracks used in the film.

The film also has a strong interest in another hybrid cultural form, which is of particular interest in Brazil: rap. Street musician Sabotage, who was employed as the film's advisor on questions of street style, sounds, and language, is the author of the rap music used in the film, and makes a cameo appearance in one scene. Sabotage was killed in a street shootout approximately one year after the release of the film. The longest sequence employing one of his rap compositions, called 'Zona Sul', comes approximately halfway through the film when Anisio takes Marina on a tour of his rough neighbourhood by car. The couple travel tourist-like through the poor neighbourhoods of the southern zone of São Paulo, and the camera at times focuses on their mirrored sunglasses and at other times adopts their point of view, with the words and music of the rap on the audio track. Here, the windscreen of the car becomes a self-conscious analogy for the cinema screen, turning urban space and poverty into a spectacle for consumption (Figure 3.5).

What interests me here is this way of traversing the city which combines a car journey with a meta-commentary on the process by which urban poverty is transformed into cinematic spectacle and is reified within the culture industries. This idea is summarized by García Canclini in his book *Consumidores y ciudadanos* (*Consumers and Citizens*) when he compares urban commuting in a car to the visual practice of the video clip:

Figure 3.5 Megapolitan *flânerie*: surveying the city through a car window in *O invasor* (courtesy of Europa Filmes).

To narrate is to know that the experience of order which the *flâneur* hoped to establish in his passage through the urban landscape of the turn of the [twentieth] century is no longer possible. Now the city is like a video clip: an effervescent montage of discontinuous images . . . I end up wondering if we shall ever again be able to narrate the city. Can there be stories to tell in our urban conglomerations dominated by disconnection, atomization and meaninglessness? It is no longer possible to imagine a narrative organized from a centre . . . at this juncture, we can only glimpse fragmentary reinventions of neighbourhoods or zones, momentary attempts to transcend anonymity.

(García Canclini 1995: 100; my translation)

These fragmented reinventions correspond closely to the ironic citation of *flânerie* in *O invasor*. Insofar as there remains something of the *flâneur* and even of the *flâneuse* in megapolitan relations, it resides specifically in the differential modes of inhabiting, experiencing, and navigating urban space, in the power and dominion over urban spectacle which the fact of 'our' being able to traverse so easily the space of flows gives us – as privileged spectators as well as privileged travellers – as we glimpse the neighbourhoods, places, and localities from within the mediatized rhythms of postmodern velocity.

A sequence from the end of *O invasor* shows a somewhat different way of traversing urban space, completely opposed to the earlier (ironic) representation of *flânerie*. Here we see Iván's bout of madness when he realizes that his supposed lover is in fact a prostitute paid for by his business partner Giba to spy on him and control him. The sequence, which cuts back and forth

between Iván's crazy careering along a night-time freeway in São Paulo, and explicitly sexual shots of Marina, a female friend, and Anisio having sex (all three of them) in a nightclub illuminated by rhythmically pulsed coloured lights, is accompanied by a heavy punk audio track sung by Paulo Miklos. We glimpse here, I believe, a filmic commentary on the mediatization of subcultural forms through the filters and schemata imposed by an intense libidinalization of social alterity – here, through fear of an 'invasion' by the underclass of the violent megalopolis transmuted into an image of sexual perversity. Such are the anxieties and desires mediated by the *spectacle* of the violently globalized megalopolis at the beginning of the twenty-first century, and it is to the wider prevalence of these vectors of fear and mediatization that I should like to turn by way of conclusion.

The aforementioned media theorist Jesús Martín Barbero (2000) has written on the tight relationship between fear (*los miedos* in Spanish) and the media (*los medios*). Urban fear (primarily of social alterity) decomposes 'urbanity' into primal libidinal investments, reconfiguring both social relations and the citizen's cognitive map of urban space, but above all reconfiguring modes of communication as mediators of social interaction (Martín Barbero 2000: 30). Indeed, all of the films discussed in this chapter could be aligned at different points on a graph whose horizontal axis would run from fear to empathy, and whose vertical axis would run from everyday talk to the mass media. In short, these films plot out the vectors of affect and communication in the globalized megalopolis and so produce multidimensional labyrinthine maps, which exceed any Euclidean projection of megapolitan space.

In *O invasor*, it is the ferocious relations of 'wild' capitalism, the purchasing of death as commodity, which generate social monsters uncontainable within the parameters of a business contract. This invasion is represented by the mass-media appropriation of former subcultures, particularly of punk, marking a profound and generalized libidinal investment in imaginaries of fear generated by the *complicity* of capital in crime, corruption, and violence. In *Cidade de Deus*, affect is more conventionally mapped as a displacement of social misery and ghettoization onto crime, infused with the stereotypes of its mass-media representations. This is complicated only by a self-reflexive focus on the parallel between the mass-media trade in technologically reproduced images of violence (represented by the camera) and the trade in the technology of killing (represented by the gun). In *La virgen de los sicarios*, the shooting of a screen inaugurates a whole series of increasingly brutal, even random, acts of violence: it is the complicity of the national mass media with the neoliberal ideologies of privatization and dissolution of public commons which is allegorized as the generator of violence within the globally connected metropolis of Medellín. And, finally, in the films of Víctor Gaviria, *La vendedora de rosas* and *Sumas y restas*, cocaine, like money in the analyses of Marx, is an accumulation of congealed violence and dispossession, the 'pure', reified expression of a dissolvent power. Yet, here, the violent dissolution of the most basic social structures of the city is counterpoised by

something perhaps surprising in this otherwise bleak scenario. At the heart of the para-urban wastelands, these films, with their non-professional actors and improvised dialogues, are testimony to an irruption of popular idioms and expressions, a vital and unstoppable counterflow, perhaps, to the fear-laden media appropriation of the signs and spaces of social communication.

4 Temporary discomfort
Jules Spinatsch's documentation of global summits

Hugh Campbell

NOTHING HAPPENS

Samuel Beckett's *Waiting for Godot* was famously described by Vivian Mercer as a play in which nothing happens, twice. In a recent project by the Swiss photographer Jules Spinatsch, published in 2005 as a book entitled *Temporary Discomfort Chapters I–V*, it might be claimed that nothing happens five times. Each of the book's five chapters uses different photographic techniques to examine the short-term transformations visited on the venues of various meetings of the G8 and the World Economic Forum in Davos, Genoa, New York, Evian, and Geneva. The heavy security restrictions and procedures surrounding these events are what produce the temporary discomfort of Spinatsch's title. The title has a deliberately low-key, anticlimactic ring, at odds with the usual emphasis on the prestige and importance of the gathering and the scale and vociferousness of the attendant protests. Accordingly, the exclusion zones and security areas which Spinatsch depicts are mostly quiet, emptied of activity, often shrouded in darkness. Suspended between the political business and the choreographed theatre of the talks themselves and the drama and fervour of the protests surrounding them, Spinatsch's chosen territory is a no-man's-land, constructed precisely to put distance between the two main sets of actors. Except for a single shot of a protestor mounting a fence, the principal actors are absent. Instead it is those intended to keep them apart – the security men and police officers – who populate the photos. However, even these are rarely seen engaging in anything that might be construed as action. Mostly, they stand around and watch and wait. Mostly, in other words, these are documents of highly organized, technically sophisticated inactivity. Nothing happens.

Spinatsch's work in this project is, at least in part, a reaction against the established consensus that photojournalism is about getting as close as possible to the action in order to relay the truth of events. Robert Capa's iconic images of the D-Day landings are among the founding documents of this credo and the Magnum photo agency, founded by Capa with Cartier-Bresson and others in 1947, has long acted as its high church. To a veteran Magnum photojournalist like Philip Jones Griffiths, the well-known mantra 'If the

picture's no good, its because you're not close enough' still has the status of gospel. For Spinatsch, however, in the era of embedded journalism, where even the most seemingly spontaneous events can be staged, the imperative of proximity can no longer apply. Indeed, he suggests it might now be more appropriate to state that if your picture's no good, it's because you're not far enough away (Spinatsch 2004). Distance might now be the only means of achieving any kind of objectivity. It can also offer the freedom to see beyond the set photo opportunities, and the accepted signifiers of 'events'. Instead of wanting to capture those decisive moments when events reach their climax, when defining gestures are made, or when conflict flares into life, Spinatsch prefers to look away from the action, dwelling instead on the paraphernalia which surround and underpin these events. By keeping his distance, and by shifting his viewpoint so that he is dealing with absence rather than presence, he is able to reinvent the visual grammar by means of which such global events are depicted and understood.

Cartier-Bresson's decisive moment, the dominant idiom of the past half-century or more, had been made possible through advances in the technology of lenses and shutters. Now the digital era might offer new possibilities for different kinds of looking, and different forms of photographic representation. Images such as Adam Broomberg and Oliver Chanarin's meticulous digital reconstructions of suicide bombs might be more eloquently communicative of the impact of terrorism than countless hours of rolling news coverage. Ironically, the longer, slower looking at the aftermath of war evident in, for instance, Simon Norfolk's work in Afghanistan owes more to nineteenth-century images like Roger Fenton's classic Crimean War photo 'The Valley of the Shadow of Death' than to the twentieth-century journalism permitted by fast, light cameras.

THE VALLEY

The photos in Spinatsch's first chapter – entitled 'The Valley' – were taken during the World Economic Forum in Davos, Switzerland in 2001. Chaotic demonstrations the previous year meant that on this occasion, as Spinatsch puts it, 'The question was "How to spot a protestor" ' (Spinatsch 2005a). He notes that 'the authorities even recommended to locals not to leave their houses in order not to appear suspicious' (Spinatsch 2005a). Under these circumstances, Spinatsch observes, 'everything or everybody – photographed from wherever – was suspicious and the landscape itself became political' (Spinatsch 2005a). Spinatsch portrays this political landscape through night-time shots of parts of the perimeter fence, and of the security personnnel that police it. He also takes photographs of what he calls 'hotspots' from a vantage point on the Schatzalp at over a kilometre distance and 500m elevation from the so-called summit.

Shooting at night using a 2400mm telephoto lens, the photographer's extended gaze alights on locations in the town, some the settings for the

Figure 4.1 Jules Spinatsch, TEMPORARY DISCOMFORT CHAPTER I, THE VALLEY. Hotspot No. 3, World Economic Forum (WEF), Davos-CH, 2001 (courtesy of Jules Spinatsch).

forum, but others innocuous places like resort hotels or the night-skiing trail. The telephoto technique in itself is enough to make all the locations portrayed seem as if they are being surveilled. And this in itself is enough to render them simultaneously significant and suspicious: something interesting must be going on there, we think. As Spinatsch puts it, 'technology and nocturnal light add up to images imbued with an aesthetics of surveillance and an atmosphere of all-encompassing suspicion' (Spinatsch 2005a). Long exposure times give ordinary lights the same intense brightness as the beams that scan across sections of the perimeter fence. Taken together, the distant shots and the close-up fragments communicate an atmosphere of tense anticipation.

OPPIDUM

The same atmosphere is conjured in a different manner by the images in Spinatsch's second chapter, taken at the G8 meeting in Genoa in July 2001. The title, 'Oppidum', refers to the enclosed military settlements of the Roman Empire, suggesting parallels between that regime and the intense, extensive, and heavy-handed security surrounding the Genoa event:

> The Genoa summit promised to be bigger than any other and the protest against it loomed equally large. The Italian government shut down most

of the center of Genoa for several days, creating various restricted areas such as the Blue Zone, the Yellow Zone and the sacrosanct Zona Rossa, the Red Zone, in which the summit meetings would take place. Normal transportation and life ground to a halt for miles around the city. 15-foot-high barbed wire fences were built across every street and alley leading into the Red Zone, like a kind of Berlin Wall in the middle of the city. The atmosphere was eerie: the streets and piazzas, with their renaissance palaces and baroque fountains, were entirely empty and quiet, while the protestors massed on the periphery of the city, miles from the Ducal Palace, the main seat of the summit. Many Genoans living in the city center left town, and most shops and cafes closed, leaving the oldest and poorest residents of Genoa in an ill-served ghost town. A rumor swirled among the commuity of protestors that the people trapped in the center had run out of garlic, and so some protestors were passing or pressing garlic through the barbed wire fences leading to the Red Zone. 'Free Genoa!' was one of the cries of the demonstrators.

(Stille 2002: 4)

Stille's description is contained in Joel Sternfeld's photographic study of the summit, *Treading on Kings*, which, following an opening selection of images of the aftermath of the notorious police raid on the Armando Diaz school, consists of characteristically frank portraits of protestors, accompanied by brief quotes outlining their rationale for being in Genoa.

Sternfeld's instinct is to humanize the protest by offering intimate glimpses of the participants and their heartfelt, often self-deprecating, and never confrontational statements. But Spinatsch has no interest in this kind of approach:

What was there to be photographed? Naturally, there had to be an iconic image of an activist of the type 2001, but then it was necessary to withdraw from the protest in order not to succumb to its predictably sensationalist temptations. The alternative was a stroll along the red zone, as close as possible to the actual conference location, the Palazzo Ducale – as close to power as possible.

(Spinatsch 2005a)

Again, the territory that Spinatsch depicts is largely emptied of life. There is an eerie, unnatural stillness. Images such as 'Empty Sea, Pool and Sportsground' show how the normal activities of the city on a beautifully clear July day (everyone remembers the day of the riots as being unusually clear) have been suspended. As a report in the *Guardian* noted, La Superba had become La Vuota ('the empty') (Vidal 2001). Of course, Spinatsch may also have been referencing the tendency towards the sober formal depiction of empty urban space in the work of prominent contemporary photographers such as Thomas Struth. But there are enough signs of power evident – a line of police looking

out to sea, a helicopter overhead – to make us understand that this stillness is an enforced state rather than a discovered condition.

It is precisely this ordered space of absence which makes possible the spaces more traditionally characterized as the inside and the outside of the event – the summit within and the protests without. Each has its own visual grammar: on the one hand, the formal structure conferred by the dais and the conference table; on the other, the teeming mayhem of the boulevard. By holding his focus on the zone between, Spinatsch misses out on conveying the atmosphere of the talks or the brutal and tragic events which surrounded them. Nonetheless, he relies on us knowing this context in order to appreciate that what his images show is the armature of exclusion which produces both.

REVOLUTION MARKETING

This same armature of order is made more intimately apparent in the next chapter, which looks at the 2002 WEF (World Economic Forum) meeting that took place in New York as a 'gesture of solidarity' with the city in the wake of the 9/11 attacks. Instead of the expected air of hysteria and panic, however, the gathering had a very low-key atmosphere. This was, at least in

Figure 4.2 Jules Spinatsch, TEMPORARY DISCOMFORT CHAPTER II, OPPIDUM. Empty pool, sea, and sportsground, G8 Summit, Genoa-IT, 2001 (courtesy of Jules Spinatsch).

54 *Hugh Campbell*

part, due to a security strategy in which all the blocks immediately surrounding the Waldorf Astoria on Park Avenue, where the Forum took place, were treated as a single high-security zone. With no outsiders able to enter, there was little need for the overt presence of cordons and police on the ground.

Spinatsch's strategy at this meeting was to get himself accredited as a participant. He was in fact the only photographer to have this access. This allowed him access to the hotel and its immediate surroundings, known as Zone B. As he points out, 'this illustrates to what degree images are a question of organisation these days. The "decisive moment" often takes place ahead of the actual event' (Spinatsch 2005a). Having acquired such access, however, Spinatsch chose not to enter the main venue, but instead to photograph the activity of the guards around its perimeter. Again, he deliberately avoids the centre of attention, continuing instead to explore the possibilities

Figure 4.3 Jules Spinatsch, TEMPORARY DISCOMFORT CHAPTER V, REVOLUTION MARKETING. Antilogo No. 1, G8 Summit, Geneva-CH, 2003 (courtesy of Jules Spinatsch).

Spinatsch's documentation of global summits 55

of a kind of peripheral vision. All of the work is done by night. Internal and external lighting combine to create a pervasive glow, intensified by the long exposure times. Immersed in this artificial aura, police and security guards are shot mostly in extreme close-up. Figures intended to blend into the background become the centre of attention. The bleeding of the images across spreads and pages in the book adds to a feeling of these shots being 'stolen glimpses'. Such intimate access, combined with the pervasiveness and warmth of the light, gives the chapter an almost domestic feeling, although the title 'Corporate Walls' reminds us that it is through the participation of the corporate tenants in the surrounding towers that this cosy, temporary oasis has been constructed.

But in 'Revolution Marketing', the final chapter of the book, the corporate presence in the city is itself perceived to be under threat. While the 2003 G8

Figure 4.4 Jules Spinatsch, TEMPORARY DISCOMFORT CHAPTER V, REVOLUTION MARKETING. Antilogo No. 8, G8 Summit, Geneva-CH, 2003 (courtesy of Jules Spinatsch).

56 *Hugh Campbell*

Figure 4.5 Jules Spinatsch, TEMPORARY DISCOMFORT CHAPTER IV, PULVER GUT. Discontinuous Panorama C240700: World Economic Forum WEF, Davos-CH, 24 January 2003. Camera C: Congress-Center North Entry, Promenade Davos Valley. 817 still shots from 07h00–08h30 (courtesy of Jules Spinatsch).

Summit was officially held in the small resort town of Evian, it was the nearby city of Geneva which acted as the main logistical centre, and therefore also as the potential focus for protest. In preparation, most of the city's shop fronts and signs were boarded up. In Spinatsch's view this was as much to do with invisibility as protection. Any well-known logos were seen as likely targets. Hence something as innocuous as a freestanding roadside signboard became a shrouded, ghostly presence. The yellow plywood sheeting wrapping the stores and signs conferred a kind of homogeneity on the city. In turn, this became a blank canvas on which the protestors could create their own logos and signs. Again, the summit produced a kind of absence or clearing within the city. Its buildings were rendered temporarily mute.

PULVER GUT

Chapter IV of the book is perhaps its most ambitious. Certainly it contains the most widely discussed and exhibited of Spinatsch's work. In photographing

the World Economic Forum at Davos in 2003, Spinatsch moved away from traditional camera techniques and instead adopted the very instruments of surveillance and control he was critiquing. Interestingly, though, he insists that his initial inspiration also came from the town's own website, which offers hourly updated panoramic views of the valley and the surrounding slopes. ('*Pulver Gut*', the chapter's title, translates as 'Good Powder Snow', and refers to Davos' usual identity as a ski-resort).

In order to make the works in this chapter, Spinatsch mounted three programmable network cameras in and around the security area of the Forum (again, this was done with the cooperation of the authorities), creating a triangle of surveillance. For the duration of the forum, an empty library became the location for programming and downloading the images. Each camera was capable of sweeping 180 degrees horizontally and about 40 degrees vertically, and could be programmed to track up and down and gradually across a territory over a number of hours. From the matrix of images produced, Spinatsch could create vast tessellated panoramas which, read from left to right, traced the passing of time (usually about two hours) as they panned across the perimeter territory, picking out the fences, guard huts, and security personnel which by now had become the familiar leitmotifs of his work. Most are taken in the early morning, so that we witness dawn light gradually flooding the scene.

Figure 4.6 Jules Spinatsch, TEMPORARY DISCOMFORT CHAPTER IV, PULVER GUT. Discontinuous Panorama B251356: Anti-WEF World Economic Forum Demonstration, Davos-CH, 25 January 2003. Camera B: Hertistrasse, Talstrasse, Congress-Center South Entry, Kurpark. 1740 still shots from 13h56-17h15 (courtesy of Jules Spinatsch).

The image shown in Figure 4.5, for instance, consists of 817 still shots taken from Camera C between 7.00 and 8.30 a.m. on 24 January. Despite the ninety minutes encompassed across its breadth, there is very little evidence of activity, or even of human presence, besides the three (or more like two and a half) guards at the building's entrance. Other images in the series betray more signs of life. In the scene shown in Figure 4.6, taken from Camera B, there are figures scattered across the territory, and we are able to begin to trace movement within the image – of this guard moving in the direction of the camera, for instance, his upper half captured repeatedly as the camera's trajectory bisects his. This reminds us of course that the nature of the technique means that the camera's path might conceivably miss out on any amount of significant action. This is certainly the case in this image, where a substantial gathering of protestors is reduced to a single lone figure with a placard. His companions have all escaped the camera.

In the most elaborate of the series, Spinatsch set Camera A to record activity around the entrance to the forum for three hours over each of the six days. Each day the camera made between three and four horizontal sweeps of the territory. The images were relayed to a Zurich gallery, where they were printed on A3 sheets and assembled on the gallery wall. Over the course of the week, the panorama gradually built up to an overall size of 20m by 5m. But again, the cameras captured only vestigial signs of activity. Spinatsch had to rely on a parallel series of so-called 'hotspot recordings' in which the same location was repeatedly photographed, in order to catch anything of the comings and goings – a bus entering the compound, a few token protestors.

In part, the relative lack of activity was due to what had by then become the standard security strategy of having protests staged at a considerable distance from the summit – in this case, in Zurich and Bern. But nonetheless, the relative blindness of even the most elaborate and seemingly comprehensive surveillance is striking. On the one hand, the picture shows every aspect of the terrain. On the other hand, it shows almost nothing of the action. Furthermore, we only recognize action as such by the way in which the movement of the camera has distributed its elements across the picture. (This is reminiscent of the way in which the finish line of a race is photographed so

60 *Hugh Campbell*

Figure 4.7 Jules Spinatsch, TEMPORARY DISCOMFORT CHAPTER IV, PUL-VER GUT. Discontinuous Panorama A240635: World Economic Forum WEF, Davos-CH, 24 January 2003. Network-Camera A: Promenade, Congress-Center North and Middle Entry, Kurpark. 2176 still shots from 06h35–09h30 (courtesy of Jules Spinatsch).

that eight separate instants become assembled as if they were a single episode in time.)

In a subsequent project, Spinatsch trained a similar network camera on Berne stadium during a World Cup qualifying match between France and Switzerland. Over the course of 160 minutes, the camera captured crowds arriving before the match, surveyed the length of the pitch during the ninety minutes of action and then covered the gradual dissipation of spectators after the game. The match ended in a 1–1 draw, but, despite consisting of 3,300 shots, Spinatsch's image doesn't depict either goal, or indeed the ball itself. As he writes:

> On 8th October in Berne the ball flew twice into the goal but never into the picture, during a later game it could well be the other way round.
> The football panorama shows, in both its speculative and precise way, just what the media presentations in the press and on television do not

show, and vice-versa. In the media the ball is in the centre, the cameras and the players follow it like magic and everything else, especially the bodies, are composed in relation to it. In my concept, however, it is clear from the start that the camera even with 3000 exposures can only with any luck really capture the ball once. A ball in the picture is almost as rare as a hole-in-one in golf.

(Spinatsch 2005b)

What we are being shown is what Spinatsch terms the 'event landscape' rather than the events themselves. Things are put in context. This, it might be argued, is much more like what it feels like to be at a football match, where the long spells of relatively uneventful activity usually far outweigh the occasional climactic moments.

ANTECEDENTS

Usually the photograph is far more associated with these climactic – or decisive – moments than with the wider spatial and temporal landscape within which they occur. However, almost since its inception, photography

62 *Hugh Campbell*

Figure 4.8
Jules Spinatsch
HEISENBERG'S OFFSIDE
Panorama – Installation of 3003 still shots from interactive network camera
Duration: 165 minutes

Switzerland – France
World Championship Qualification
Stade de Suisse, Bern Wankdorf, 8 October 2005

1 : 1 (0 : 0)

Goals: 52. Cissé 0 : 1, 79. Magnin 1 : 1 (Freekick)
Attendance: 31 400 (sold out)
Remarks: Free swiss flag on every seat

(courtesy Jules Spinatsch)

Spinatsch's documentation of global summits 63

has periodically sought to extend its own capacities to depict space and time. In the late nineteenth century, Eadweard Muybridge explored both. His panoramic view of San Francisco was painstakingly assembled from thirteen large glass plate negatives. And later, of course, came his more famous experiments in capturing the motion of humans and animals using rapid sequential shooting. But while this work contributed to the development of moving pictures as well as feeding into the aesthetics of the Cubists and the Futurists, photography itself tended to remain largely wedded to the single, perspectival frame.

It was a frustration with this self-imposed limitation that led David Hockney to begin experimenting with multiple images in the early 1980s. Initially he worked with a Polaroid camera, assembling gridded, composite portraits of people and places over the course of a couple of hours. For Hockney, the technique produced what he called 'the revitalisation of depiction' by allowing him to dwell more fully on the inhabited spaces, or to extend an event like someone swimming in that iconic pool across a whole matrix of images. In his

later, more complex Polaroid collages, he began to build into the finished works references to the process of their own construction. In one image, the photographer Bill Brandt and his wife are looking at early photos in the collage, which – in a further twist – Hockney then later substitutes with photos of himself.

Subsequently Hockney abandoned the Polaroid format for a 35mm camera, which allowed him greater freedom. He began to create what Lawrence Weschler has memorably called 'long banners of looking', distributing individual photos in looser, overlapping arrangements to create cumulative images of places and events which achieve, in Weschler's words, 'the depiction of real space and real time, the rendering of people in the fullness of their living, the breaking of the rectangle' (Weschler 1984: 31). As if to point out the advance this represents over traditional photography, Hockney recorded a photo shoot with Annie Leibowitz in which, next to Hockney's fluid account of events, her single frame seems meekly inadequate. 'With this kind of photography there is no out-of-the-picture', Hockney remarks (in Weschler 1984: 34).

For all its seeming comprehensiveness as a way of looking, however, this method of picture-making is in fact both extremely selective and unexpectedly composite. For proof of the latter, look at the iconic *Pearblossom Highway* and consider how what appears as a single, centralized view is in fact composed of many individual shots, the taking of which involved several trips, climbing up ladders, etc. For proof of the former, look at Hockney's depiction of a lunch at the British Embassy in Japan and note how some aspects are dwelt on (his neighbour's face), some merely sketched in (his host's face), and others almost entirely omitted (lunch). The work demonstrates more about the selectivity of human vision than its ceaseless inclusivity. In his discussion of this work, Weschler draws attention to the maid in the background. Hockney's expanded vision has managed to incorporate her, but, as with the security guards in Spinatsch's panoramas, only half of her makes it into the picture (Weschler 1984: 31).

In making these works (he made about 200 between late 1982 and mid-1983, and stopped soon afterwards) Hockney speaks about 'figuring out ways of telling stories in which the viewer can set his own pace, moving forward and back, in and out, at his own discretion' (Weschler 1984: 33). In fact, the panoramas of the late eighteenth century might be seen as offering precisely this kind of immersive experience. These vast wraparound paintings were displayed in cylindrical, top-lit buildings specially designed to maximize the feeling of being in the location depicted – what Bernard Comment has described as 'the pursuit of maximum illusion' (Comment 1998: 21). In their early years, most of these panoramas were content simply to transport their visitors to these locations, showing them every detail of the physical landscape, offering glimpses of the inhabitants going about their business.

However, the panoramic form also proved highly suited to the depiction of epic scenes of battles and historic events. Like latter-day Bayeux tapestries,

Figure 4.9 David Hockney, 'Luncheon at the British Embassy, Tokyo, Feb. 16, 1983', 1983 (© David Hockney).

360-degree panels allowed entire historic episodes to be played out. Spinatsch explicitly refers to one of the most famous of these in his notes on '*Pulver Gut*': the Bourbaki panorama in Lucerne (which, while undergoing restoration, itself became the subject of a panoramic photograph by Jeff Wall). He points out the contrast between the staged drama of such epic scenes and the inchoate, undramatic nature of his own work – its refusal to conform to the expectations of spectacle. In reality, though, there are as many elements in common as there are points of contrast. The events portrayed in the Bourbaki panorama are in fact decidedly unheroic – 88,000 French soldiers laying down their arms in order to gain asylum in Switzerland at the end of the Franco-Prussian War. This is unpromising subject matter for spectacle, it might be argued, and in its way is every bit as downbeat and anticlimactic as Spinatsch's security zones. And, of course, despite his protestations, when installed in a gallery, Spinatsch's work is undeniably spectacular thanks both to its scale and to the iterative manner of its execution.

NOTHING HAPPENS, TWICE

Despite these aspects of the spectacular, it can safely be asserted that, compared with the usual means by which global events are reported and represented, in Spinatsch – as in Beckett – nothing happens. However, the atmosphere is charged by the constant possibility that something might. His deflatory title – *Temporary Discomfort* – knowingly takes the sting out of the vast panoply of security measures on display in his images and renders them faintly comedic. Just as Beckett's tramps found that there was 'nothing to be

66 *Hugh Campbell*

Figure 4.10 Rotterdam: Schouwburgplein at night (courtesy of West 8 urban design & landscape architecture).

done', Spinatsch's security personnel are there to ensure that there is nothing to be seen, nothing to detain us. Beckett conjured the landscape and atmosphere of *Waiting for Godot* while walking south in voluntary exile from Paris during the German occupation (another kind of temporary discomfort). In the wake of invasion, and in the midst of tumultuous upheaval, here was a landscape trapped in inaction. Similarly, Spinatsch discovers within the shifting drama of global events an unexpectedly inert centre, but one made uneasy by an immanent sense of threat, a feeling that at any moment, as it did in Seattle and in Genoa, violence is still liable to erupt. This is the eye of the storm.

Indeed, sometimes it feels as if this kind of no-man's-land, in which spatial and temporal codes get rewritten, has spread beyond the summits and forums to become the current model for public space itself. The poster for the symposium at which this paper was first presented featured an image of the Schouwburgplein in Rotterdam designed in the late 1990s by West 8 architects. This square might be taken as emblematic of the nature of much contemporary public space: empty but tense, highly mechanized and choreographed although rarely inhabited, its forms and surfaces hinting at a latent violence, offering nothing but temporary discomfort.

5 American military imaginaries and Iraqi cities

The visual economies of globalizing war

Derek Gregory

When President George W. Bush declared his 'war on terror' in the wake of the terrorist attacks on 11 September 2001, he made it clear that this was to be a global war. 'We will fight them over there,' as he later explained, 'so that we don't have to fight them in the United States of America.' This military project has been wired to neoliberal globalization in many ways: the armature of accumulation by dispossession, visible in the stripping and reappropriation of strategic sectors of the Iraqi economy by foreign capitals; a sort of flexible militarism whose 'derivative wars' trace arabesques between the predatory logics of securitization in global battle spaces and global financial markets; and a brutal geographing of the borders between 'insured life' and 'non-insured life' throughout the planet (Harvey 2003; Martin 2007; Duffield 2008). The project has also seen the world's most powerful military machine, transformed through a Revolution in Military Affairs (RMA), forced to engage in so-called 'new wars' fought by militias, insurgents, and terrorists in the breaches of former empires and the ruins of postcolonial states. This conjunction has deepened the investments of late modern war in globalization (and vice versa). The RMA was promoted as a means for the United States to project 'full spectrum dominance' around the globe, and is in its turn part of a global trade in arms and military technology, while the new wars are fought by para-state, post-national, and transnational forces that are enmeshed in what Nordstrom calls a 'shadow globalization' (Bauman 2001; Kaldor 2006; Münkler 2005; Nordstrom 2004).

In the first phase of the war, the American military relied on its continuing force transformation (a stripped-down military with a thick support belt of private contractors), combined in Afghanistan with the use of the proxy paramilitaries of the Northern Alliance, to achieve rapid and decisive supremacy over its weaker opponents. As political and public attention shifted to Iraq, however, and as invasion bled into occupation and insurgency, so the military machine faltered. Pentagon planners were determined to ramp up 'kinetic' (offensive) operations through the deployment of explosive firepower, as in the levelling of Fallujah in the autumn of 2004, but many commanders on the ground were already improvising a counter-strategy that emphasized the protection of the civilian population and the role of

'non-kinetic' operations in what came to be called culture-centric warfare. Here too the economic and the political marched in lockstep, yet the commodification of culture is a commonplace while the weaponization of culture remains unremarked (Gusterson 2008). Nobody has done more to reveal the entanglements of culture and power than Edward Said, whose critique of Orientalism was written in close proximity to wars in the Middle East. He later suggested that the struggle over geography is complex and interesting 'because it is not only about soldiers and cannons but also about ideas, about forms, about images and imaginings' (Said 1993: 7). So it is; but the critical focus has been on Said's last clause, on the imaginative geographies that circulate through political and public cultures to underwrite the divisions between 'our space' and 'their space' – between fighting them 'over there' and fighting them 'over here' – rather than on the images and imaginings that direct the soldiers and the cannons.

In what follows, in contrast, I trace the cultural turn within the American military imaginary and pay close attention to the visual economies on which it depends. The concept of a visual economy draws attention to two crucial issues: first, the strategic role of visuality, of techno-culturally mediated vision, in linking and de-linking 'sight' and 'site' in late modern war through the spatialities of targeting and the virtualization of violence and, second, the visual performance of the social field rather than the social construction of the visual field: the material consequences of enframing and envisioning the world in these ways (Campbell 2007).

The cultural turn is itself framed by two global imaginaries. First, the American military divides the world into six geostrategic regions and assigns a unified combatant command to each of them. This geographical imaginary is centred on the United States, but the Area of Responsibility for its Central Command (CENTCOM) is the Middle East, East Africa, and Central Asia. This has been the principal arena of operations for the 'war on terror', but it is also the locus for a series of demotic geographical imaginaries that construct the Middle East as what Fareed Zakaria called 'the land of suicide bombers, flag-burners and fiery mullahs' (Zakaria 2001). In that astonishing sentence the various, vibrant cultures of the region are fixed and frozen into one diabolical landscape. The cultural turn can be read, in part, as a belated response to such absurdist cartoons that invite incomprehension and incite military violence of an extraordinary and exemplary intensity against the threat they are supposed to represent. Second, and closely connected to these characterizations, the American military has become preoccupied with the prospect of fighting most wars of the immediate future in the cities of the global South. Military strategists fear that this will compromise the global projection of American power because the very nature of what they construe as radically Other, non-modern cities would induce 'signal failures' within network-centric warfare and insulate insurgents from the vertical power of the late modern military machine. The immediate response has been to intensify the RMA to develop the technical capacity to provide ground troops with

real-time situational awareness from the air and to conduct automated, cybernetic, and ultimately robotic warfare on the ground (Taw and Hoffman 1994; Graham 2007, 2008). The cultural turn can also be read, in part, as an attempt to soften or supplement these predispositions with a conditional intimacy: not so much a rejection of technophilia as its redirection.

I begin, therefore, by showing how American air operations reduced Iraqi cities not only to strings of coordinates but also to constellations of pixels on visual displays, while ground operations reduced them to three-dimensional object-spaces of buildings and physical networks. I then trace the arc of the cultural turn and its attempt to people these hollowed-out cities and to recover the meanings that are embedded in them. Although this manoeuvre developed as a critical response to the prevailing military imaginary, however, I will argue that it was prompted by the same concerns and satisfies the same desires: that it functions as a 'force multiplier' fully consistent with the doctrine of full spectrum dominance.

LATE MODERN WAR AND THE CITY AS VISUAL FIELD

The RMA promised total mastery of battle-space through a combination of aerial surveillance and 'bombing at the speed of thought'. The capacity to commingle what Chad Harris called 'the mundane and the monstrously violent' (Harris 2006: 114) was already apparent during the first Gulf War. The United States developed a three-day targeting cycle, a cascading series of translations from images through data to targets and back again, and Harris argued that these mediations worked to obscure the violence on the ground in Kuwait and Iraq from those organizing it at the US command and control centre in Saudi Arabia (Cullaher 2003; Harris 2006). This optical detachment, at once a characteristic and a desideratum of late modern war, is reinforced by the very syntax of deliberative targeting, which implies the careful isolation of an object – the reduction of battle-space to an array of *points* – whereas in fact targets are given a logistical value by virtue of their calibrated position within the infrastructural *networks* that are the fibres of modern society. The geometries of these networks displace the punctiform coordinates of 'precision' weapons, 'smart' bombs, and 'surgical' strikes so that their effects surge far beyond any immediate or localized destruction.

By the second Gulf War the targeting cycle had accelerated to a matter of hours and the missiles were supposedly more accurate, but the envelope of effects was still designed to ripple out in time and space. Thus air strikes on Iraqi power stations in 2003 were intended to disrupt not only the supply of electricity but also the pumping of water and the treatment of sewage. The kill-chain has since been compressed still further by adaptive targeting, which depends on the identification, and sometimes the laser-painting, of targets of opportunity by ground forces (including special forces) that call in close air support (Herbert 2003; Weber 2005). At the same time, the distance between target and command centre has increased, a process that reaches its

temporary limit in the deployment of Unmanned Aerial Vehicles (UAVs) in Iraq. Take-offs and landings of Predator drones, armed with heat-seeking cameras and Hellfire missiles, are controlled by American pilots at Balad Air Force Base north of Baghdad, but the missions are flown by pilots at Indian Springs Air Force Auxiliary Field, part of the Nellis Air Force Base in Nevada, some 7,000 miles away. 'Inside that trailer is Iraq,' one visiting journalist was told, 'inside the other, Afghanistan' (Kaplan 2006).

It is hard to overstate the degree of optical detachment implied by such a casual reduction. But it is also symptomatic, for, as these examples imply, late modern targeting depends on an electronic disjuncture between the eye and the target, 'our space' and 'their space'. The techno-cultural form of this disjuncture makes the experience of war (for those in 'our space') less corporeal than calculative because it produces the space of the enemy as an abstract space on a display screen composed of coordinates and pixels and emptied of all bodies (Chow 2006: 25–43; Gregory 2006). The effect is compounded by the mediatization of late modern war through which the same images are relayed to distant publics who watch military violence in a space that is, as in the 'Shock and Awe' bombardment of Baghdad in March–April 2003, at once de-materialized ('targets', 'the capital') and de-linked ('buildings', 'bunkers'). We are invited to contemplate such scenes not only from a safe distance and without human presence, as Lilie Chouliaraki shows, but also without any sense of the very interconnectedness of life that is being sundered, a process that reaches its terrible apotheosis in urbicide (Chouliaraki 2006: 272–3; Coward 2006).

Ground operations transposed the visual logics of targeting to render the city as a three-dimensional object-space. The Handbook for Joint Urban Operations, issued in September 2002, treated the city as a space of envelopes, hard structures, and networks, and the same abstracted visualizations framed pre-deployment training. From November 2003 thousands of soldiers trained for convoy duty by driving through a virtual Baghdad, and since February 2005 an enhanced three-dimensional database of the city has been used to conduct virtual staff rides to study the 'Thunder Runs' made by armoured brigades during the invasion. The simulations render buildings, bridges, and streets with extraordinary fidelity; yet the inhabitants are nowhere to be seen. 'The important thing for us is the terrain,' explains the officer in charge. The latest US Army Field Manual on Urban Operations (FM 3–06), released in October 2006, opens by emphasizing the sheer complexity of the 'multi-dimensional urban battlefield' and diagrams the city as 'an extraordinary blend of horizontal, vertical, interior, exterior and subterranean forms'.

These visualizations are closely connected to the city-as-target; in fact, they are often part of the same process. They assume the same highly sophisticated, technically mediated form, as detailed images from satellites, aircraft, and drones are relayed to display screens in command centres and combat zones, and they produce the same optical detachment: staring at the brightly lit screens of the Command Post of the Future (CPOF) outside

Fallujah, according to one observer, was 'like seeing Iraq from another planet' (Shachtman 2007; Croser 2007). These visualizations make powerful, almost forensic claims about their accuracy and reliability – they are the real-time 'real' – even as they reduce the city to a body undergoing an autopsy. Physical models cannot claim the same mimetic power, but they share the same discourse of object-ness. In November 2004, before the second assault on Fallujah, Marines constructed a large model of the city in which roads were represented by gravel, structures under 40ft by poker chips, and structures over 40ft by Lego bricks, while Army officers conducted briefings using bricks for buildings and spent shells for mosques (al-Badrani 2004; Barnard 2004).

These reductions of the city to physical morphology have three powerful effects. First, they render the city as an uninhabited space, shot through with violence yet without a body in sight. This repeats the colonial gesture of *terra nullius* in which the city becomes a vacant space awaiting its possession; its emptiness works to convey a right to be there on those who represent it thus. Second, they are performative. As John Pickles shows, 'mapping, even as it claims to be representing the world, produces it' (Pickles 2004: 93). Before the final assault on Fallujah, one captain instructed his platoon commanders: 'The first time you get shot at from a building, it's rubble. No questions asked.' But in an important sense the city was rubble before the attack began; the violence wrought by the US military in Fallujah cannot be separated from the violence of its visualizations of it (Barnard 2004). Third, these representations have legitimating force; as they circulate through public spheres they prepare audiences for war and desensitize them to its outcomes. The reduction of the city to a visual field is naturalized not only through the media barrage of satellite images and bomb-sight views but also through representations that hollow out the city on the ground. In a striking graphic from the *Los Angeles Times*, for example, tanks rumbled down a street, soldiers scrambled across roofs and hugged walls; but there was no other sign of life. In this re-enchantment of war, an enterprise expressly devoted to killing magically proceeds without death.

I have made so much of Fallujah because many military commentators regarded the US assault as 'a model of how to take down a medium-sized city'. Air strikes had pulverized the city before the ground offensive, but the decisive innovation was the use of persistent intelligence, surveillance, and reconnaissance from air and space platforms. This 'God's-eye view', as several commanders called it, made it possible to pre-assign targets, and during the attack UAVs provided visual feeds to command centres and combat troops. These airborne sensors 'opened up a full-motion video perspective on the street battle' so that, as one ground controller put it, 'We knew their alleyways better than they did' (Grant 2005; 'Operation Dawn' 2005). But some field commanders insisted that knowing the skeletal geometry of a city was no substitute for understanding its human geography. Such abstracted renderings of the city have been sharply criticized from outside the military

too, but Thomas Ricks (2007) claims that with its new cultural awareness the Army turned the war 'over to its dissidents', and it is this critique from inside the machine that I propose to interrogate.

GENEALOGIES OF THE CULTURAL TURN

The cultural turn had multiple origins, but it was provoked by the looming failure of the American mission in Iraq. By 2004 it seemed that the military had won the war only to lose the occupation. Travelling between the Green Zone and the Red Zone that was the rest of Iraq, reporter George Packer became 'almost dizzy at the transition, two separate realities existing on opposite sides of concrete and wire' (Packer 2005: 224). In a tortured landscape that was 'neither at war nor at peace', firepower was 'less important than learning to read the signs', but an aggressive series of counter-insurgency sweeps revealed only that 'the Americans were moving half-blind in an alien landscape, missing their quarry and leaving behind frightened women and boys with memories' (Packer 2005: 233). This was not surprising. The invasion had transferred thousands of young men and women from small-town America to a cultural landscape for which they literally had no terms. They were issued with two expedients. One was an *Iraq Visual Language Survival Guide* which provided a list of Arabic instructions ('Hands up', 'Do not move', 'Lie on stomach') and a series of point-at-the-picture cartoons showing ambushes, booby traps, vehicle stops, and strip searches. The other was an *Iraq Culture Smart Card* whose twenty panels provided a basic Arabic vocabulary, a bullet-point summary of Islam, and terse tabulations of Iraq's cultural and ethnic groups, cultural customs, and cultural history. This may have been more effective – it's hard to imagine it being less – but it had limitations of its own that derived as much from how culture was conceived as how it had to be abbreviated. The panel on 'Cultural Groups' in the 2006 version, for example, was concerned exclusively with ethno-sectarian divisions: 'Arabs view Kurds as separatists [and] look down upon the Turkoman'; 'Sunnis blame Shia for undermining the mythical unity of Islam'; 'Shia blame Sunnis for marginalizing the Shia majority'; and 'Kurds are openly hostile towards Iraqi Arabs [and] are distrustful of the Turkoman'. Culture was a force-field of hostilities with no space for mutuality or transculturation.

Commanders were at a loss, too, confronting an adversary 'that was not exactly the enemy we war-gamed against', as one general famously complained. The Pentagon was so invested in high technology and network-centric warfare against the conventional forces of nation-states that it was radically unprepared for the resurgence and reinvention of asymmetric warfare. In 2004 Major-General Robert Scales made a powerful case for cultural awareness to be given a higher priority than the technical fix of 'smart bombs, unmanned aircraft and expansive bandwidth' (Scales 2004). Commanders in Iraq had found themselves 'immersed in an alien culture', he said; 'an army

of strangers in the midst of strangers' forced to improvise and to share their experiences by email (Scales 2004). By December 2005 their practical knowledge was being collated at a Counterinsurgency Academy in Baghdad, and twelve months later the capstone was put in place with the publication of a new Field Manual on Counterinsurgency (FM 3–24) (US Army 2006b).

The new doctrine defined the population as the centre of gravity and established its protection as the first priority. This required not only cultural knowledge – 'American ideas of what is normal or "rational" are not universal' and should not be imposed on other people (surely the most remarkable injunction in the book) – but also 'immersion in the people and their lives'. Sequestering troops in large Forward Operating Bases and only issuing out to conduct aggressive sweeps was counterproductive. Instead, non-kinetic operations would assume a crucial importance. The 'basic social and political problems' of the population had to be acknowledged and addressed, and while this did not preclude the use of deadly force it had to be applied 'precisely and discriminately' in order to minimize civilian casualties and to strengthen the rule of law (US Army 2006b).

This is the sparest of summaries, and I need to make a series of deeper cuts into the construction of the new military imaginary. I concentrate on four of its architects, but the cultural turn cannot be reduced to the forceful projection of individual wills. It is a heterogeneous assemblage of discourses and objects, practices and powers distributed across different but networked sites: a military *dispositif*, if you prefer. As such, it is a contradictory machine. For war, occupation, and counter-insurgency are not coherent projects; they are fissured by competing demands and conflicting decisions, and they are worked out in different ways in different places. So it is with the cultural turn.

FROM CULTURAL MORPHOLOGY TO THE CULTURAL SCIENCES

The ground had been partly prepared by the lead writer of FM 3–06 on Urban Operations, Lieutenant-Colonel Louis DiMarco. By the autumn of 2003 he was involved in planning the invasion of Iraq, which was widely expected to centre on urban warfare, but he soon realized that there was a gulf between the generalities and geometries of FM 3–06 and the situational exigencies of Iraq's cities. Convinced that a purely physical visualization of the urban battle-space would be insufficient, he proposed a revolutionary emphasis on *cultural* morphology. This was a significant advance, but it was geo-typical rather than geo-specific and, crucially, it remained a morphological approach so that its sense of the spatialities of culture – visually conveyed in urban models, plans, and diagrams – was neither fluid nor transactional. DiMarco paid little attention to the modern Arab city, which was seen as axiomatically normal and so non-threatening. Consistent with the essentialist diagnostics of Orientalism, the focus was on the 'traditional' city, which was identified as the epicentre of political Islam. As such it was invested with cultural meanings that required translation, but these were

inscribed in physical places and structures: the mosque, the market, the neighbourhood, and the home. DiMarco's concern was kinetic operations, his language resolutely one of 'attackers' and 'defenders', so that throughout the text the ordinary meanings attached to these sites were retrieved and interpreted only to be subjected to a violent *détournement* in which military meanings took absolute priority: mosques isolated from the community by shaping operations, neighbourhoods controlled through checkpoints. The city was to be choreographed by the US Army (DiMarco 2004).

These were textbook recommendations, however, and in practice such reversals threatened to capsize the American mission. By the summer of 2004, Major-General Peter Chiarelli, commanding the 1st Cavalry Division in Baghdad, was convinced that the doctrinal progression from combat to 'stability operations' was mistaken. Attempting to see military actions 'through the eyes of the population', he concluded that a purely kinetic approach to the insurgency risked alienating local people not only through its spiralling circles of violence but also through its indifference to their own predicament. 'We went after the insurgents,' Chiarelli explained, 'while at the same time – really simultaneously – we maximized non-lethal effects' that targeted the provision of basic services, local government, and economic regeneration (in Hollis 2005: 5). DiMarco had sutured poverty to political radicalism, too, but Chiarelli's Baghdad was not the traditional city of an unreconstructed Orientalism. Before deploying to Iraq, he and his officers consulted city administrators in Austin, Texas, and, while he said he 'knew we weren't going to create Austin in Baghdad', he also knew they would be confronting a modern city whose infrastructure had been degraded by years of air strikes, sanctions, and war. Chiarelli recognized the significance of cultural knowledge, and laid his model of modern urban infrastructure over 'a fully functional model of the norms of the Arab people [and] the current status of Baghdad services and government'.

A major focus was Sadr City, which had been designed by Constantinos Doxiadis and funded by the Ford Foundation as part of the 1958 master plan for Baghdad. It was no Orientalist labyrinth, therefore, but a modernist grid that had become a vast, sprawling slum. Chiarelli used a prototype of the Command Post of the Future to implement a spatial monitoring system – a visualization of the city as an 'event-ful' field in motion rather than a static morphology – that revealed that '[Mahdi Army] cell congregations, red zones and anti-coalition, anti-government religious rhetoric originated from those areas of Baghdad characterized by low electrical distribution, sewage running raw through the streets, little or no potable water distribution, and no solid waste pickup. Concurrently, unemployment rates rocketed in these extremely impoverished areas and health care was almost nonexistent'. In short, 'areas where local infrastructure was in a shambles became prime recruiting areas for insurgent forces' and, in turn, danger zones for US troops. This was the reversal that Chiarelli put into effect: the Mahdi Army 'target[ed] disenfranchised neighbourhoods', providing both services and shadow

government, and his response was to target the same districts and to focus on producing visible improvements in people's daily lives (Chiarelli and Michaelis 2005; also see Hollis 2005; Croser 2007).

Chiarelli's approach was to treat counter-insurgency as 'armed social work'. The phrase is David Kilcullen's, an ex-Australian Army officer who was a key contributor to FM 3–24 and, until July 2007, served as Senior Counterinsurgency Adviser to General Petraeus. 'Your role is to provide protection, identify needs, facilitate civil affairs', Kilcullen wrote in a memorandum for company commanders, 'and use improvements in social conditions as leverage to build networks and mobilize the population' (Kilcullen 2006b: 106). Insurgent violence was part of 'an integrated politico-military strategy' that could only be met by an integrated politico-military counter-strategy. Precisely because counter-insurgency was population-centric, it required what Kilcullen called 'conflict ethnography'; otherwise it would be impossible to understand the connections between the insurgency and the population at large. 'Culture imbues otherwise random or apparently senseless acts with meaning and subjective rationality', he argued, so that it was unhelpful to locate insurgents outside the space of Reason. But the space to which he appealed most often was that of the tribe. Although the urbanization of insurgency is one of the cardinal distinctions between classical and contemporary insurgency, Kilcullen's commentaries on Iraq have consistently privileged tribalism and, on occasion, reduced Iraq to a tribal society. When critics complained that FM 3–24 paid insufficient attention to religion, for example, his response was dismissive: 'When all involved are Muslim, kinship trumps religion'; the 'key identity drivers' are tribal. During the summer of 2007 Kilcullen described the tribal basis of growing Sunni resistance to Al Qaeda in Iraq (AQI) in Anbar, and then propounded 'the Baghdad variant'. Although he conceded that the capital 'is not tribal as such', Kilcullen argued that there are such close connections between city and countryside that 'clan connections, kinship links and the alliances they foster still play a key underlying role' (Kilcullen 2005, 2006a, 2007a, 2007b, 2007c). I have no doubt that they do; but, while some military authors have written about 'tribal cities' as a category apart from the 'hierarchical cities' that 'we Americans know' – which is not, I think, Kilcullen's intention – it is misleading to treat Baghdad in such one-dimensional terms and to marginalize a countervailing Arab modern.

Perhaps this simply indicates Kilcullen's distance from anthropology: but a close connection between counter-insurgency and the cultural sciences raises its own red flags. In a combative series of essays Montgomery McFate, a cultural anthropologist and a former AAAS Defense Fellow at the Office of Naval Research, called on anthropology to reclaim its historical role 'to consolidate imperial power at the margins of empire' (McFate 2005a: 28). In her view, 'cultural knowledge and warfare are inextricably bound', and counter-insurgency in Afghanistan and Iraq demanded nothing less than 'an immediate transformation in the military conceptual paradigm' infused by

the discipline 'invented to support warfighting in the tribal zone': anthropology (McFate 2005b: 42–3). It is not difficult to see why so many scholars were riled, but McFate was adamant that 'cultural intelligence' was not a scholastic exercise. It was important strategically, but it also made a crucial difference operationally and tactically, so that the thrust had to be on the production, dissemination, and utilization of 'adversary cultural knowledge' on the frontlines (McFate 2005b: 44). In November 2004 McFate organized a conference on Adversary Cultural Knowledge and National Security, sponsored by the Office of Naval Research and the Defense Advanced Research Projects Agency (DARPA). 'The more unconventional the adversary,' she told the delegates, 'the more we need to understand their society and underlying cultural dynamics' (McFate 2005b: 48; McFate and Jackson 2005). Over the next eighteen months, McFate's ideas were transformed into the Human Terrain System, for which she is currently Senior Social Science Adviser. The HTS aims to provide field commanders with a 'comprehensive cultural information research system' – filling the 'cultural knowledge void' – through a visual display of 'the economic, ethnic and tribal landscapes, just like the Command Post of the Future maps the physical terrain' (Kipp et al. 2006; Schachtman 2007; Gonzalez 2008).

All of these contributions rely on visualizations of one sort or another, and often make extensive use of visual technologies. But Lieutenant Colonel John Nagl, one of the lead contributors to FM 3-24, was more interested in what the visual displays could not show: 'The police captain playing both sides, the sheikh skimming money from a construction project', Nagl asks: 'What color are they?' (Schachtman 2007). The examples are telling; the cultural turn is never far from a hermeneutics of suspicion. But Nagl's question also speaks to the presumptive intimacy of cultural intelligence. In one sense, the reliance on visual displays to capture adversary culture combines optical detachment with the intrusive intimacy of the biometric systems used by the American military to anatomize the Iraqi population. But the cultural turn also implies another sort of intimacy that extends beyond the compilation of databases to claim familiarity, understanding, and even empathy. A primer for US forces deploying to the Middle East emphasizes that cultural awareness involves more than 'intelligence from three-letter agencies and satellite photographs' (Wunderle 2007: 3); Scales's culture-centric warfare demanded an 'intimate knowledge' of adversary culture (Scales 2004); and Kilcullen's conflict ethnography required a 'close reading' of local cultures (Kilcullen 2007c). While this 'rush to the intimate', as Stoler calls it, is conditional, forcefully imposed, and unlikely to be interested in thick description, 'the ethnographic has become strategic military terrain' (Stoler and Bond 2006: 98). Just like military knowledge of any other terrain, it has to be taught. 'The military spends millions to create urban combat sites designed to train soldiers how to kill an enemy in cities', Scales told Congress. 'But perhaps equally useful might [be] urban sites optimized to teach soldiers how to coexist in a simulated Middle Eastern city' (Scales 2004).

RE-SCRIPTING AND REMODELLING IRAQ

American troops prepare for deployment by rotating through Combat Training Centers, where prefabricated settlements are used to train for urban operations. In contrast to Di Marco's concern with cultural morphology, however, there is little attempt at verisimilitude. The same physical structures serve for Afghanistan and Iraq, as though the two are interchangeable, and the buildings are crude approximations. One journalist described 'Wadi al Sahara' in the Mojave Desert as 'an impressionist painting'. From the surrounding hills it could be mistaken for part of Basra or Fallujah, but 'a walk through its dusty streets shows it to be only a vast collection of shipping containers' (Hamilton J. 2006). This too has performative consequences. Shipping containers are an improvement on poker chips and Lego bricks, but reducing living spaces to metal boxes and studio flats conveys a silent message about the sort of people who live in them.

The focus at all the training centres is on interactive realism, and the cultural turn has transformed the terms of engagement. The emphasis used to be on air strikes and ambushes, and on state-of-the-art special effects that drew on the visual and pyrotechnic skills of Hollywood and theme-park designers. Exercises still include kinetic operations, though these now focus on combating IEDs and suicide bombings, but the main objective is no longer scoring kills but 'gaining the trust of the locals'. More than 1,000 Civilian Role Players are on call at the Joint Readiness Training Center at Fort Polk, Louisiana, including 250 Arabic speakers, who play community leaders, police chiefs, clerics, shopkeepers, aid workers, and journalists. New scenarios require troops to understand the meaning of cultural transactions and to conduct negotiations with local people. Careful tallies are kept of promises made and fulfilled by commanders, and the immediate consequences of civilian casualties are dramatized in depth. Mock newscasts by teams representing CNN and al Jazeera remind troops that their actions can have far-reaching consequences. 'It is no longer close in and destroy the enemy', one officer explained: 'We have to build relationships with Iraqis in the street' (Filkins and Burns 2006; also see Tower 2006; Beiser 2006; Rez 2007).

These Mission Rehearsal Exercises have become increasingly expensive and they pose formidable logistical problems. Yet, for all their size and complexity, they cannot convey the scale of operations in a city like Baghdad; and, precisely because they are conceived on the grand scale, it is difficult to inculcate the face-to-face sensibility on which the cultural turn relies. For these reasons, the military has become increasingly invested in computer simulations and videogames (Figure 5.1). Although these are also used to train for kinetic operations, there has been a major effort to devise 'first-person thinker' versions that model non-kinetic operations. In parallel with the introduction of Civilian Role Players to Mission Rehearsal Exercises, the Pentagon's cyber-cities have been peopled too. The first attempts to model civilians treated them as aggregations. Computer-generated crowd federates

Figure 5.1 Virtual Fallujah: US Marines training at Twentynine Palms, California, 6 March 2007 (US Marine Corps, photo by Lance Cpl Eric C. Schwartz).

animated the city as a series of physical trajectories and collective behaviours ('flocking', 'path following'), but this was a *danse macabre* that conveyed little sense of the city as a space of meaning, value, and transaction. MetaVR has introduced highly realistic 3-D crowd animations into its Virtual Reality Scene Generator, but these are typically part *of* the scene, extras in a movie, and provide few opportunities for interaction. More significant are those simulations that attempt to incorporate the transactional intimacy of the cultural turn by using Civilian Role Players in Massively MultiPlayer Online Games or by using Artificial Intelligence to model cultural interactions. I will consider each in turn.

Forterra Systems produced the first closed virtual world for the American military in 2004 to simulate checkpoint operations in one square kilometre of a geo-typical Baghdad (Figure 5.2). Avatars represent American troops, insurgents, Iraqi police, and Iraqi civilians, all played by role-players who log on from remote stations, including Arabic-speaking Civilian Role Players from the Combat Training Centers. Interactions are unscripted, and players communicate through speech, text, facial expressions, and gestures. The company subsequently developed an enhanced suite of scenarios that require troops to negotiate with a community leader to improve the delivery of food and medical supplies, or 'to establish rapport with shoppers in a Baghdad market, only to confront angry civilians as well as insurgents who chose to launch an attack with an IED and small arms' (Peck 2007: 14). Media coverage consistently emphasizes the non-kinetic priorities of the simulations,

Figure 5.2 Checkpoint simulation (Forterra Systems).

which are described as 'sandboxes where people learn to interact' (Laurent 2007) and being 'more about social interactions than fire-fights' (Peck 2007: 14; also see Mayo et al. 2006).

The University of Southern California (USC), and in particular its Institute for Creative Technologies (ICT), has spearheaded the application of Artificial Intelligence to replicate military–civilian interactions. These simulations mimic the closeness and intimacy that is the fulcrum of the cultural turn in three ways. First, they are highly immersive: ICT claims to transport (even to 'tele-port') participants 'experientially' to its virtual worlds. The power to draw players into these scenarios has been dramatically enhanced by advances in Virtual Reality and by experiments in 'mixed' reality. ICT's *FlatWorld* integrates digital flats – large rear-projection screens that use digital graphics to produce the interior of a building, a view to the outside, or an exterior – with physical objects like tables, doors, and windows, and immersive audio, lighting, and smell. Players can walk or run through these simulated rooms, buildings, and streets, moving 'seamlessly' between physical and virtual worlds, and three-dimensional Virtual Humans can be projected onto the flats to engage players in dialogue. These hybrid simulations mount a renewed assault on optical detachment; as Leopard (2005) argues, *FlatWorld* and its Virtual Humans actively interpellate players, entreating them to respond in particular, engaged ways to the situations in which they are so viscerally immersed.

Second, these virtual worlds are often local, even domestic. Military operations are staged in the places of everyday life, not in an abstracted battlespace but in homes, neighbourhoods, and clinics, and they require close, personal interaction with individuals, 'face work' that involves learning to read gestures and expressions. *Tactical Iraqi*, for example, was developed at USC's Information Sciences Institute to provide troops with the language skills and cultural knowledge necessary to accomplish specific tasks. The player is an Army sergeant who must navigate from public into private space to find a community leader who can help locate a source of bricks so that his platoon can rebuild a girls' school damaged in a fire-fight. Similarly, in an ICT simulation the player is an Army captain who must negotiate with two full-body avatars, a Spanish doctor who works for a medical relief organization and an Iraqi village elder, to persuade them to move a clinic to a safer location (Kenny et al. 2007). Scenarios like these register the presence of military violence – it is what makes them both possible and necessary – but as a temporal absence, banished to the past (a fire-fight) or postponed to the future (an air strike) to create a space for the non-kinetic and the humanitarian mission: the school and the clinic.

Third, *Tactical Iraqi's* Social Puppets and ICT's Virtual Humans invoke the interpersonal by making trust central to crosscultural interaction. In *Tactical Iraqi*, as Losh puts it, 'trust is both the precondition of play and the currency of the game' (Losh 2005: 72). If the sergeant succeeds in gaining the trust of the local people they will cooperate and give him the answers he needs to advance in the game. A crucial part of doing so is observing the social formularies and protocols that establish the sergeant's knowledge of and respect for Iraqi culture (Losh 2005). In ICT's clinic scenario, trust is a function of shared goals, believable claims, and, again, ritual politeness. In a model dialogue, the clash between combat operations and the work of the NGO is made clear from the beginning. The doctor tells the captain: 'This conflict is madness, it is killing people!' When the captain suggests 'it will be a problem to stay here', the doctor replies: 'You are the problem, your bombs are killing these people.' As the dialogue develops, non-verbal behaviour changes to mirror the progress of negotiations. As in the Mission Rehearsal Exercises, promises made must be ones that can reasonably be kept: 'The doctor is unlikely to be swayed by an offer of aid if he does not believe the captain can and will fulfil his commitments' (Core et al. 2006).

THE CULTURAL (RE)TURN

These developments represent significant departures from reductions of the city to target and terrain, and the cultural turn has been advertised as a 'counter-revolution' in military affairs. But there are also three continuities with its predecessors. The first is largely formal: the cultural turn is consistent with the neoliberal armature of late modern war in opening up new opportunities for private contractors. The new Mission Rehearsal Exercises

have involved extensive outsourcing to provide role-players, instrumentation, and special effects, and the Pentagon has leveraged commercial videogames and entered into joint ventures with engineering and software companies, videogames companies, and the academy to develop its military simulations (Lenoir 2000). The other two continuities are substantive.

The cultural turn is consistent with the Orientalism that has underwritten the 'war on terror' since its inception. In its classical form, Orientalism constructs 'the Orient' as a space of the exotic and the bizarre, the monstrous and the pathological – what Said called 'a living tableau of queerness' (Said 1978: 103) – and then summons it as a space to be disciplined through the forceful imposition of the order that it is presumed to lack: 'framed by the classroom, the criminal court, the prison, the illustrated manual' (Said 1978: 41). Although the cultural turn softens these dispositions – part of its purpose is to displace the monstrous if not the pathological – it remains, like its governing military project, an inherently disciplinary programme in thrall to a martial Orientalism. This is strengthened by the constant citation of T. E. Lawrence ('Lawrence of Arabia'). The title of Nagl's (2005) book on counter-insurgency, *Learning to Eat Soup with a Knife*, is taken from a remark in Lawrence's *Seven Pillars of Wisdom*, and I doubt that it is a coincidence that the Human Terrain System is based on 'seven pillars'. Its lead authors describe Lawrence's writings as 'standard reading for those searching for answers to the current insurgencies' (Kipp et al. 2006). The pre-deployment *Primer* dutifully reprints Lawrence's famous '27 Articles' (Wunderle 2007; Lawrence 1917); and, going one better, Kilcullen (2006b) titles his own seminal memorandum '28 Articles'.

Lawrence is a totemic figure, a powerful representation of a close encounter with an other who remains obdurately Other. His talismanic invocation repeats the Orientalist gesture of rendering 'the Orient' timeless: calling on Lawrence to make sense of modern Iraq is little different from expecting Mark Twain to be a reliable guide to twenty-first-century America. And yet the cultural turn places America outside history, too, because there is little recognition of the part that its previous interventions in the Middle East play in provoking opposition and resistance. In *Tactical Iraqi*, for example, Losh emphasizes that the avatars are 'incapable of speech acts that are not scripted by the US military' and cannot ask awkward questions about US foreign policy or military operations (Losh 2005: 71). While the model dialogues in ICT's clinic scenario acknowledge American violence in the present ('Your bombs are killing these people'), these are prompts to provide a competing interpretation and do not register the long shadows cast over cultural memory by American violence in the past (Losh 2005: 71).

Finally, the cultural turn continues the exorbitation of cultural difference that is at the heart of the 'war on terror'. There is little room for Arab modern in most of its versions – hence the 'traditional city' and 'tribal society' – because Muslims or Arabs opposed to US foreign policy and its military adventurism are supposed to be outside and opposed to the modern. Where

that leaves the rest of us who are also opposed to these things remains a mystery, but in fact the prospect of any sort of common ground between 'us' and 'them' is marginalized. The cultural turn acknowledges that there are cultural practices and values to be understood, but locates them in a completely separate space. Perhaps not surprisingly, the sense of alien estrangement is most vividly conveyed in Virtual Reality. Here is the project director of *FlatWorld* explaining its versatility:

> In the morning you could be training in Baghdad, and in the afternoon you could be in Korea,' she says. Or on Mars. One moment, the windows of FlatWorld look over a simulacrum of the Iraqi desert; when [she] dials in stereoscopic images from Pathfinder, the flood plain of Ares Vallis extends to the red horizon ... Suddenly a translucent 3-D rendering of a robot walks into the room, pauses in front of me, and walks back out. When a more sophisticated version of this 3-D projection is fortified with artificial intelligence and bathed in ... virtual lighting, the mechanical invader will become a *Fedayeen* soldier ...
>
> (Silberman 2004)

Evidently it is not only the Command Post of the Future that enables Iraq to be visualized as if it were another planet. The emphasis on cultural difference – the attempt to hold the Other at a distance while claiming to cross the interpretative divide – produces a diagram in which violence has its origins in 'their' space, which the cultural turn endlessly partitions through its obsessive preoccupation with ethno-sectarian division, while the impulse to understand is confined to 'our' space, which is constructed as open, unitary, and generous: the source of a hermeneutic invitation that can never be reciprocated.

THERAPEUTIC DISCOURSE AND THE BIOPOLITICS OF COUNTER-INSURGENCY

These continuities matter not because nothing has changed – that is not my point at all – but because they speak directly to the politics of the cultural turn. Outsourcing has made the connections within the Military–Industry–Media–Entertainment more intimate, and this has materially assisted the packaging of the new military imaginary for public consumption. The new counter-insurgency doctrine and its emphasis on cultural awareness have been the subjects of a carefully staged media campaign, in which video clips and screenshots have played a key role in showing how troops are now trained to make sense of those 'unconventional adversaries'. This is part of a culturalism that presents Arabs as exotic, alien, radically other: as Matthew Yglesias puts it with exquisite irony, 'because Arabs are horrified of shame, it's not a good idea to humiliate an innocent man by breaking down his door at night and handcuffing him in front of his wife and children before hauling him off to jail. Now it seems that Arabs are also so invested in honor that they don't

like it when mercenaries kill their relatives' (Yglesias 2008). This is an artful gavotte between estranging and understanding the Arab other, and in performing this military two-step the US Army can claim to have learned from Abu Ghraib and the running battles over the treatment of detainees. Once those histories are superseded, so are the others, and if the role of invasion and occupation in provoking violence can be made to disappear, then the military can be repositioned as an innocent bystander in an ethno-sectarian conflict for which it bears no responsibility. Given its new reserves of cultural tact and cultural intelligence, the responsibility for continuing violence must lie with the Iraqis. Hence the move from *Newsweek*'s cover of 15 October 2001 – 'Why they hate us' – to *Time*'s cover of 5 March 2007: 'Why they hate each other'.

These manoeuvres are, I think, therapeutic for an American public disillusioned with the war, but the cultural turn treats the counter-insurgency strategy as therapeutic for Iraqis too. In fact, FM 3–24 describes the three stages of counter-insurgency in explicitly biomedical terms:

- **Stop the bleeding**: similar to emergency first aid for the patient. The goal is to protect the population, break the insurgents' initiative and set the conditions for further engagement.
- **Inpatient care – recovery**: efforts aimed at assisting the patient through long-term recovery or restoration of health – which in this case means achieving stability ... through providing security, expanding effective governance, providing essential services and achieving incremental success in meeting public expectations
- **Outpatient care – movement to self-sufficiency**: expansion of stability operations across contexts regions, ideally using HN ['Host Nation'] forces.

(US Army 2006b)

Similar metaphors reappear across the field of contemporary counter-insurgency. But the military project in Iraq is more than emergency triage, and the same military that once insisted 'we don't do body counts' has become obsessed with them. Monitoring its success depends on visualizations of the kind shown in Figure 5.3. These military plots of murders and executions in Baghdad resemble medical scans of the body politic in which ethno-sectarian violence is visualized as a series of tumours. When General Petraeus reported to Congress in September 2007 and again in April 2008, he superimposed similar displays over his base-maps and described ethno-sectarian violence as 'a cancer that continues to spread if left unchecked' (Petraeus 2008).

This is an extraordinarily powerful rhetorical claim, in which the visual and the verbal registers work together to justify the most radical (and always supposedly 'surgical') intervention: more killing to stop the killing. Like Nagl, however, I am interested in what these displays do not show: the deaths attributable to US air strikes and ground operations. For the cultural turn has

Figure 5.3 US military plot of ethno-sectarian murders and executions in Baghdad, July–August 2006 (MNF-I Press briefing, 6 September 2006).

not displaced other modes of waging war, and air strikes have in fact shot up in Afghanistan and Iraq since 2006. Seen thus, the cultural turn becomes part of a profoundly biopolitical strategy that counterposes the benign and the malignant. The benign is located in 'our space', and its therapeutic interventions legitimize America's continuing presence within the 'host nation' (another astonishing phrase), while the malignant is located in 'their space'. In short, these visual economies provide a different way of advancing the same strategy with which I began: fighting them 'over there' so we don't have to fight them 'over here'.

Part II
Memory

6 Globalization and the remembrance of violence

Visual culture, space, and time in Berlin

Simon Ward

Some of the contributions to this volume are important reminders that the impacts of imperialist capitalism have been acted upon and reacted to for the past century. Berlin, though evidently affected heavily in the past two decades by the end of the Cold War and the consequent market liberalization, also bears the traces of earlier phases of globalization. In the notes that accompany his 1991 design for the rebuilding of the Potsdamer Platz in Berlin, which is discussed below, Daniel Libeskind makes an observation that helps explain the surfeit of academic and cultural projects that have been associated with the city in the past two decades. He writes: 'Berlin could be seen as an exemplary spiritual (geistig) capital of the 21st century, as it once was the apocalyptic symbol of the 20th century's demise' (Libeskind 1997: 58).

As the meeting-point of the era's two defining global ideologies, Berlin was arguably the city of the twentieth century – though not its capital, perhaps. If one were to attempt to write a history of globalization and its effects on the city of Berlin, then the Second World War, first with the global ambition of the Third Reich, and second with its carpet bombing of certain parts of the city and the physical (and psychological) damage inflicted by the invading Soviet army, would loom large in that narrative. What concerns me in this chapter is the way that the Second World War, as a form of globalized violence, manifests itself in the urban environment of contemporary Berlin, and more importantly how visual culture attempts to make the memory of violence visible in that urban environment through a process of defacement.

This concern is made more complex by the impact of the contemporary phase of globalization on the city: the enlarged presence of multinational corporations in the city, whose impact is principally a violent one. This influx of capital violates the pre-existing spaces, erasing the traces of time. I elucidate in the first section of the chapter the amnesiac dimensions of such globalizing processes.

There is, however, also an enhanced presence of international cultural producers and academics working in the city and thinking about the way it remembers its violent past. Not only that, but Germans also think about the city in terms of its relationship to a global marketplace, something evident in

a film such as Oliver Hirschbiegel's *Downfall* (2004), which markets the violent end of the Third Reich to a global audience.

Libeskind's observation helps explain contemporary international academic and artistic interest in Berlin. It is an open space for future ideas, poised between the 'no longer' and the 'not yet'; things are in process here and can be tested here that would not be possible elsewhere in the Western world. For that reason, I would argue that the two processes outlined above must be thought together. Rather than arguing that these works of visual culture focus on space, their defacement of that space actually constitutes attempts to produce the experience of time in the (presumed) empty, homogeneous space of contemporary global capitalism. The predominance of visual culture in the generation of remembrance is important, as Henri Lefebvre identifies a 'logic of visualization' (Lefebvre 1991: 98) in the increasing dominance of abstract space within the city, with the visual gaining the upper hand over the other senses.

MEMORY AND MONUMENTS IN CITY SPACE

Writing in 1995 on the 'museum boom', Andreas Huyssen argued that, 'even if the museum as institution is now thoroughly embedded in the culture industry', it was not commodity fetishism that was at stake (Huyssen 1995: 33). He argued that the 'museum fetish transcends exchange value', carrying with it something like an 'anamnestic dimension, a kind of memory value' (Huyssen 1995: 33). One can identify two major forerunners to Huyssen's terminology. Such fetishizations and the 'memory value' associated with them do not rely on a deep knowledge of the material object (on display), and as such have strong affinities with Alois Riegl's term 'Alterswert' ('age value'), used in his reflections at the beginning of the twentieth century on what he saw then as the 'moderne Denkmalkultus' ('modern cult of monuments') (Riegl 1996: 145). Riegl recognized that 'age value', which judged the patina of age definitive in determining the value of buildings, was gaining ground over the 'historical value', where such value was determined by antiquarian knowledge of a building's history. Elsewhere Huyssen suggested that 'the newfound strength of the museum and the monument in the public sphere may have something to do with the fact that they both offer something that television denies: the material quality of the object' (Huyssen 1995: 255). This again echoes Riegl, who promoted a radical conservation policy by which buildings were to be maintained but eventually allowed to deteriorate and 'amortize' their full age value 'naturally'. Such perception of the patina of age is dependent on the pleasure of the spectator, indicating that such age value lay more in the aesthetic impulse than the ethical.

Given that the auratic power of materiality is connected with the visual pleasure of seeing the object, another important forerunner for Huyssen's conception of 'memory value' is Walter Benjamin's consideration of 'Ausstellungswert' ('exhibition value'). For Benjamin, the cultic value of the sacred

object was transferred into the value imbued into the material presence of the individual (non-reproducible) artwork being exhibited (Benjamin 1989: 484). Both Riegl and Benjamin were attempting to describe how auratic value is established in terms of 'cultural capital'. The 'memory value' of an image or object from the past derives its auratic quality from being, in Benjamin's terms, 'the unique phenomenon of a distance, however close it may be', due to its indexical link to an inimitable past (Benjamin 1989: 479). With its roots in Riegl's and Benjamin's examination of the powerful aura of objects from the past, Huyssen's 'memory value' implies that what we may have witnessed in the last thirty years is a further stage in the processes of acceleration and decomposition that first generated Riegl's reflections of the 'modern cult of the monument'.

There are two major distinctions to be made, however, between Huyssen and his predecessors. First, both Riegl and Benjamin were writing about the relatively narrow field of art and architecture, whereas Huyssen's frame of reference is much wider. Second, Huyssen explicitly places 'memory value' in relationship to 'exchange value', raising the question of how this operates in the arena of commodified public space. Huyssen writes of the 'power' of monuments that stand in a 'reclaimed public space' (Huyssen 1995: 255), but how might we conceive of that power? Is it economic, political, or aesthetic? And how might it manifest itself?

Henri Lefebvre examined the meaning of the monument within 'absolute space', which is made up of 'sacred or cursed locations ... a space at once indistinguishably mental and social which comprehends the entire existence of the group concerned' (Lefebvre 1991: 240). Such monuments 'offered each member of a society an image of that membership, ... a collective mirror more faithful than any personal one' (Lefebvre 1991: 220). Although Lefebvre writes against any straightforward teleological development, he nevertheless describes a discernible contemporary tendency for 'absolute space' to yield to 'abstract space':

> Such monumental space is incompatible with abstract space, which is a medium of exchange (with the necessary implications of interchangeability) tending to absorb use ... It is in this space that the world of commodities is deployed, along with all that it entails: accumulation and growth, calculation, planning, programming. Which is to say that abstract space is that space where the tendency to homogenization exercises its pressure and its repression with the means at its disposal: a semantic void abolishes former meanings (without, for all that, standing in the way of a growing complexity of the world and its multiplicity of messages, codes and operations).
> (Lefebvre 1991: 307)

It is important to remember, however, that 'abstract space is not homogeneous; it simply has homogeneity as its goal, its orientation, its "lens"'

(Lefebvre 1991: 287). That orientation leads to the principle that 'the entirety of space must be endowed with exchange value' (Lefebvre 1991: 287). As suggested, Lefebvre examined the monument within the context of absolute space. If we now live in an era dominated by 'abstract space', then the 'memory value' of the monument may operate as a potential irritant to the semantic void, which the production of abstract space has as its goal.

MEMORY VALUE AT POTSDAMER PLATZ

Lefebvre argued that space is 'produced' through the interaction of three aspects – spatial practices, the development of representative spaces, and the construction of spaces of representation. From the 1990s onwards in Berlin, the most prominent example of the production of abstract space dominated by visual 'representations of space' is the Postdamer Platz. The physical state of the square before 1989 was that of a remnant of the end of the Second World War and its outcome: the bombing and division of Berlin into four sectors, and the building of the Berlin Wall. The ongoing ruinous condition of Potsdamer Platz was directly linked to the low exchange value of the site, cut off from the circulation of goods and commodities. Ironically, precisely that ruinous condition made possible a number of scenes set in the walled-in wilderness in Wim Wenders' 1987 film *Wings of Desire* (*Der Himmel über Berlin*) which demonstrated, however, that the invocatory power of the name had far from disappeared.

The potential of the space was transformed by the events of 1989 and 1990. Indeed, the historical Potsdamer Platz was invoked in designs by those planning the production of a new centre in this space – rather conventionally by the new owners of the space and rather more radically by Daniel Libeskind (1997: 59–61). The construction of a new Potsdamer Platz also had to deal with the reality that the space was not entirely empty. In contrast to other buildings, such as the GDR's Palace of the Republic, there may have been relatively few people who could invoke the memory value of specific spatial practices associated with the site in the 1920s. Nevertheless those who had used it since the Second World War, such as those living in the caravan settlement (Wagenburg) on the site, had a very different attitude to spatial organization. While the Wagenburg was moved elsewhere, there were also less mobile physical remnants, including two major buildings – Hotel Esplanade and Weinhaus Huth – and a row of trees as a reminder of what had previously been the Potsdamer Strasse, not to mention remnants of the Wall. It had been established that all of the first three named remnants had to be maintained in any reconstruction of the Platz. The new Potsdamer Platz thus had to negotiate with the potentially awkward 'memory value' of the remnants. The answer was to incorporate the memory traces into the corporate citadel and by doing so delimit the semantics of their memory value.

The remnants of the past that are to be found at Potsdamer Platz are exhibits in the architectural display that is the square as a whole. In

technologically very complex manoeuvres, Weinhaus Huth was incorporated into the surrounding buildings of the Daimler Quarter and the 'Kaisersaal' of the Hotel Esplanade was transplanted to be incorporated into the Sony Centre (Figure 6.1). It need hardly be said that both are sites of visual and physical consumption. The trees in the Potsdamer Strasse, which had survived the planning for Albert Speer's Germania and the post-war building of the Wall and the Kulturforum, were integrated into the renamed Alte Potsdamer Strasse, a neat signifier of 'age value'. The S-Bahn sign that had stood by the Wall throughout the years of the Cold War was incorporated into the Sony Tower when it was renamed Bahn Tower after the Deutsche Bahn moved its headquarters there (Figure 6.2). In addition, there is a reconstruction of the famous green signal-box from the 1920s. Its lights change, but it has no bearing in controlling the circulation of the traffic or consumers (Figure 6.3).

Three aspects of these remnants need to be drawn out. First, their artificiality. They could not have been maintained 'naturally' in their condition within all the new construction that has taken place. In that sense, the signal box is the simulacrum of a material remnant. Second, there is the use of signs to limit the semantic potential of the monument, for, as Lefebvre suggests, a monument 'does not have a "signified" (or "signifieds"); rather it has a *horizon of meaning*: a specific or indefinite multiplicity of meanings' (Lefebvre 1991: 222). In the case of both the S-Bahn sign and Hotel Esplanade, these

Figure 6.1 Hotel Esplanade, Potsdamer Platz (photo by Simon Ward).

Figure 6.2 S-Bahn sign, Potsdamer Platz (photo by Simon Ward).

signs do not locate the meaning of these remnants in their fate during the post-war era. Rather, reference to the bullet hole in the S-Bahn sign relates its memory value to the Second World War, rather than, say, its emblematic quality as a remnant of divided Berlin. In turn, the Hotel Esplanade's signs point towards the hotel's role in the Wilhelmine Empire. These signs offer narratives that offer a fundamentally affirmative narrative of the relationship of the past to the present. Perhaps even more striking than the use of signs is, third, the employment of glass. This way of presenting traces has also become fashionable in the presentation of the memory landscape in Berlin, if one considers Norman Foster's glass cupola, and more particularly the graffiti left by the Russian soldiers at the Reichstag in 1945.

The meaning of the remnants on Potsdamer Platz is thus fixed in a quite specific fashion: a remnant is an object behind glass. They have become intended monuments whose meaning, however, is exhausted in exhibition value. The glass exhibits the aura, but also arguably dematerializes and

Figure 6.3 Traffic signal-box, Potsdamer Platz (photo by Simon Ward).

neutralizes it. These remnants are no longer irritants in the smooth efficient functioning of an interchangeable abstract space, but belong to the exhibition spectacle that works against the potential for the trace as a palimpsest of historical processes as it fixes them in a musealized situation. What matters on Potsdamer Platz is the *image* of the past as fixed in the past and *incorporated* within the present face of the urban environment.

These corporate strategies of incorporation at Potsdamer Platz are also made more complex by the need to integrate the other major remnant of the past, the Berlin Wall, a trace of the global Cold War enacting its own architectural violence on the centre of the city. In August 2003 the archaeologist Leo Schmidt from the Technical University of Brandenburg in Cottbus argued that barely noticeable remnants of the Berlin Wall (such as the light masts on Heinrich-Heine Strasse), which his team had spent two years documenting, might, as material testament to the Cold War, become a World Cultural Heritage site, joining such Berlin locations as the Museumsinsel and Sanssouci. Many parts of the Wall (such as the towers at the Bornholmer Strasse and the colourful Eastside Gallery) have long been placed under preservation orders. In 2003, at Potsdamer Platz, where the Wall had been very noticeable, one slab of Wall was to be found by the entrance to the S-Bahn station, and a further series of slabs were placed to the south of the square along with the remains of a former watchtower, while another slab was situated on the not-yet-completed Leipziger Platz (Figure 6.4).

Figure 6.4 Fragment of Berlin Wall, Potsdamer Platz, 2003 (photo by Simon Ward).

By 2008, the presentation of the Wall had become more organized, as illustrated in Figure 6.5. Here, the material remnants are placed in such a way as to divert (predominantly) tourists from their chosen path, and situated in alternating fashion alongside signs which provide historical information about the Wall and the experiences related to it. Thus the space of the Potsdamer Platz is fractured by the past, but, other than in the apparently self-conscious provisionality of the sight, the extent to which this goes beyond the exhibition value demonstrated by the corporate solutions is debatable. The exchange value of such material, ironically referred to in Edgar Reitz's television series *Heimat 3* (where Warner Bros profit from the mediatization of Wall fragments), is never far from such locations in Berlin, as illustrated by Figure 6.6. Never far away either is the dominating presence of corporate architecture, as illustrated in the way in which the Beisheim-Center towers over the fragments in Figure 6.7.

The strategies of incorporation outlined above have been countered by a

Figure 6.5 Fragments of Wall, Potsdamer Platz, 2008 (photo by Charlotte Govaert).

Figure 6.6 Fragments of Wall and souvenir seller in Soviet army uniform, Potsdamer Platz, 2008 (photo by Charlotte Govaert).

Figure 6.7 Fragments of Wall below the Beisheim-Center, Potsdamer Platz, 2006 (photo by Andreas Steinhoff).

number of artistic interventions, which, rather than superficially fracturing space, instead emphasize the fracturing of time. The photographic works by Michael Wesely and Manfred Walther are both fascinated with the construction process at the site, and through the use of time-lapse photography transform it into a sight that questions the 'timeless' logic of visualization embedded in the grandiose architectural designs (although Wesely's project was perhaps not insignificantly funded by Daimler Benz). *The Empty Centre* (*Die leere Mitte*), completed in 1998 by Hito Steyerl, is, by contrast, a film that reveals layers of history underneath the construction site at Potsdamer Platz throughout the period from 1990 to 1998. The film makes use of slow superimpositions to uncover the architectonic and political changes of those eight years, while – through dissolves of archive material with present-day images – the film engages the viewer in what might be termed an archaeology of the present. In Steyerl's film, history is condensed in metaphorical transitions from one frame to the other, from GDR socialism to FRG capitalism, from past to present, but hidden connections between continents are also revealed, an unknown genealogy of earlier globalizations. Steyerl's aesthetic strategy is the temporal defacement of the façades of the new structures on the Potsdamer Platz. He does this to reveal, as it were, the complex, authentic historical space. The Potsdamer Platz as a palimpsest whose layers need to be revealed by a process of archaeological

defacement was also central to Daniel Libeskind's plan for the reconstruction of this space.

Libeskind's major contribution to Berlin's built environment is the Jewish Museum, but the design which perhaps best connects to the projects I have just described are his 1991 plans for the Potsdamer Platz, which involve the conception of a space radically idealistic in light of the pragmatic spectacle that would eventually be built in the city. In Libeskind's plan, Berlin is conceived as potentially 'an exemplary spiritual capital of the 21st century', a space for the enactment of what Libeskind describes as the 'post-contemporary city, where the view is cleared beyond the constriction of domination, power and the gridlocked mind' (Libeskind 1997: 58). Strikingly, though, 'what is needed is a connection of Berlin to and across its own history'; the 'profound undertaking of refounding Potsdamer Platz must be taken at its face value, through the presence of witnesses, dates, anniversaries' (Libeskind 1997: 58). The clearest note in Libeskind's musings is his rejection of a conventional reconstruction of a 'hollow past'; he argues strongly that his design is not utopian, but concrete. This archaeological mosaic is illustrated in the Illuminated Muse Matrix, what would effectively be a series of life-worlds embedded within the topology of Berlin's culture, refracting this urban space through the intervention of time.

In the case of Libeskind and Steyerl, the staging of the remembrance of the past has a critical intentionality. They are attempts to instrumentalize the poetic qualities of a memorial location and its visual representation to establish a form of critical insight. This can be contrasted with the ways in which other objects are framed at Potsdamer Platz, which could be described as monumental through the way it reduces the contextualization of the image, implying an unmediated access to the past and emphasizing its poetic qualities, also through aesthetic strategies. Such monumentality combines age value and exhibition value in the service of an affirmative narrative. This distinction between the two strategies, which can be linked to the memory value associated with the object, requires some elucidation.

A Benjaminian auratic quality is the foundation of both 'critical memory value' (Steyerl and Libeskind) and 'monumental memory value' (other remnants at Potsdamer Platz). These terms are derived from Nietzsche's analysis of history in 'On the Uses and Abuses of History for Life', where monumental history equates to a form of history that is ultimately poetic in its appeal to the aesthetic sense and fundamentally affirmative, whereas critical history is a form of history that ultimately appeals to the use of reason in a critical understanding of the past (Nietzsche 1977). Nietzsche's third category, antiquarian history, is more appropriate to a reading of visual culture in the heritage and conservation context of *Denkmalpflege*. The usefulness of these categories for an analysis of forms of visual culture and remembrance in contemporary Berlin is what I want to illustrate next.

98　*Simon Ward*

THE AESTHETICS OF MONUMENTAL MEMORY IN POST-UNIFICATION BERLIN

The power of the visual, as well as the temporal and spatial location of the spectator, are important factors in the 'construction' of a ruin. For the remnant to be a 'ruin', it has to be seen as such. Prior to, or indeed after, that moment, it is regarded as meaningless, 'undistinguished' material. For Alois Riegl, a Baroque palace in a state of ruin had been an object in need of restoration, not a ruin to be admired as such, like a medieval castle (Riegl 1996: 169). Over the course of the twentieth century, processes of ruination have accelerated and what has been seen as a ruin has expanded, and is indicated by the photograph in Figure 6.8, taken by Spanish photographer Miguel Parra and posted on the Trekearthers website.

The photograph shows people in front of a constructed image of the ruins of central Berlin at the end of the Second World War which was temporarily installed at the centre of the new capital by the artist Marcel Backhaus, who was working for the architectural association Gruppe 180, and with the backing of the Berlin Senate in 2005, to mark the sixtieth anniversary of the end of the Second World War ('Künstler' 2005). It could be said to 'fracture' the monumental space of the city centre that is framed by the Brandenburg Gate, the Reichstag, Albert Speer's East–West axis that leads to it, and the Pariser Platz on the far side of the gate. Nevertheless the aesthetic strategies it employs in fact heighten the poetic effects of the image in an assimilating fashion: the Gothic rubble and the predominance of stone produce the ruin aesthetic, while the use of a monochrome image only heightens the sense of historical distance – the past does not

Figure 6.8 Image of ruins at the Brandenburg Gate, 2005 (photo by Miguel Parra).

troublingly co-exist with the present, but is clearly designated as distinct and yet directly accessible in visual terms. The absence of the actual ruined material is compensated for by the material photographic image of the material, and so the photograph of the ruin operates as a surface on to which memory value can be projected. Here, the perspective engendered from a certain standpoint would place the quadriga atop the contemporary Gate atop the ruined Gate. Given this fact, and also in the way that Parra's image eschews almost any kind of textual correlate or supplement that would interrupt the aesthetic perception of the image (in the form of signage, for instance, since the pictorial ruins are in reality flanked by visual designs – unseen here – explicating how it was constructed), the 'memory value' invoked is monumental in that the visual is self-evident and apparently self-sufficient.

A significant part of this image is the cupola of the ruined Reichstag, a building that, prior to its refurbishment, was the site for Christo's *Wrapped Reichstag*, put into practice in 1995 after decades of planning. Beatrice Hanssen has described this project as an example of 'globalized art in a national context' and suggested that it presented 'the first truly global media art event' (Hanssen 1998: 264). Christo's project does not deface in order to reveal the 'true' face, but adds yet another layer to the palimpsestic quality of Berlin's urban environment. It may add another layer, but it is also reliant on the presence of the layer below. It exists in an explicit dialectical relationship with the past, but one that is now rendered invisible.

Christo's project was just the first stage in the rehabilitation of the Reichstag completed by Norman Foster's architectural reconfiguration. Foster's cupola ostensibly makes that history transparent. His reconstruction of the building was mostly interior, but his exterior reconfiguration clearly involves the 'masking' of the building's face, which is literally marked by history and is a remnant of Imperial ambition. This monumental façade was ultimately to create a new meaning to the face, allegedly symbolizing the democratic transparency of the new dispensation, although this metaphor is at least debatable, if not downright suspect, since perhaps democracy, like globalization, does not have a face.

A further example of 'monumental memory' in contemporary Berlin is Peter Eisenman's €25.3 million 'Monument to the Murdered Jews of Europe'. In many ways, although it occupies the same topographical terrain as both the Reichstag and Backhaus' temporary photographic installation referred to above, it is the converse of those images. The monument is made up of 2,711 concrete steles and covers an area the size of three football fields (Figure 6.9). The steles precisely refuse visual referentiality, denying the representability of the past, scarcely permitting any 'horizon of meaning' and demanding a spatial (aesthetic) experience in the present. Nevertheless, although they could be said to fracture the spatial organization of the modern city, they do not fracture the (a)temporal organization of the contemporary urban environment. Admittedly, an underground information centre, added to the

100 Simon Ward

Figure 6.9 Holocaust Memorial, 2005 (photo by Simon Ward).

original design, might be said to mediate the monumental experience of the site through historical information, although it is invisible.

What all four pieces of visual culture discussed here have in common is that their aesthetic strategies eschew the use of text as a way of mediating the 'horizon of meaning' of their object. That horizon is left deliberately open, and the aesthetic power of the visual is allowed freer play to generate ambiguity or, perhaps more frequently, a reassuring 'monumental' narrative of the relationship of past to present.

CRITICALLY REFRAMING THE TRACES OF VIOLENCE

The aesthetic strategies of Marcel Backhaus in the gigantic photograph at the Brandenburg Gate were prefigured by work in the early 1990s by Shimon Attie and Christian Boltanksi. These works, however, like those of Steyerl and Libeskind, seek to evoke a critical relationship to both past and present.

Shimon Attie's *Writing on the Wall* project was realized in 1992–3 in Berlin's former Jewish quarter, the Scheunenviertel, located in the eastern part of the city, close to the Alexanderplatz. At the heart of Berlin, the Scheunenviertel was a centre for Eastern European Jewish immigrants from the turn of the century. The few historical photographs that remained after the Holocaust reflect the world of the Jewish working class rather than that of the more affluent and assimilated German Jews who lived mostly in the western part of the city.

Attie slide-projected portions of pre-war photographs of Jewish street life

in Berlin onto the same or nearby addresses today. By using slide projection on location, fragments of the past were introduced into the visual field of the present. Thus, parts of long-destroyed Jewish community life were visually simulated, momentarily recreated. The projections were visible to street traffic, neighbourhood residents, and passers-by. The contrast with the 'ruin image' at the Brandenburg Gate is in the intersection of past and present as an aesthetic strategy. Rather than presenting an 'old face' *alongside* the 'new', Attie defaces the contemporary face with the 'old' face, creating a complex object that fractures and places in question the contemporary experience of time. Although, due to his source material, the 'old' photographs are black and white, they are also frequently 'textual', containing Hebraic lettering, that acts as a kind of self-consciously textual supplement to the image, as alluded to in his title for the work.

Attie also noted that, in the early 1990s, the Scheunenviertel was a neighbourhood undergoing rapid gentrification. His own commentary runs as follows:

> After the fall of the Berlin Wall, it has become the new chic quarter and frontier for many West Berliners. As a result, the neighbourhood has seen a huge influx of new residents and capital from the West. Within the course of only a few years, block after block of houses and buildings in the Scheunenviertel had become completely transformed. Most have been entirely renovated, from the inside out. Others have been transformed into fashionable and trendy bars and restaurants.
> (Attie 2003: 75)

As a result, Attie observed, the Scheunenviertel has become almost unrecognizable even in the few years since the *Writing on the Wall* project was realized (Attie 2003: 75). The 'remaking' of the Scheunenviertel affects both Jewish as well as post-war East German collective memory and identity, as the last physical evidence of these histories is now disappearing as well (Attie 2003: 75).

It is clear from the photographs taken by Attie that his project involves the violation of the everyday visual field of the urban environment, defacing it to make another face evident. But his commentary also makes clear that he has perceived the ways in which his project *not only* confronts the fact that the Jewish presence in this part of the city has vanished, but also engages, almost unintentionally, with processes of gentrification and the influx of capital into an urban location seen as ripe for redevelopment. What begins as a comment on German forgetting becomes through time a more general comment on the effacing of time in the urban environment through the workings of capital.

Christian Boltanski's work *The Missing House* (from 1990) focuses on an empty site in Grosse Hamburger Strasse left by a house destroyed in aerial bombardment in February 1945. It is thus an immaterial trace that has eluded

redevelopment that would have effaced even the absence. As with Attie's project, the focus was initially on Jewish experience, dealing with an area that had a large proportion of Jewish residents until the 1930s. The artist carried out archive research on the building's former residents and discovered that the Jewish inhabitants had been expelled or deported by the Nazis. Plaques were attached to the firewall of the adjacent building bearing their names, occupations, and the dates they lived in the house (Figure 6.10).

The gap left by the destroyed house is thus linked with references to its former residents, who are thus no longer anonymous. These are, however, not just the names of the Jews, but also of those who were resident in the house at the time of the bombing. Boltanski thus mediates the horizon of meaning of his 'unintended monument' through these textual references, another form of textual supplement. He also linked his installation with the presentation of his research findings, giving visitors additional information

Figure 6.10 Christian Boltanski, *The Missing House* (2008) (photo by Charlotte Govaert).

on what happened to each of the residents. Ownership of the work later passed into the hands of the district office of Berlin-Mitte, and today the archive findings are on display at the district's local museum. Boltanski's aim was to open up a 'space for memory' between the exemplary and 'authentic' place on the one hand and the researched individual biographies on the other, aiming to encourage the viewer to take the initiative in reflecting on them.

So Boltanski too defaces the urban environment as a way of making another, more complex face visible. His work also functions as a kind of defence mechanism against redevelopment; once this space is designated as a material trace of memory, it is 'sacred', absolute space in Henri Lefebvre's terms, and thus (still in 2009) offers a kind of resistance to the homogenizing violations of the 'specifically local' enacted by the economic dimensions of capitalism. 'This vacant lot stands out all the more as others are filled in and as the neighboring buildings are renovated', wrote Brian Ladd, but 'some passers-by see only the new restaurant garden in front of the installation' (Ladd 2000: 7). The works of both Boltanksi and Attie are comparable to those of Steyerl and Libeskind in their invocation of a 'critical memory value' that seeks to instrumentalize the aesthetic qualities of a material space and its visual representation to generate a form of critical insight through the fracturing of the time of the city.

Such aesthetic strategies of defacement are serious and sincere in their implication that the pre-defacement 'face' is the bearer of a false consciousness of space, but more importantly of time. Particularly striking is the fact that these works date from the early 1990s, a time when Berlin was most clearly an open space for future ideas, poised between the 'no longer' and the 'not yet', and the meaning of both has been transformed as that 'window of liminality' has become increasingly closed, perhaps best demonstrated by the demolition of the GDR's former representative building, the Palace of the Republic. After 1990 it had functioned as a site of cultural intervention both in its cadaverous interior and in visual manifestations of its exterior (see, for example, the photographic work of Tacita Dean). This demolition, discussed very publicly since 1990, became a very public dismantling in the summer of 2007 that resembled nothing so much as a state-sponsored Gordon Matta-Clark installation/exhibition (Figure 6.11).

It is intended that the Palace of the Republic will be replaced by a new building that sports the façade of the former City Palace that had stood on the site before being demolished by the nascent GDR state in 1950. Thus the memory of images comes to dominate in creating a suitable global identity for the city of Berlin, something already seen in the coalescence of Christo and Norman Foster's work in the 1990s and the Senate's support for Backhaus' project. We see here the way in which culture and memory can be appropriated in the construction of a 'monumental' civic and international urban identity. Memory can thus be used to put a 'face' on the city's image, or urban processes can efface that memory.

Figure 6.11 Palace of the Republic, 2007 (photo by Simon Ward).

FACES INSTEAD OF TRACES

Sleeper (2007), Mark Wallinger's 154-minute video of himself dressed in a bear costume pacing around the New National Gallery in Berlin, won the artist the Turner Prize, and can be read as exploring the mechanics that underpin Berlin's civic symbolism in a global era. The bear has indeed long been a heraldic symbol of Berlin's civic identity, and has been optimistically reinvented in the post-unification era as a 'cuddly' image for the former Cold War city (Figure 6.12).

Wallinger's recent version of this mutation of Berlin's civic identity is interesting, because it refuses the pose of memorial sincerity underpinning the aesthetic strategy of defacement in favour of the playfulness of the mask itself that has effaced any depth behind it. Wallinger takes this civic tourist image and literalizes it, with the bear becoming a spectacle for tourists presumably on their way to or from the nearby Potsdamer Platz.

Wallinger's mask may be a playful reminder of the espionage specialists who roamed the city during the Cold War era and the terrorists who may be lurking in its contemporary midst, but it can also be shown that the site of the New National Gallery is itself an archetypal example of the palimpsestic quality of Berlin's urban environment to which so many cultural products discussed here have alluded. Wallinger may evoke the city's spy past, but he does not specifically invoke the historical. The 'blank' face of Wallinger's

Figure 6.12 Buddy Bear Pariser Platz.

bear is mirrored by the images of his installation, which give the impression of an empty, homogeneous, dehistoricized 'white cube' museum space. Indeed the gallery building is itself a reminder that Berlin is a site for the presence of architects working on a global stage: it was designed by Mies van der Rohe, not originally for this location or this function, but as corporate offices for Bacardi in Havana (Johnson 1978: 216). When that project could not be fulfilled, the building was erected in Berlin in the early 1960s, a stone's throw from what were then the abandoned wastelands of Potsdamer Platz. The building was at that point a part of the 'Cultural Forum' built on this space, which was effectively cut off from the flows of capital through the fact that the road on which it was located, the Potsdamer Strasse, came to a very sudden halt not half a mile later at the Wall. So, it was indeed part of West Berlin's civic symbolism during the Cold War, a reminder that this was a war waged on all fronts – political, economic, and cultural. We could, however, go back further and recall that the site was also the location of one of the few buildings actually erected in the execution of Albert Speer's megalomaniac plan for Germania: this was the site of the House of Tourism, which was then erased after the end of the war. So Wallinger's contemporary 'tourist icon' of Berlin is pacing around a site previously devoted to the tourist marketing of a very different notion of Germany. The traces of that earlier site, however, have been utterly effaced. In line with the new image of 'new' Berlin, the New National Gallery has been the site of such moments of event culture as the

MoMA exhibition held there in the autumn of 2005, where most reporting related to the length of the queues of (tourist) visitors.

The historical depths that may be drawn from Wallinger's work show how it implicitly engages with the same kinds of concerns we saw in the work of the other cultural producers, but significantly he does not engage in the gesture of defacement, but instead playfully engages with the city's surfaces, its own attempts at transmutation, rather than suggesting some authentic depth in contrast to the superficial present. He consciously engages with (his own) exchange value, rather than a memory value, be it monumental or critical, that is believed to exceed it.

Wallinger's interest in transmutation is clearly linked to Berlin's changing civic face, and as such addresses the tension between the 'local' and the 'global', both in terms of municipal identity-strategies and also in terms of a global art world. It highlights the process by which artists such as Wallinger come to Berlin to create works of art that can be consumed (i.e. are consumable) elsewhere. The very blankness of Wallinger's white cube stage is an implication that this stage could exist anywhere on the globe. What draws all the artists discussed in this chapter to Berlin is the desire to trace how processes of globalization cause violence to be enacted upon the city fabric, and how the origins of that city in global violence have become masked. Violent defacement is required to make that process visible. There is thus a subterreanean link between their contemporary work and the Second World War as one of the founding moments of our contemporary era of globalization and violence, an era distilled in the work for which Wallinger, in effect, won the Turner Prize in 2007: 'State Britain', his reconstruction of Brian Haw's protest site directed against the Iraq war outside the Houses of Parliament.

NOTE

I would like to thank Charlotte Govaert for taking, under my instruction, many of the photographs in this chapter.

7 Trash aesthetics

New York, globalization, and garbage

Christoph Lindner

A tricky business, that of understanding New York. The city is always on the move, forever shifting.

(Maffi 2004: 1)

Although the two towers have disappeared, they have not been annihilated. Even in their pulverized state, they have left behind an intense awareness of their presence. No one who knew them can cease imagining them and the imprint they made on the skyline from all points of the city. Their end in material space has borne them off into a definitive imaginary space.

(Baudrillard 2002: 52)

CITY-SPACE

A metropolis forever in the making, New York is a constant reminder of the mutability of urban landscape and the radical impermanence of the city. Since the terrorist attacks of 2001, the city has also become a notorious symbol of the links between globalization and violence. Engaging with these issues as they relate to contemporary New York, my focus in this chapter is an urban landscape architecture project called Lifescape. Under construction since 2008, Lifescape is an ambitious, long-term plan to transform the Fresh Kills Landfill on Staten Island (Figure 7.1) into a public park and recreation area. There are two reasons for my interest in this project to rehabilitate a garbage dump, and both are connected to a broader interest in the interplay between the material and imaginary spaces of the global city.

First, Lifescape marks a significant effort to reclaim and reimagine a derelict landscape that is connected in both material and symbolic ways to the lived space of the city. Second, following the events of 9/11, the wreckage from Ground Zero was transported to the Fresh Kills Landfill, which was specially reopened to accommodate the 1.2 million tons of material. As one commentator has noted,

> Fresh Kills . . . is not just the place where, for more than 50 years, the rest

108 *Christoph Lindner*

Figure 7.1 Aerial view of Fresh Kills Landfill, 2001 (courtesy of Field Operations).

of the city sent its potato peels, broken dishes and every kind of household trash. For several months after the terrorist attacks on the World Trade Center, the sad bits of busted buildings and broken lives were sifted on mound 1/9 of Fresh Kills, piece by shattered piece.

(DePalma 2004)

Crucially, the Lifescape project acknowledges the presence of these remains and envisions a commemoration of the Twin Towers and the recovery effort in the form of a giant earthwork monument. How this monument evokes the memory of the towers, as well as how it connects the park's landscape back to New York's cityscape, remain significant concerns for this chapter.

Through an analysis of Lifescape's transformative vision and, in particular, its plans for a 9/11 earthwork monument, I want to consider the ways in which the Twin Towers continue to haunt the contemporary imagination, exerting an almost ghostly presence over the skyline of New York. My argument is that Lifescape works simultaneously to reveal and conceal the mutability of urban landscape, attesting not only to the extraordinary versatility of urban space but also to the imaginative ways in which – responding to an experience of collective trauma – such space can be recycled, renewed, and remade in the present era of '21st-century green, global connectedness' (Hamilton 2006).

As such, the Fresh Kills Landfill relates in a number of interesting ways to

New York as a global site. The most obvious connection is that, as the location of the World Trade Center (WTC) Recovery Operation, Fresh Kills played a key role in the federal investigation of 9/11 and its efforts to understand how and why New York's symbolic centre of transnational corporate capitalism succumbed to terrorist attack. In the process, Fresh Kills also bore witness in the most detailed and intimate way possible to the violence and horror involved in the destruction of the vertical architecture of globalization. Over a ten-month period, during which the landfill was designated a federal crime scene, the debris from Ground Zero was meticulously sifted and sorted in search of human remains, personal effects, and objects of everyday life. The resulting process of inspection and introspection – fuelled in the national imagination by both the media and travelling exhibits such as the New York State Museum's WTC Recovery Exhibition – contributed to wider public efforts to work through the trauma of 9/11.

Fresh Kills is also tied into New York's status as a global city in another way entirely. In its function as a dumping ground for New York's household rubbish, Fresh Kills stood for over fifty years as 'the largest symbol of American waste' (Hayden 2002: 62). The overproduction of waste may not be one of the defining processes of globalization, but it is a direct consequence of the culture of runaway consumption that has increasingly come to dominate the contemporary scene in global (and globalizing) cities worldwide. Indeed, as Harold Crooks (1993), Mike Davis (2006), and others have shown, the politics of waste – which have long gripped cities ranging from New York, London and Tokyo to Lagos, Jakarta and São Paulo – are now inextricably tied to the politics of globalization. Fresh Kills represents a poignant reminder of the material excesses of the global metropolitan condition.

Perhaps the most significant connection between Fresh Kills and New York City as a global site, however, is to be found in the Lifescape project. The reason is that, in its radical plans to redefine the space and function of Fresh Kills, Lifescape is part of the 'new spatial order' that Peter Marcuse and Ronald van Kempen (2000) see as a definitive feature of globalizing cities since the 1970s. While this reordering typically manifests itself in the proliferation and accentuation of spatial divisions between the urban poor and an urban elite, it is also evident in the retreat of the middle class from urban centres into peripheral clusters and secured enclaves.

In such terms, and mainly because of its location on the suburban margins of the city, Lifescape could be seen as a project aimed at meeting the outdoor recreational needs of a spatially segregated exurban middle class, effectively reinforcing an established pattern of separation. At the same time, however, Lifescape could equally be seen in a more positive light as an intervention in the spatial reorganization of the global city that deliberately resists the divisive trend of contemporary urban development by reclaiming an inhospitable, toxic site for new, sustainable public use. In this respect, Lifescape poses a profound challenge to conventional thinking about what constitutes waste (and wasted space) in today's post-industrial world cities.

Fresh Kills is therefore a critical site within contemporary New York, and one that has been largely overlooked in existing analyses of the city's development in the era of globalization. Yet, as a prominent symbol of consumer waste, a repository of late capitalism's most notorious architectural ruins, and an experiment in new spatial order, Fresh Kills is more than just a controversial garbage dump. Alongside the other urban sites and scenes discussed in this volume, Fresh Kills is one of New York's truly extraordinary locations in which the tensions, trends, and possibilities of the global city come together in unique and revealing ways.

Before focusing my discussion on Fresh Kills and the Lifescape project, however, it is necessary to comment further on the World Trade Center towers and the skyline to which they belonged. This is partly because it is impossible to discuss contemporary reshapings of New York's urban landscape without raising the spectre of the Twin Towers and addressing at least in some small way the significance of 9/11. While seeking to avoid repeating recent commentary on the topic – after all, much of the crucial architectural, cultural, and historical analysis of the life and death of these iconic buildings has already been done by interdisciplinary publications like Sorkin and Zukin's *After the World Trade Center* (2002) – the discussion draws next on the philosophical musings of two notable New York outsiders in order to contribute a deceptively straightforward idea. The idea is that New York's skyline is a site of instability and change distinguished in the contemporary urban imaginary by visions caught somewhere between the sublime and the uncanny. This line of thought is developed by revisiting Michel de Certeau's aerial view of Manhattan in *The Practice of Everyday Life* (1984), which is then contrasted against Jean Baudrillard's strangely detached perspective on the vertical city in his 'Requiem for the Twin Towers' (2002). Far from extraneous to the subjects of globalization and garbage, this *détournement* into the philosophy of high-rise architecture lays important groundwork for the analysis of Lifescape that follows.

CITYSCAPE

In *The Practice of Everyday Life*, Michel de Certeau famously writes about the experience of visiting the observation deck of the World Trade Center in New York in the late 1970s. Looking out over Manhattan from the summit of the skyscraper, de Certeau finds himself 'transfigured into a voyeur' (de Certeau 1984: 92). And in his voyeuristic gaze, the undulating mass of the city becomes immobilized into a whole, graspable image:

> Seeing Manhattan from the 110th floor of the World Trade Center. Beneath the haze stirred up by the winds, the urban island, a sea in the middle of the sea, lifts up the skyscrapers over Wall Street, sinks down at Greenwich, then rises again to the crests of Midtown, quietly passing over Central Park and finally undulates off into the distance of Harlem.

> A wave of verticals. Its agitation is momentarily arrested by vision. The gigantic mass is immobilized before the eyes. It is transformed into a texturology in which extremes coincide – extremes of ambition and degradation, brutal oppositions of races and styles, contrasts between yesterday's buildings, already transformed into trash cans, and today's urban irruptions that block out its space ... A city composed of paroxysmal places in monumental reliefs. The spectator can read in it a universe that is constantly exploding ... On this stage of concrete, steel and glass, cut out between two oceans (the Atlantic and the American) by a frigid body of water, the tallest letters in the world compose a gigantic rhetoric of excess in both expenditure and production.
>
> (de Certeau 1984: 91)

One of the most distinctive features of de Certeau's cityscape is the description of New York's vertical architecture in terms of motion and fluidity. And yet, this sense of movement is counteracted by the immobilizing effect of the high-rise view, creating a tension between motion and stasis.

This frozen, long-distance image of New York is what de Certeau goes on to contrast against the chaos and confinement of the city street – the space and level of everyday life. For de Certeau, the pleasure of high-rise voyeurism lies precisely in the liberation it offers from the mess of the street, a liberation made possible by the distancing, estranging perspective of the high-rise view. It is questionable, however, whether such an extreme spatial dichotomy between the vertical and horizontal axes of the city actually holds up under closer scrutiny. In particular, de Certeau's position that the high-rise view offers anything remotely approaching a totalizing image of the city is problematic, even if that image does represent, as de Certeau is careful to stress, only an 'imaginary totalization' (de Certeau 1984: 93). Setting aside this point of contention, however, what is worth taking away from de Certeau here is the broader idea that the high-rise view produces a depopulated and immobilizing image of the city, frozen in a state of suspended animation, caught somewhere between the living and the dead.

Commenting on the destruction of the Twin Towers in his essay 'Requiem for the Twin Towers' (2002), Baudrillard touches on this subject. Interspersed between reckless remarks about how the collapse of the towers resembled a form of suicide and how their aesthetic of 'twin-ness' invited a violent return to 'a-symmetry' and 'singularity' (Baudrillard 2002: 46–7), Baudrillard does offer some critical insight:

> All Manhattan's tall buildings had been content to confront each other in a competitive verticality, and the product of this was an architectural panorama reflecting the capitalist system itself – a pyramidal jungle, whose famous image stretched out before you as you arrived from the sea. That image changed after 1973, with the building of the World Trade Center ... Perfect parallelipeds, standing over 1,300 feet tall, on a

square base. Perfectly balanced, blind communicating vessels ... The fact that there were two of them signifies the end of any original reference. If there had been only one, monopoly would not have been perfectly embodied. Only the doubling of the sign truly puts an end to what it designates ... However tall they may have been, the two towers signified, none the less, a halt to verticality. They were not the same breed as the other buildings. They culminated in the exact reflection of each other.

(Baudrillard 2002: 42–4)

Like de Certeau before him, Baudrillard sees New York's modern architecture in terms of energy and chaos, also stressing the legibility of the city when seen from a distance. De Certeau's 'tallest letters in the world' (1984: 91) become Baudrillard's doubled signs. What those endlessly mirroring signs designate, of course, is the present age of globalization, and Baudrillard concludes that this symbolism is the reason why the Twin Towers were destroyed: 'the violence of globalization also involves architecture, and hence the violent protest against it also involves the destruction of that architecture' (Baudrillard 2002: 45).

In the case of the Twin Towers, however, the link between architecture, globalization, and violence is far more complicated than Baudrillard's comments suggest. Given the global impact of 9/11, it is important to remember that the destruction of the Twin Towers was brought about by factors that included but also exceeded the symbolic dimensions of the Twin Towers. For instance, as Stephen Graham argues in *Cities, War, and Terrorism*, the WTC attacks were also connected to the city's cultural and ethnic heterogeneity:

The 9/11 attacks can be seen as part of a fundamentalist, transnational war, or Jihad, by radical Islamic movements against pluralistic and heterogeneous mixing in (capitalist) cities. Thus it is notable that cities that have long sustained complex heterogeneities, religious pluralism, and multiple diasporas – New York and Istanbul, for example – have been prime targets for catastrophic terror attacks. Indeed, in their own horrible way, the grim lists of casualties that bright New York day in September 2001 revealed the multiple diasporas and cosmopolitanisms that now constitute the often hidden social fabric of 'global' cities like New York.

(Graham 2004: 9)

While the argument that New York's cultural and ethnic heterogeneity rendered the city a terrorist target oversimplifies the impetus behind the attacks, Graham does highlight an important dimension of New York's globalism that is too often overlooked. Baudrillard is therefore partially right in saying that the Twin Towers were party to their own destruction, but not in the way – or for the reasons – he proposes.

Together, the skyscraper musings of Baudrillard and de Certeau bring into focus one of New York's most striking and enduring features. As their comments suggest, the city has one of the most visually compelling and symbolically charged skylines in the world today – so much so that it enables, as discussed in the next section, a kind of undead afterlife for the Twin Towers. Significant here is that, in their response to vertical New York, both philosophers see the skyline in broadly similar terms as a peculiar commingling of the sublime (in the Burkean sense of an aesthetic wonder that awes and overwhelms) and the uncanny (in the Freudian sense of the familiar made newly strange and alien).

The reason for stressing these points about Baudrillard and de Certeau is because their urban panoramas belong to a broader vision of the city that is shared not only by many New York artists, writers, and filmmakers (Lindner 2005), but also by New York's Department of City Planning and its ambitious efforts to revivify the dead space of the Fresh Kills Landfill. In other words, the idea of an urban landscape marked by a tension between the sublime and the uncanny also has a certain resonance for the City of New York's vision of a new public parkland emerging from the site of what was both the world's largest domestic garbage dump and the operational centre of the World Trade Center recovery effort.

LIFESCAPE

'A green oasis for all New Yorkers' ('Fresh Kills' 2006: 2) is how Michael Bloomberg describes Lifescape in the preface to the project's master plan. The New York City Mayor's endorsement is followed by a series of equally bold and exuberant statements by various city officials. The Staten Island Borough President, for example, declares Lifescape to be a 'simultaneous ending and beginning', a 'life within a landscape' ('Fresh Kills' 2006: 2). The NYC Department of Parks and Recreation Commissioner in turn suggests that Lifescape is 'reminiscent of the popular movements that gave rise to Central Park, Prospect Park and many of our other greatest parks', and that the city's newest green space will become 'a tangible symbol of renewal' ('Fresh Kills' 2006: 3). Commenting on Lifescape's cultural significance, the NYC Department of Cultural Affairs Commissioner anticipates that 'the expansive parkland will serve as a cultural destination like no other, engaging New Yorkers and visitors in the city's unique and vibrant creative community' ('Fresh Kills' 2006: 3).

Quite apart from the positive spin, which is to be expected from politicians and city officials seeking support for a massive expenditure of public funds, this rhetoric of renewal highlights one of the most important features of the Fresh Kills parkland project. Lifescape is not so much about constructing a new space as it is about creatively reviving a dead space and making it, as stated in the master plan, 'rejuvenating to the spirit and the environment' ('Fresh Kills' 2006: 60). Such a project is made all the more difficult yet

114 *Christoph Lindner*

significant by the presence of the World Trade Center wreckage within the site. As a way of coping with that presence, the 9/11 earthwork monument is a critical element of the park's design, a symbolic centrepiece that will play a key role in the project's potential to rejuvenate the body and soul of New York in the face of urban decay and post-disaster recovery.

Before examining this symbolic centrepiece, however, it is important to place the earthwork monument in the broader context of the park's overall design. So first of all, some background and facts about the site and project. Fresh Kills Landfill on Staten Island has served as a dumping ground for New York City's household garbage since 1948, and is the largest domestic waste landfill in the world. The site covers an area of 2,200 acres, which makes it approximately two and half times the size of Central Park. The landfill was closed in early 2001, but briefly reopened later that year to accommodate the 1.2 million tons of wreckage from Ground Zero. The decision to reclaim the land for new public use had already been reached at this point, but the selected design for the transformation of Fresh Kills was not confirmed by the Department of City Planning until later that year. Following a two-stage international design competition to develop a plan for the adaptive end use of the site, Lifescape was announced as the winning entry in December 2001. The first draft of the Lifescape master plan was completed in 2005, and construction on the project began in 2008, with the first major phase due to be completed within ten years. The full transformation of the site, including its environmental recovery, is expected to take thirty years (Figure 7.2).

Figure 7.2 Rendering of Lifescape from the southeast (courtesy of Field Operations).

Lifescape's multi-disciplinary design team is being led by James Corner and his landscape architecture practice, Field Operations. Interestingly, Field Operations is also working on another ongoing effort to reclaim a derelict space within New York City. This other project, called the High Line, involves redesigning a defunct elevated railway bed on Manhattan's far West Side into a public walkway, garden, and park (Figures 7.3–7.5). In the project's design statement, Corner's team describes High Line's goal as being 'the retooling of an industrial conveyance into a post-industrial instrument of leisure, life, and growth' ('High Line' 2006). Corner's team also cites the importance of creating 'an experience of slowness, otherworldliness, and distraction' ('High Line' 2006). These comments may be directed at the High Line, but they could just as easily be applied to the park at Fresh Kills. This, however, is not entirely accidental. Both Lifescape and the High Line are not only being designed by the same practice but also belong to a larger trend in contemporary landscape architecture towards the reclaiming of once-vital pieces of urban infrastructure for new, imaginative, and sustainable forms of public use.

This trend towards creative, sustainable renewal of infrastructural urban space most clearly registers in Lifescape's vision of transforming a landfill not just into a landscape, but into an eco-friendly natural parkland complete with communal gathering spaces, playing fields, pedestrian and cycle paths, wetlands, grasslands, woodlands, and a wildlife preserve. Commenting in a 2005 journal article on the philosophy and values behind the design, James Corner explains that 'Lifescape is both a place and a process' (Corner 2005: 15):

Figure 7.3 The High Line, NYC: sectional view (courtesy of Field Operations).

116 *Christoph Lindner*

Figure 7.4 Gansevoort Entry: Slow Stair and Vegetal Balcony (courtesy of Field Operations).

Figure 7.5 Lighting concept, High Line level (courtesy of Field Operations).

Lifescape as a place is a diverse reserve for wildlife, cultural and social life, and active recreation. The aesthetic experience of the place will be vast in scale, spatially open and rugged in character, affording dramatic vistas, exposure to the elements, and huge open spaces unlike any other in the New York metropolitan region.

Lifescape as a process is ecological in its deepest sense – a process of environmental reclamation and renewal on a vast scale, recovering not only the health and biodiversity of ecosystems across the site, but also the spirit and imagination of people who will use the new parkland.

(Corner 2005: 15)

This double inflection of Lifescape as place and process – as both sanctuary space and sustainable space – is graphically articulated in the master-plan renderings, many of which present idealized scenes of pastoral serenity and utopian moments of sociality and leisure, all enabled by the environmental reconditioning and spatial reorganization of the site (Figures 7.6–7.8).

Given Lifescape's emphasis on spatial and environmental transformation, one of the more interesting elements of the design is that it plans to retain most of the artificial topography created by the undulating mounds of garbage (Figure 7.6), some of which reach heights of over 200ft. These mounds will be sealed beneath a protective polymer lining and topped by a thick layer of soil, facilitating the environmental recovery of the site. On the surface, therefore, Lifescape will be a vibrant and varied natural landscape, an idea reinforced by the word 'life' in the project title.

Underlying this natural landscape, however, will be the cumulated waste of one of the world's most excessive cities. So while Lifescape will appear at first to be disconnected from the city – indeed, the parkland is mainly conceived to offer an escape from the conventional experience of urban

Figure 7.6 Rendering of park interior (courtesy of Field Operations).

118 Christoph Lindner

Figure 7.7 Rendering of the creek landing esplanade with market roof (courtesy of Field Operations).

Figure 7.8 Rendering of floating gardens and old landfill machinery exhibit (courtesy of Field Operations).

space – the landscape will nonetheless remain intimately and inextricably connected to the city at a much more fundamental level. In a very real way, this rehabilitated natural landscape will be shaped and sustained by a hidden cityscape of urban waste.

Included in that waste, of course, are the material remains of the Twin Towers, which will be commemorated by the earthwork monument (Figure 7.9). The monument itself will be formed by two inclining landforms that mirror the exact width and height of each tower laid on its side. And, in a further commemorative gesture, the monument will be oriented on an axis with the skyline where the towers originally stood (Figures 7.10 and 7.11). This will allow for a panoramic view of Lower Manhattan in the far distance –

Figure 7.9 Rendering of 9/11 earthwork monument (courtesy of Field Operations).

Figure 7.10 Location and orientation of earthwork monument (courtesy of Field Operations).

a view that will eventually include the Freedom Tower rising from the redeveloped site of Ground Zero. Fittingly, the new tower will not only serve in its own right as a monument to urban renewal but, like the two mounds at Fresh Kills, will also evoke the incompleteness of New York.

In this sense, the earthwork monument establishes a strong link back to the lived space of the city. The orientation of the landforms creates direct visual and symbolic connections with the New York skyline, encouraging visitors to gaze at the city from the vantage point of its recycled dumping ground. Meanwhile, the shape of the monument evokes the origins of the urban wreckage contained in the nearby ground. It transforms the landscape into a

Figure 7.11 Earthwork: 360-degree view of the region (courtesy of Field Operations).

symbolic burial mound for the urban superstructures that once stood as the world's most prominent icons of globalization.

Putting these aspects of the monument together, it becomes clear that what the earthwork will do is frame an experience that ensures visitors see much more than what is visibly present on the skyline of Manhattan. The monument will also ensure that visitors remember and reimagine the violent urban reshapings that took place on 11 September 2001. Such a meditative experience of city-gazing, in which the estranging effects of the high-rise view described by de Certeau in *The Practice of Everyday Life* (1984) are effectively replicated from a horizontal rather than a vertical perspective, is exactly what James Corner has in mind when he imagines how visitors will respond to the monument: 'the slow, simple durational experience of ascending the incline, open to the sky and vast prairie horizon, will allow people to reflect on the magnitude of loss' (Corner 2005: 20). In other words, the monument will ask visitors to experience an absence, to gaze upon an urban view that no longer exists.

In this abstract sense the Twin Towers have not entirely disappeared from the New York skyline. Rather, at Fresh Kills, they will continue to engage and disturb the contemporary imagination, dominating both the park and the view of the city through their ghostly reincarnations. With the construction of the earthwork monument, the Twin Towers will thus acquire an undead afterlife. In their new horizontal form, they will once again become landmarks from which to observe the shifting verticals of New York's architecture of globalization – a skyline now marked by a tension not just between absence and presence, but also between memory and loss, between motion and stasis, and between the spectral and the spectacular.

LANDSCAPE

In his essay 'Scapeland', Jean-François Lyotard suggests that landscape is an excess of presence that leads to an experience of estrangement – what he calls '*dépaysement*' (Lyotard 1988: 39). Despite the debatable claim that estrangement is a precondition for landscape, Lyotard's words perfectly capture the dynamic at work in Lifescape's earthwork monument. It *is* an excess of presence carefully designed to create an experience of wonder and unease – a site of the urban uncanny aimed at the ultimate source of the urban sublime. Remembering the appearance of the Twin Towers in their original location in Lower Manhattan, the architectural historian Mark Wigley describes them as 'a pure, uninhabited image floating above the city, an image forever above the horizon, in some kind of sublime excess, defying our capacity to understand it' (Wigley 2002: 82). This image of the towers as a hovering, otherworldly excess of presence that invites yet resists interpretation is precisely what the earthwork monument seeks to revive. From their new location on Staten Island, and in their new imaginary state, the undead towers will continue to function as New York's most powerful and conflicted symbols of globalization.

8 Global Beijing

'The World' is a violent place

Stephanie Hemelryk Donald

A world where . . . transit points and temporary abodes are proliferating under luxurious or inhuman conditions (hotel chains and squats, holiday clubs and refugee camps, shantytowns threatened with demolition or doomed to festering longevity). A world thus surrendered to solitary individuality, to the fleeting, the temporary and ephemeral, offers the anthropologist (film-maker) (and others) a new object, whose unprecedented dimensions might usefully be measured before we start wondering what sort of gaze might be amenable.

(Augé 1995: 78)

NEW CHINA

In late March 2007 a number of migrant workers from Sichuan were trapped in the works of a new underground train link at Suzhou Qiao station in the university district of Beijing. Several were injured and six were killed. Neither the company nor the metropolitan government was forthcoming on the incident at first, but news was leaked via the other workers' mobile phones, and three days later some commentators in the Chinese press were calling for permanent memorials to workers who have died in the construction of new Beijing. The additional underground train link was of course part of the enormous efforts to construct a 'new Olympics new Beijing' for 2008.

The men who died were all domestic migrants who had come to Beijing from less affluent provinces in search of work. They included Zhou Yongqian and Zhou Jie, an uncle and nephew. Their names are remarkable only in that they are known at all. But, they were, for a short while at least, media ciphers for the numerous rural migrants and laid-off workers from large state enterprises who are building new 'new China' for the next generation, although not it seems for themselves. In the following discussion, Zhou and Zhou's personal tragedies are merged with the fiction of characters in Jia Zhangke's 2006 film *The World*, in order to comment on place, space, and violence. This is not because the two men do not, of themselves, matter, but because the way in which they have been named in the press renders their names symbolic of the many others injured or killed through the working conditions of the

Reform economy. Augé's (1995) notion of 'non-place' captures these dangerous interstices of development. It collapses the clean and the dirty, the planned and the unplanned. His version of hyper-modernity is to an extent resonant of a Baudelairean vision of modern urban space (for Baudelaire the old and new sit together whilst he, the poet, looks on at the cityscape that thus presents itself to his view, whereas for Augé it is the grandiose and the unwashed that must go side by side and there is no point of view).

In China, of course, the collaboration between old and new is not part of the project for modernization. The old is razed or reduced to ignominy, unless it has some significance as a national or culturally valuable monument. Furthermore, the rate of growth of cities is such that there is no 'old' to be compromised in many of the sprawling new developments and concreted rural suburbs (Chu 2004). There is, as Augé describes, grand and transitory non-place, because there are airports, malls, theme parks, and hotels. There is also dirty non-place, and 'inhuman conditions'; the space of the poor in the interstices of the rich hotels and the kitchens of the elite clubs and apartment blocks, the non-place that operates like the wings and dock of a theatre, where the performers hover, waiting for their little spotlight of service to the rich.

And, of the filmmakers currently active in China, it is Jia Zhangke who most skilfully captures the profound losses visited on so many provincial workers in the city. In this chapter I discuss his film *The World*, where the idea of non-place is very useful, but it is worth mentioning that his oeuvre includes several other films where the transitory and the non-specific similarly define the lives of the working poor.

VIOLENT SPACE

My aim here is to situate violence as inherent in the construction of new modern spaces in an accelerated globalization programme such as that under way in China. I do not mean symbolic violence – and I note concerns from some contemporary philosophers on that issue – but actual violence resulting in loss of livelihood, freedom of employment, or indeed life itself. The discussion reconsiders the spatial logic of modernization, and its repercussions upon the articulation of class, within the post-Maoist, Reform economy situation that pertains to the PRC. Space in China is both a controlled entity and an imagined arena through which culture and politics are maintained, defended, or depressed. It has defining overlaps with political power and sovereignty, and with the techniques and topographies of patriotism and ideology. Such overlaps make the non-places of the powerless important, but also vulnerable and, ironically, under-policed and safeguarded.

The classed experiences of urban China as the Reform era progresses are therefore extreme. Whilst the Party-State aspires to creating a harmonious society of a middling class (made possible by those who have entrepreneurial skills and led by the elites with political capital) (Bian 1997; Guo 2008), the

infrastructure of the new economy relies on the deprivation of welfare rights, a split between rich, richer than before, and poor (Donald and Zheng 2008), and the suppression of protest (Solinger 2006). Class is both obvious in terms of social layering, and yet only vaguely accepted as a political category in everyday parlance. There is academic and governmental debate on the notion of a middle market (*zhongchan jieji*) or well-off (*xiaokang*) normative groupings, but these categories are deracinated from the aspirations and disappointments of most Chinese workers. The imperative in governance is to strengthen national cohesiveness and to manage the differential experience of modernization through the discourse of 'harmonious society'. Whilst being richer than before is acceptable to this discursive parameter, the absolute exclusion of poverty is not. A class-based analysis is therefore inherently contradictory, given that the class descriptors available through governmental and official media discourse are determined to obscure problematic class-creating conditions and structures.

Class in Chinese society may nonetheless be noted and analysed through the spatial thematics of visibility, authenticity, and place. To do so, I draw particularly on three comparative premises, all from outside Chinese Studies. First, Marc Augé's theory of non-place, which I reinterpret from the perspective of the déclassés and displaced in contemporary China, and their limited access to 'places that matter'. In his thesis of globalization and non-place Augé writes of 'luxurious or inhuman' conditions (Augé 1995: 78), a bland environment in which the grand and the squalid are contrasting versions of the same phenomenon, and where the key indication of modernity is the displaced person wandering in ephemeral blankness. In China, this anti-poetic vision is the starting point in understanding non-place, although it is not sufficient to its description. Arguably, in so far as place is occupied often by those who have little choice in the matter (the workers in big hotels, the long-term occupants of refugee camps and barrios), no place is 'non-place', in that occupation renders it human and therefore a place to be respected on that account. This is the anthropological counter to Augé's framing. Nonetheless, as I have argued elsewhere (Donald 2008), there are some places that are 'no place at all' for certain groups of people, as the spatial imagination, which builds and maintains the structures of modern progress, discounts these people as true occupants and beneficiaries. The violence of 'no-place at all' resides in and emerges through that assumption of invisibility. The theory of non-place is used therefore not to confirm the invisibility of human occupation, nor to fall into the trap of seeking and overestimating authenticity where none exists, but to argue that the concept of non-place is a valuable tool in identifying how humanity is declassed and delivered into violence.

CLASSED SPACE

Classing space according to its accessibility, and its scale of ephemerality, is one way to manage our understanding of how and where violence is factored

Figure 8.1 The Suzhou Qiao underground train station, Beijing, 2007 (courtesy Phototime, photographer Wu Xinhua).

into normal spatial relations. In large Chinese towns, the hotel chains, the theme parks, and the 'luxury home' developments are visibly accessed and aspired to by those who are richer than before (*bi qian fu*). In the extremes of wealth, the rich are mobile and cosmopolitan and able to take the world on board as a cosmopolitan experience (Szerszynski and Urry 2006). These facilities are built, staffed, cleaned, and maintained by those who are not wealthy or ever likely to be so. The night and early-morning economies of maintenance, here as in all global cities, produce the silent occupancy of people who 'do not matter' in places that are created for those who 'do'. Between, underneath, and behind the glossy shop-fronts of Reform economics there are the other places, 'transitory abodes', where the poor live or through which they must pass in service to the logic of capital and growth. These are also categorically non-place. They have no permanency, no rights of abode attached to them, and are created with no consideration of continuing cultural or social meaning. These are the asbestos-walled dormitories where many migrant workers live, the sordid rooms where women in massage parlours find themselves subjected to casual male assault, the building sites where men swap tobacco and stories, and the back gate and filthy front steps to the Beijing train station where people flood out from the inter-provincial routes laden with baggage and goods to sell in impromptu markets. The quintessential scene of violence is of a migrant worker standing by a canal in Beijing watching as a policeman heaves his unlicensed goods, and thereby his savings, into the water. The violence of non-place begins with the precariousness of mobility without means (Butler 2004).

Place is nonetheless where the anthropological relation happens, and non-place therefore must be acknowledged as 'site' for an anthropology of deracinated and decontextualized human relations. Non-place is space traversed, occupied but not inhabited in the domestic and intimate sense of place (or home). Non-place is not truly homogeneous, but nor is it expected

to accumulate the traces of particular histories and memories which would make it specific. Thus the task of building a spatially experienced relationship between time, the times, and culture seems both impossible and irrelevant. Of course, people still try. It might appear that the urge to make China's cities correspond entirely to one another is a harmonious political convenience, neatly evacuated of the complexities of everyday human relations. But those relations persist, which is why the Zhou family's tragedy was as much about class as about building regulations, and why Jia's films about the migrant condition make such emotional sense (Zang 2006).

THE WORLD IS A VIOLENT PLACE

In Jia Zhangke's film *The World* (*Shijie*, 世界, China, 2006) migrants from the Shanxi (a large northwestern province) are working in a Beijing theme park called 'The World', which boasts replicas of international landmarks and stages shows loosely based on international culture. The theme park is the epitome of non-place in that its spatial contours consist of miniaturized, decontextualized, and non-specific cultural referents. The Taj Mahal is a few metres from the Tower of London, and the Eiffel Tower is also close by. The obvious amusement factor for an international audience at these geographic liberties is dispelled by the pride with which workers at the complex introduce its wonders to their friends and relatives from their home province. Through Jia Zhangke's cinematic eye, we are trained to respect those whose lives are curtailed by the contingencies of their origins, education, and quality (*suzhi*), and thus to see and mourn the banal and major violence visited upon their daily lives.

The World's plot concentrates on an engaged couple, both working in the amusement park, she (Xiaotao) as a performer and he (Taisheng) as a security guard. These jobs are a poor substitute to their ambitions when they first came to the metropolis several years earlier, an issue that is rapidly dissolving the romantic and aspirational basis of their relationship. The film opens with the disturbance of an ex-boyfriend stopping by on his way overseas in order to say goodbye to Xiaotao. She is clearly moved by his visit, and her wistful response to his departure acknowledges the disjuncture between her precarious existence in 'non-place' and his privileged adventure to somewhere else, a place that matters. She performs in the evening show of the imagined 'World' he is travelling to study. *The World* thus intimates the beginnings of class difference, with education and travel being core aspects of the hierarchy of non-place in and beyond the global metropolis.

Xiaotao's boyfriend, Taisheng, is also moved but for different reasons. Having followed Xiaotao to Beijing, he is now aware that he has very little of material value to offer her in their still unconsummated relationship. In the first few scenes of the film the contrast between the couple's need for intimate fulfilment and the places they occupy is made starkly apparent. The railway station, the shared dormitory of the security guards and other male staff, the

bus on the ring road taking the workers back to the theme park, where icons of the outside world play on the screen loop of the bus's AV system, and the dressing room in the park's theatre are the locations in which their emotional lives are played out. As their lives unravel across the space of the film's narrative, these non-places become more threatening: the corridor to an underground bar where rich men assault young hostesses, a ladies' powder room where Russian and Chinese working women vomit out their disgust at having performed fellatio for money to send home to their children, and, finally, the sides of a coal heap where the young couple are asphyxiated by gas fumes.

The non-places in *The World* are mainly of the interstitial variety. Jia sees little point, it seems, in reminding his audiences of the upscale department stores in which the fruits of China's Reform success are spent. His vision helps us to distinguish between the different genres of non-place and the different degrees of temporariness that they might induce. Arguably it is those differences that produce and maintain class privilege. The presumed inhabitant of the hotel lobby is also the owner of an apartment, the carrier of an international passport (perhaps), and he certainly has some access to privacy. The inhabitant of the interstitial non-place may have no access to anything much – a train ride home might cost up to four months' wages (always assuming the wages have been paid at all) and the privacy afforded in such places is meagre. Most crucially, the non-place is dangerous, sometimes lethal.

Figure 8.2 Publicity still for *The World*, Xiaotao in the corridor (courtesy X Stream Pictures).

Jia's great contribution as a filmmaker is his ability to craft cinematic space as non-place. Whilst the choices of locations in themselves make up an extended montage of the concept and experience of the 'fleeting, the temporal, and the ephemeral', so do certain shots nail the point home at moments of extreme narrative tension. When a young worker dies in a dank hospital room after an industrial accident, grief is conveyed by a protracted shot of his elder relative crouching distraught and guilty in the corridor outside. The context for his tragedy is loneliness, and being nowhere in particular. The random placing of human experience in places where there is no familiar or familial security is both accurate and effective in describing the depths of their vulnerability.

SOCIAL IMAGINARY

> The Revolution's social vision of unanimity, predicated on the notion of an indivisible people, should be taken seriously on its own terms because it had important cultural implications. In the shorter term it probably contributed to the Republic's political instability – just as they could not conceive of a loyal opposition in politics, the actors of the French Revolution found it difficult to countenance the coexistence of legitimately competing social interests ... hence social difference was demonised as political treason, usually under the guise of the all purpose 'aristocrats'.
>
> (Maza 2002: 122)

My second premise for analysing the violence inherent in the accelerated development in China's cities is taken from French historical studies. I refer to Sarah Maza's persuasive essay on the revolutionary vision of the Third Estate as 'the people' in France. Maza argues that historical research suggests that the French middle class was not a hegemonic factor in the Third Estate, except in retrospective accounts written by the bourgeoisie themselves, and subsequently repeated by modern historians. I do not presume that this exact condition applies to China – in some ways it is quite the opposite – but note that Maza's determination to read class off against recorded contemporary attitudes as well as against an actual or retrospective strategy of class leadership is a useful corrective to the impulse to make class fit a convenient global model. Her arguments help us, for instance, to comprehend the Chinese government's key strategy of launching the idea of a harmonious society (*hexie shehui*) as an achieved goal. In other words, harmonious society is both declared as the aim of policy development but is also assumed to be already the condition of the Chinese state and people. Harmonization operates as a rhetorical description of class change in China, which yet immediately and retrospectively elides and occludes the problems of the underclass, the shifting value of working-class political capital, and the rise of the new rich elites. Chinese social relations and the non-places that support class relations are

not accidental phenomena, but the discourse of harmonization renders them invisible, and thus allows the violence visited upon the poor to continue.

The men who died in the underground tunnel, for instance, are now forgotten in Beijing, where, at the time of writing this chapter, popular and mainstream media, as well as the blogging and Sina-YouTube communities are concerned only with the national perception of Western bias and conspiracy against the Chinese Olympics and Chinese development in the post-torch and Tibet debacles of early 2008. At this point, the Western media, and particularly CNN, became the cause of all threats to social unity and to developmental success. Again, the political and populist trend to make problems invisible, or to treat them as caused exclusively by forces external to China, allows the daily violence of urban and migrant poverty to continue unabated in non-place.

> We should always remember what Chairman Mao told us, the foreign capitalists will never stint in their efforts to destroy us. 2008 was supposed to be a great year for China – the Olympics would allow us to shine, our development and economy would accelerate, all would be well. Instead, having endured the snow of the terrible winter of 2007 . . . We are now faced with the farce of the Western cabal.
> ('China Stand Up' 2008)

Reading Maza reminds us, then, to tread warily in the fields of contemporary class relations on the one hand and *national–social* relations on the other (above all in not assuming that one is the other) in China. The quotation above is from a strongly worded, nationalistic, and angry web video put up on China's YouTube after the Paris and London demonstrations against the Olympic Flame (in April 2008). The video response encapsulates the views of many Chinese when the worst happens (there are of course contradictory and measured responses which are not so prominently discussed in media on all sides of the debate). The Sina-YouTube text goes on to accuse foreign investors of having caused the rise in Chinese food prices and of supporting China's economy only to take it over. That foreign interests are iniquitous and anti-China is not an unusual belief amongst Chinese mainstream society, yet the same people know, too, that social suffering is caused by the class relations which privilege bosses over workers, and the urban rich over the rural poor. Both perspectives need to be taken seriously on their own terms, recognizing that they compete for hegemony in the discursive and interpretive field of Chinese modern space.

Despite known inequalities of modernization, nevertheless, the governmental category of *hexie shehui* serves to promote one normalized 'all-purpose' non-class – which incorporates both the well-to-do and the aspirational working middle, rather as the French bourgeoisie are credited in retrospect with the Revolution, and the category of aristocrats were cited at the time as the root and destination of all ills. The aristocrats of China

are the new rich, but the pilloried sector only includes those who are perceived to be in cahoots with Western capital, and of course Western capitalists themselves. China's harmonization 'should be taken seriously', as it has real cultural implications given the level of support it receives through policy decisions in Beijing. Conversely, it is hard to accept governmental analyses of the social structure given the obvious inconsistencies with so many people's lives.

In less heated times than early 2008, the citizen journalism of the Chinese people is not limited to nationalist logic and vitriol. Debates on the internet, as well as in contemporary independent film, openly report sour relations between urban and migrant workers. In these sources, social distinction is felt to be a powerful social force, and one supported by discriminatory codes and practices in urban governance. I quote just a few comments from an online discussion board in 2001:

> [In reference to the abuse of the permit system by city authorities] What does normal (*hen zhengchang*) mean? Does it mean: this is how it should be, or is it, there are too many cases of this type of wrongdoing out there, therefore it's normal?
>
> An urban pregnant woman told a rural pregnant woman: when my child is born s/he will be of a higher grade than yours. This is only a story but it reflects the absurdity of social reality. The cause of this is all in that one bit of paper the residency permit (*hukou*).
> (Blog site; reference withheld for ethical reasons)

VIOLENCE AS NORMAL

Third, I refer to the historian Dror Wahrmann's (1995, 2004) work on the language of class-based moral ascendancy in mercantile England. Wahrmann's analysis makes a profound contribution to comprehending the pernicious impact of the notion of social quality and migrant populations in Chinese cities today. Wahrmann argues that middle-class virtue has often been accorded normative legitimacy to the extent that to be middle class is to be virtuous or, at least, respectable. Likewise, 'middle class-ness' (if not a class indicator, then certainly a term of social approbation and allowable aspiration) in China operates as a Latourian absence in the political and social realm. It is the space that is normalized by its own success, and therefore, in a supposedly post-Marxist class-free society, the only possible vanishing point of aspiration and normative power. Indeed, it offers a safe discursive haven for the new rich as well as those who are simply richer than before, indicating the social embarrassment and personal fears (given the uneven history of class conflict and the emphasis on harmony in Chinese society and politics) of the global class now emerging from accretions of personal, domestic wealth. The extremes in wealth and poverty, and the violence of the relationship

between the two, are usefully obscured through an ideal of harmonious, virtuous middle-class-ness.

In this context, Wahrman's essays bring to mind the thoughts of Siegfried Kracauer in the Weimar period of German modernization. Kracauer was astute in his observations of the acculturation of a salaried class being managed in ways that kept them spiritually and physically fit, but which yet avoided, or aimed to avoid, over-politicization. Of course, in that case, the Nazification of German politics showed the failings of that attempt at virtue without ideology. As David Frisby comments on Kracauer, from 1915 he is 'preoccupied with the consequences of the growth of a material civilization emptied of meaning and the increasingly problematic individual whose inner core or essence remains either lost or unfulfilled' (Frisby 1985: 111).

The Chinese working poor, the rich and professional, and almost rich middle classes are not the salaried masses of Kracauer's era. Nevertheless, their collective relation to the state, well exemplified in early 2008, is both patriotic and demanding, both volatile and docile. The press response to the subway accident in Beijing, once news had leaked out through mobile phones, was very much that of a virtuous middle class, trying in retrospect to make amends to the people killed building their city. In the proposed construction of a monument for the people for whom Beijing is a sequence of non-places where their lives and deaths are unmarked in time or space, there would indeed have been some fixing of place, and a sense in which spatial patterns were acknowledging the structures of violence underpinning the city's development. The monument has not, as far as I am aware, been commissioned or executed.

In the empirical aspects of this research into class emergence, I have held interviews and extended discussions with several high-income individuals and families. Their common denominator, apart from level of income (over 80,000–400,000 yuan per annum), is that they enjoy a great deal of personal and educational mobility. Moreover, they are secure in terms of regional identity and status (possessing intellectual or commercial 'gold collar' credentials, combined with a place-based 'local' status and visibility). Most, if not all, will happily admit to being 'of the middle', but none volunteered themselves as very rich. In a survey currently under way in Shanghai and Chengdu (a comfortable city in Sichuan), preliminary results suggest that the professional classes deliberately describe themselves as of the middle income, but not as middle class. Nevertheless, those in the group that did have significant global levels of personal wealth, made it clear that they lived where they did (in gated developments outside the city) because they wished to be with people like themselves, and they wanted to build a long-term community of interest, based on education, environmental benefits, and personal comfort. Mr Pei (a fifty-something developer, who used to work in the equivalent of the Civil Service), commented that one advantage of living in his particular gated community was that he could stick to people of his own social, economic, and, increasingly, *cultural*, standing. Pei is sure that

his class of people, which for him are people of *quality*, are both what China needs and the kind of people with whom one enjoys an everyday association.

Another respondent couple in Chengdu, Mr Liu, a tycoon on the Top 500 list, and his wife, a mature student of philosophy, agree. When we met Liu, a man in his mid-to-late forties, Chengdu local, and vice-CEO of the New Hope Group, he was just back from a board meeting in Hawaii that very afternoon; he was sharp, with barely suppressed energy. Both the Lius were well-educated, and they have a four-year-old son. In our conversation the Lius were quite clear: their choice of Luxehill was based on concern for family security, longing for nature and peaceful environment, and the need to be within a community of like-minded and like-means people. They quoted the age-old Chinese proverb 'Things group according to species and people gather in kind'. They therefore made the decision to purchase while the complex was still being built, and trusted the developer's vision and ability to deliver at first sight. Like Pei, Liu thinks that people of his kind are still small in number, but are growing, and so are their taste structures, as demonstrated in the growing popularity of residences like the Luxehill project where they currently live.

These conversations with, it must be said, highly articulate, thoughtful, and urbane people, indicate that class is happening, and that it is, as always, a process of inclusion and exclusion based on economic and cultural indicators. Meanwhile, the conversations and analyses of other scholars show the many sides of the social prism. Tani Barlow's (2005) commentary on the pornographic city (wherein to read gutter or yellow literature is seen as lacking in class, but also tainting the class of one's relatives – thus revealing class as an indicator of personal and familial quality) gives an insight into the conventions which enforce the links between migrant dispossession, low cultural capital, and the discourse of 'quality' in urban life.

The various perspectives and theoretical frames which I have referred to in this short chapter allow us to view the men in the subway building project as already subject to multiple forms of social violence, which attaches exactly to physical harm. First, they are discursively placed as without quality; their taste is presumed to be pornographic, and their home towns are necessarily poor, dirty, and without promise. The future of China is defined by those with the economic power to have an influence on that future, as the rise of people who are *not* like them. As the rich move away from the filth of city pollution and create their own places that matter in developments outside town, the poor are relegated to whatever is left over. Their children are systematically distanced from the opportunities of education and play. Second, the places they inhabit are the non-places of modernity – but both like the transit points defined by Augé (1992), and unlike the non-places which define the glittering infrastructure of development, these migrant spaces form the interstices of globalization: the train tunnels which collapse below the silvered architecture towering above them, the discoloured eating and sleeping quarters behind the

five-star hotels, and the demountable dormitories a few hundred metres away from the Olympic venues.

Third, for the men in the tunnel and the characters in Jia's films, violence is literally the price paid for the rush to prosperity. Work safety regimes and equipment inspection requirements are inadequate, and the need to rest and thus maintain safe levels of competence in the workplace is ignored in the context of poor pay and infrequent pay periods. In *The World*, an engaging and hopeful young migrant, Little Sister (so-called because his mother wanted a girl), wonders aloud at the uniform that his cousin is wearing, asking if he had to pay for it himself. Taisheng avoids answering his question by asking another one. The actual answer is, yes, of course: the migrant worker pays for everything, as though paying for the audacity of having arrived in the city at all. *The World* thus brilliantly encapsulates the fantasy and fragility of mobile lives. As Little Sister wonders at the scale of international experience in miniature, he inadvertently articulates his relative remoteness from the benefits and power of modernization in the actual world, which he has come to build for China's future. The workers in the amusement park are in a virtual and paradoxical loop of aspiration – between one place (Shanxi) and another ('The World' outside Beijing), but never in places that really matter. The interstitial world of migrant Beijing uses the rhetoric of global class and global cities to offer illusions of mobility, spatial transcendence, or the liberations of travel. The people we meet ride through these fantasies, but are in actuality bound to trajectories of violence and fantasy.

Figure 8.3 Still from *The World*, on the building site (courtesy X Stream Pictures).

CONCLUSION

The story of the Zhous' deaths in the subway site collapse resonates because of their ubiquity in migrant experience. In Jia's film, made before the subway collapse but referring to many, many other deaths and injuries on construction sites around Beijing, the victim is Little Sister, who dies, exhausted, on an overnight shift. The men he has travelled with, and Taisheng himself, are all related to each other and the loss of the precious younger cousin is a huge blow. They are especially ashamed in front of Little Sister's parents, who arrive to collect a paltry compensation, and are furious with themselves and with the situation which allowed him to work late, long hours without safety measures. The film's narrative structure is such that all other relationships and certainties finally crumble from this section of the film, making the wider point that vulnerability to tragedy can at any moment crack apart the aspirational dream of development. In Beijing in 2007, Zhou and Zhou both died. Others were injured, and, if no longer able to work due to injuries sustained, they will have been deported back to their home towns, with little, if any, compensation for the loss of livelihood. These are the stories that Jia maps onto the urban landscapes and global ambitions of Beijing, giving an anthropological depth to the dirty non-places of declassed workers in China's harmonious society.

Part III
Spectacle

9 The poetics of scale in urban photography

Shirley Jordan

To experience a city is to contemplate scale. Photography, which 'fiddle[s] with the scale of the world' (Sontag 1979: 4), is a natural companion to such contemplations and city photography is especially self-conscious in its fiddling. It pits the individual against a backdrop of the sprawl, the massive, and the mass; it responds to the city's invitations to innovation in perspective and method; it records the ways in which urban environments threaten violence to intimate experiences of human scale. City photography speaks to the general problem of negotiating space, and to the specific problem of negotiating a space for dwelling. It is with good reason that Dominique Baqué appends to the title of her recent essay on photography of the postmodern city a question mark: 'Pour un lieu où vivre?' ('Towards a Dwelling Place?') (Baqué 2004). Baqué thus suggests that recent urban photography interrogates city space in such a way as to problematize both the conditions and the very possibility of dwelling.

This chapter concerns the challenges to photographic representation set by experiences of city space. It analyses the poetics of scale that are in evidence in a number of recent experiments. It suggests that urban photography is subject to a dual impulse: on the one hand, photographers are involved in conquering scale and making it intelligible; on the other, the city's spatial excess – its height, sprawl, openness, congestion – remains a subject of fascination, even awe. My purpose is to consider the place of the individual in postmodern urban landscapes through analysis of images which display the city's extremes of architectural scale, and/or which study and produce disorientation. The violence with which I am concerned is not that of bloodshed or riots. It is rather violence as material condition; the kind of pervasive violence that cities have always engendered, but are perhaps now engendering differently.

We shall examine, then, some representational strategies of a medium which has evolved contemporaneously with, and at least partially in response to, the urban environment. Our focus will not be on any particular city, but on the overarching, generic context of the urban. In a recent essay on the history of the city in photography, Graham Clarke predicts that 'every city will begin, as far as the photograph is concerned, to look the same. Every image will be untitled: the postmodern city will not so much be a place as a

condition; and to capture that condition will be the challenge for the camera' (Clarke 1997: 98). This idea of the photographer's intent to get at something generic about the city as condition and process is one of the areas we shall examine. Images which dwarf human subjects, which are emptied of them, or which confound any sense of their being 'in place' will be of interest to us, as will the dialectic between the originating viewer (the photographer, whose implied presence has always lent human scale to images) and those who encounter the finished photograph. We will see that there are some interesting paradigm shifts at work in the way that photographers have recently been getting a purchase on the overwhelming nature of the city.

In an essay entitled 'Cognitive Mapping the Dispersed City' (2006) Stephen Cairns draws, *inter alia*, on Marc Augé's over-cited yet still useful idea of *non-lieux* ('non-places') (1995), and on Dutch architect Rem Koolhaas' notion of quality-less urban magma, or 'junkspace' (2002). Both raise the generalized problem of orientation, of the seemingly impossible task of arriving at conceptual maps or representations that are adequate to the spatial and experiential excesses of postmodern cities on the move. Such concerns are useful to this enquiry into photography not simply for their attempts to describe the often dislocating experience of being in cityspace, but also because they suggest that we dwell not just in concrete spaces, but in the metaphors and representations that we create to imagine them.

One trope we shall revisit is the enduring one of the Baudelairean *flâneur*, analysed by Walter Benjamin (1955, 1982) and intensively used since to make sense of the modern city (see Tester 1994). What is the current relationship between city photography and *flânerie*? This question is addressed in the latest volume of Régis Durand's protracted enquiry into photographic experience (Durand 2006). Concerned to elaborate an anthropology of the making and uses of the photograph, and to explore ontology rather than aesthetics, Durand begins the volume with a section entitled 'Parcours' ('Journeys'), the essays of which investigate the photographer's encounters with globalizing cities. Durand considers what place remains for *flânerie* in the new urban landscapes, and more especially for the photographer as *flâneur*. He asks three questions: Does the trope of the *flâneur* remain pertinent in attempting to give accounts of mutating urban space? Do new city structures and spaces – and the representations of them – preclude this familiar way of experiencing cities? Can the gaze of the *flâneur*, formerly 'archéologique et critique' ('archaeological and critical') (Durand 2006: 30), now produce anything other than a nostalgia tinged with irony? I will revisit some of these questions as I consider the various postures my chosen photographers adopt vis-à-vis the city. I will also relate some of my material to the theme of Durand's third volume: that of photographic 'excess'. Obsessive ocular experiments, which puncture our idea of the real and do violence to any simple idea of representation, are a staple of today's photographic language. Many of the photographs explored here express a will to excess which is highly appropriate to the postmodern city.

It will emerge that the mapping of cityspace in the various photographic projects I analyse shares several features: a dual concern with the architectural and the experiential; a keenness to capture what customarily escapes the gaze; fascination with man-altered landscapes; an emphasis on dwarfing; and a suggestive exclusion of 'home' space. I argue that what is at stake in urban photography's highly self-conscious poetics of scale is a shared understanding of 'human scale' and of the violence done to it in the emerging cityscapes of the global era. My corpus involves strong contrasts. The first focus comprises a range of digitally enhanced photographs which 'invent' city reality and toy with scale-induced anxiety. Here, the influential work of Andreas Gursky is the foremost example. The second focus explores photography which is more documentary in mode and more obviously attentive to human scale and dwelling. The principal example here is Denis Darzacq's photographs of the French *banlieue* (2004–6). The final focus concerns the city as spectacle for the global tourist and analyses Raymond Depardon's project *Villes/Cities/Städte* (2007).

URBAN ENVISIONING: EPIC, MONUMENTAL, AND UNCANNY

One question for city photographers since the urban panorama of the late eighteenth century has been how to 'get it all in'; how to reduce the staggering multiplicity of stimuli to a single image. The expression of scale with which I begin is that elaborated in experimental photography produced since the early 1990s which is preoccupied with architectural excess. Recently the focus of a major exhibition entitled *Spectacular City* (Netherlands Architecture Institute, 2006–7), images by Andreas Gursky, Naoya Hatakeyama, Frank van der Salm, and others draw out in often surprising ways the city's contours: ways which both capture a sense of the city and violate any comfortable notion of the individual's position within it. They are concerned with what Koolhaas calls quite simply 'Bigness' (Koolhaas et al. 1994), with the overpoweringly large-scale architecture we create. Typical subjects include skyscrapers, industrial sites, and teeming spaces of work, commerce, or leisure such as factories, stock exchanges, hypermarkets, and vast hotels. These images are usually taken from high-angle perspectives and deploy both photographic and digital techniques to achieve monumentality. The technical features of Gursky's work in particular are consistent with the ambitious envisioning of city planners. Characteristically wide-angle and of immense proportions, they rely on large-format cameras, computer manipulation, and time-lapse merges to produce a hyperreal sharpness of image and an experiential saturation which are deeply disorientating. What are the common features which make all his photographs – whether of the interior of the Shanghai Grand Hotel (2000), the façade of Montparnasse apartment blocks (1993), a 99-Cent hypermarket (1999), or the Chicago Board of Trade (1999) – so disturbingly overwhelming?

First, the space of these images is utterly congested; they are examples of

the 'all-over' photograph. Second, it is very difficult to trace them back to a single embodied gaze and hence to locate ourselves with regard to them. The originating eye which habitually supplies viewers with a point of contact and orientation is deliberately neutralized: these photographs are devoid of any suggestion of point of view, their lack of comprehensible perspective seeming to affirm that the camera need no longer simulate human vision. Gursky's signature viewing stance is from a platform high above and distant from his chosen sites, and the epic mapping he undertakes, often from 'impossible photographic angles' (Jacobs 2006: 15), incorporates much more than the eye can see at a glance. One might be forgiven for thinking that these 'omniscient' images stem from some sophisticated surveillance system. So the city, always fertile in the vantage points it has offered photographers, now gives rise to something different: 'the emphasis ... is on photography as a way of seeing beyond the limitations of individual perspective, a way of mapping the extent of the forces, invisible from a single human standpoint, that govern the man-made ... world' (Jacobs 2006: 17). In technical terms, we are also struck by an amazing visual clarity and precision (achieved thanks to large-format cameras), a pristine surface perfection, and an extraordinary sense of totality. Prodigiously rich in visual information, these photographs aspire to a definitive, complete expression of a given scene, often achieved by digitally suturing several exposures together. The size too – as much as 2m high and 5m wide – is daunting. Gursky, then, is not documenting but constructing composite images, a hi-tech development entirely consistent with the hi-tech development of the city itself and in tune with the ambition of its architects.

I have already mentioned the problem of point of view: these images are not only devoid of point of view in a literal (physical) sense, but also in a figurative sense. They share an aesthetic which became popular in photographs of the 1990s and which Charlotte Cotton refers to as 'deadpan' (Cotton 2004: 84). In other words, they remain detached and emotionally illegible, and since there is nothing to lead us back to the photographer (no emotion or subjectivity) there is no sense of being guided through the image by his intentions. The mode is almost clinical and, I would argue, exclusionary. The combination of scale, technical manipulation, and lack of identifiable point of view means that the machinery of these images repels and disorientates the viewer. They have commanding presence, but we do not have a place in them. Where photography has traditionally tended to position us in such a way that it asks us to interpret the individual human experience of a place or event, Gursky places us so far away from his subjects that we cannot imagine being part of the action at all. The images are quite simply impenetrable.

Let us take one example. How does Gursky's picture of the Bundestag in Bonn (1998) work? This digitally enhanced large-scale spatial puzzle complicates our sense of depth and time, each component or scene having been set up by a separate 'take', then pieced together. Our experience of the image is fragmented, its subject unclear. Are we to focus on the imposing structure of the building with its grid pattern and its glass, or on the intense

activity of the elites inside? Closer inspection reveals further disjuncture between different scenes, some seeming to have been taken at night, some during the day. The temporal distance separating each shot results in a compound image of the activity of this institution over a twenty-four-hour period. Photography's familiar single-moment time scale is shattered in order to create a visual synthesis of the workings of political authority that this building incarnates.

As in other images where Gursky includes human figures, his technique produces a beehive effect: individuals are miniaturized and densely packed in a mass. They are reduced to function, their individuality erased in favour of the group. Gursky's eye is that of the fascinated entomologist: his studies of mass gatherings – either popular or work-based – all raise the question of loss of human scale. His elaborate compositions are poised between something painterly – even lyrical – and something more scientific and critical-edged that expresses an awed concern about the metropolis, its overbearing topography and its major centres of power. What Gursky gives us, argues Cotton, is 'a mapping of contemporary life governed by forces that are not possible to see from a position within the crowd' (Cotton 2004: 84). His images buffet us provocatively in their positioning of us between implied omniscience/omnipotence, and dwarfing. Ben Lewis's 2002 documentary on Gursky's envisioning, *Gursky World*, suggests that his experiments with urban scale have taught us to conceptualize – perhaps even to see – space differently: that Gursky's 'lens' permits a new understanding of the ambivalent position the individual occupies in the city mass. This revolution in (the technologies of) vision represents a distinct moment in urban thinking, as striking as nineteenth-century 'discoveries' of the crowd, as aesthetically overwhelming as Sergei Eisenstein's politically motivated cinematic metaphors for social forces, and immensely attractive to photographers of urban life.

Brazilian photographer Dionisio González uses similar techniques for more direct social critique. His large-scale panoramic *Santo Amaro III* of 2006 (1.5m high by 3.8m wide) displays a Gurskian concern to render the density of urban experience. Using digital tools, he collages together in seamless incoherence images of constructions from the *favelas* of São Paulo, Brazil, inserting in addition smooth and pristine sections of modern architectural design. Both the exaggerated density of habitation and the juxtaposition of refined materials (smoked glass, sculpted concrete, beautiful wood) with the crude corrugated iron, breeze block and peeling paintwork of *favela* homes, offer comment on the inadequacies of the government-devised re-urbanization scheme 'Proyecto Cingapura', intended to improve living conditions in the *favelas* but failing to maintain its buildings and to see through its ambitious promises. González deliberately contrasts spatial order as imagined/abstracted by urban planners with a non-systematic, experiential structure 'reflect[ing] the spatial order that already exists in these neighbourhoods, one that is chaotic and in flux' (Irvine 2008: 2). Like Gursky's works, such pictures defy any idea of *flânerie*: their congestion is such that they are

shown as one immense block, melded together, and literally impenetrable by the outside 'spectator'.

Uncanny visual disruptions serving as comments on the ways in which emerging cityscapes dislocate our sense of place are thus establishing a new international photographic vocabulary. Photographs from Dan Holdsworth's ironically named *A Machine for Living* project (1999) focus on liminal and transitional non-spaces such as car parks and deserted shopping areas, using night-time as the optimum condition to describe their strangeness and raising, like Gursky, questions of agency: given the implied angle of shot, who or what took these images? Japanese photographer Naoya Hatakeyama produces images which emphasize the unnavigable layout of Japanese cities and enjoys producing urban illusions. For instance, his monumental images of a stadium under construction (*Untitled/Osaka Diptych*, 1998–2000) constitute a Gursky-like play between the massive and the miniature, the life-sized and the model, while the photographs displayed in an exhibition entitled *Scales* (Canadian Center for Architecture, September 2007–February 2008) take as their subject matter elaborate scale models of New York and Tokyo. These hyperrealist trompe-l'oeil images almost pass for photographs of the original cities, but not quite. Their unreal feel requires a double-take, and in that double-take Hatakeyama leads us to consider a number of factors: that photographs are already models and as such they always miniaturize; that experiences of radical shifts in scale (we might call this 'scale-shock') are increasingly part of the global condition; that the spaces in which we live and work are modelled for us and, to a large extent, that they program what we do. Robin Collyer's *Temperance Street* (1993), another uncanny urban disruption, involves an imagining of the cityscape without signs. This image, a computer-modified take on a street in Canada, generates unease by a total absence of advertising, writing, or signs of any kind. Collyer thus defies common-sense knowledge of the city as a process of signs – a process represented in iconic, sign-saturated city images such as Berenice Abbott's *Columbus Circle* (1933) or Joel Meyerowitz's *Broadway and West 46th Street, New York* (1976). Disappearing all this information makes the city illegible and serves to underline the habitual density of the programming of our activity within urban landscapes. As French photographer Valérie Jouve remarks, it is photography's own propensity to manipulation and control that makes it 'the instrument most adapted to the urban machinery' (Jouve 2002: 4).

The spaces produced by numerous contemporary photographers, then, return us to the second of Durand's questions about *flânerie*: do such strangely structured cityscapes simply preclude this familiar way of experiencing the city? How can we penetrate, relate to, or know spaces (and images of spaces) turned so paralysingly unnavigable? To sustain concepts of the photographer as *flâneur* is to sustain the traditional perception of photographs: a) as records; b) as records of a single instant; c) as records from a single point of view; and d) as records unambiguously located at street level and at walking pace. Digital interventions in the field of photography short-circuit all these

touchstones radically. As Jonathan Lipkin comments, many contemporary photographers now operate more like still-life artists than like street photographers: 'instead of wandering the streets like a hunter tracking prey, they can venture out into the world, collect the picture elements they like, and piece them together in the dimroom, just as a still life artist would collect objects to assemble later in the studio' (Lipkin 2005: 93–6). For Lipkin, *flânerie*'s emphasis on the sudden capturing of decisive moments has given way to a compelling but slightly frightening emphasis in photography on 'the technological sublime' (Lipkin 2005: 73). Photography now *imagines* urban scenes, deploying hi-tech resources to induce and to reflect technology-inspired awe. In the face of this overwhelming onslaught, suggests Lipkin, 'our most pressing concern . . . is how to assert our humanity' (Lipkin 2005: 73).

UP-CLOSE AND INTERSTITIAL: DOCUMENTING PERIPHERIES

This section of my argument operates a shift in scale and perspective. It focuses on recent series of photographs which 'assert humanity', which espouse a documentary aesthetic, which have direct anthropological appeal, and which explore urban alienation at first-hand – not through digitally enhanced envisioning of uncanny totalities, but through intimate, interstitial fragments. For instance, small-scale constructions associated with human stories are represented in Margaret Moreton's (2000) photographs of the 'fragile dwellings' of New York's homeless. Moreton photographs unspectacular structures, quietly cobbled together from city debris and waste, set against bridges and highway ramps, and approximating to concepts of 'home'. Here, architecture and images alike are unique and unrepeatable, quiet rather than spectacular, tightly focused rather than panoramic. The black-and-white photographs are indexical, emphasizing texture and lived experience, situating photographer and viewer within the dynamic of the image and proposing engagement rather than detachment. There is, however, one common feature this project shares with the monumental photographs studied thus far: like them, it alludes to invisible commanding forces that threaten dwelling. Significantly, these tiny shelters were bulldozed not long after being photographed.

Construction and destruction, dwelling and fragility, are implicated too in the recent photography of Denis Darzacq, which reveals a special fascination for what happens to bodies in urban space. The remainder of this section will focus on two of Darzacq's photo projects: *Bobigny* (2004) and *La Chute* (*The Fall*) (2006). Both are based in the troubled outer-city zones (the *banlieue*) around Paris. Following in the traces of François Maspero's and Anaïk Frantz's *Roissy-Express* (1990), a written and photographic record of a journey through Paris's little-explored outer-city areas, Darzacq sets out to 'recuperate' the *banlieue* as more, and other, than the reductive images peddled through sensationalizing news reports, notably after the spate of *banlieue* riots in 2005. The co-created phototext *Bobigny Centre Ville* (Desplechin and

Darzacq 2006) shows its authors taking a different stance from Maspero: not 'passing through' but becoming ethnographically rooted in the area, piecing together its fabric and history, getting to know its multicultural inhabitants. As the work's title suggests, its insider perspective operates a reversal between centre and periphery, immersing us in the *banlieue* as 'centre' so that the hegemonic view of it as 'outside' sustained by Parisians from the privileged intra-muros 'ghetto' loses some of its valence.

A concern for human scale is at the heart of Darzacq's periphery photographs. Those studied here fall into several categories, each a discrete exercise in commenting on urban dwelling. *Bobigny* groups together four types: community scenes, large-scale architectural photographs, small-scale studies of doorways, and dead-pan street portraiture. Exhibited in separate sections of the book, these create between them a visual dialogue. If the first group explores the possibility of spaces of conviviality and fraternization, these appear fragile even as they are foregrounded. Their tenuousness is confirmed by a subsequent group of strangely quiet architectural studies, emptied of human presence the better to interrogate both the physical vernacular of Bobigny and the fitness of its late 1950s constructions to accommodate. There are no interior shots: the emphasis is not on how people may (or may not) be transforming private dwelling space through individual initiative, but on what it is that was planned for them. A distinctive round tower block shot from a high angle; the (coldly industrial) metal chutes of playground slides; the smaller-scale residential cubes: all still speak of Bobigny's original project for ideal dwelling. Indeed, the uncannily simplified replica blocks in the latter images resemble architect's models, reminding us of Hatakeyama's play on scale. Several images partake of the generalized vocabulary of tower-block photography, a favoured urban subject in terms of experimentation with scale. They echo Gilbert Fastenaeken's understated studies of ordinary architectural ugliness in his *Côte Belge* project (2002) or, in the case of one congested all-over image, Gursky's hallucinatory geometry. In this instance, the powerful vertical and horizontal lines saturating the photograph's frame box the gigantic living space into a near abstraction of homogeneity. The Bobigny 'concept' and the formal reality of its existence thus converge.

The impact of Darzacq's decision to exhibit his photographs as discrete image categories is especially remarkable in the case of the multiple photographs of doorways, which progressively become iconic. As Desplechin comments: 'because they play a social role, because they are spectacular, the entrance points of these residences have become symbols of the constructions' ruin' (Desplechin and Darzacq 2006: 81). Each door replicates the same tensions, scaling down the architecture to human proportion, bearing witness to unattainable coherence, carrying traces of daily routines, of time and body rhythm, which mark the urban surface. Each also emanates a strange sense of expectancy and menace. This group of images seems to offer a psychological as much as a physical mapping of Bobigny, asking us to keep in mind the intentions of the original design, the human stories this

architecture has generated, and the transformations of the place over time. The doorway photographs reveal Bobigny's structures to be strangely poised on the cusp between habitation and ruin. They seem to confirm, as Baqué suggests with reference to Anthony Hernandez's photographs of Rome's run-down periphery (*City Point: Pictures for Rome*, 1998–9) that the only architecture contemporary man is capable of producing is the ruin: not in the sense of a vestige of a great past, but 'architecture already in ruins, already useless, already scrap' (Baqué 2004: 160).

The sixteen strongly differentiated portraits of young Balbyniens which appear at the end of this book – significantly, not anonymous but of named people – speak powerfully of individuality and are qualitatively very different from the images of *banlieue* youth circulated in the media. Separating studies of human figures from studies of the built environment in this way, and ending with an affirmative, future-oriented portrait gallery which evokes the possibilities of a *République métissée* ('a racially diverse Republic') is an analytic gesture which militates against unthinking assimilation of the Parisian periphery into one dysfunctional 'pot'. Critically, what Darzacq's immersive study of *banlieue* dwelling space goes some way towards achieving is testimony not only to the physical and social fractures of outer-city living spaces, but to the possibility of suture and repair effected by the implied resilience of its inhabitants.

Such resilience is still more strikingly held in tension with precariousness in *La Chute* (Darzacq 2007), a series of photographs of bodies in midair, apparently weightless, caught in metaphorically fertile suspension as they perform Capoeira or Breakdance. Each image shows one young man in free fall against an austere, deserted urban backdrop of functionalist buildings. The small athletic bodies are harmoniously splayed or disconcertingly contorted, suspended a foot or two above the street. Perspective, scale, time, and gravity are thrown into question by these unsettling studies: are the bodies in levitation or plummeting to their destruction? Are they human beings or soft, tiny puppets? Are we to focus on their buoyant creativity or on the hostile surrounding which negates it, dwarfs them, and throws them off balance? The question of what bodies make of/in urban space is a key focus for today's photographer/*flâneur* (see the work of Valérie Jouve, Erwin Wurm, or Francis Alÿs). The dancing bodies in *La Chute* would not make sense in anything but this unyielding context: they are urban bodies, momentarily appropriating space, and the violently balletic images made of them constitute an astonishing abstraction of the individual's tenuous dwelling in the overwhelming scale of the city.

VILLES/CITIES/STÄDTE: DEPARDON'S URBAN SKIMMING

It is Raymond Depardon who, returning us to more familiar instances of bodily movement as creative urban gesture, provides my final example of photography's recent engagements with city scale. Depardon's *Villes/Cities/*

Städte (2007) is one of a number of postmodern urban walking experiments by artists/photographers aptly referred to in a recent study as '*piétons planétaires*' ('planetary pedestrians') (Davila 2002: 44). It is a project which seems to test the prediction by Clarke, cited in my introduction, that cities in photography will appear interchangeable, that images of them will be untitled and that 'the postmodern city will not so much be a place as a condition' (Clarke 1997: 98). What is the nature of Depardon's work and what does it tell us of this condition?

The physical appearance of his exhibition catalogue, based on a clever conceit, tells us something about this. Designed as a well-travelled piece of luggage, stamped with strips of fluorescent tape bearing key information about its destinations, it presents itself as proof (and trophy) of global exploration. As the spaces of urban transit scrawled on its cover make clear, this project eschews the model of intensive single-city studies which have been a staple of photography. Plural and more dizzyingly international than its three-language title implies, it offers a glut of 278 photographs of twelve cities: New York, Paris, Tokyo, Shanghai, Rio de Janeiro, Moscow, Cairo, Johannesburg, Dubai, Buenos Aires, Berlin, Addis Ababa. Depardon's method was to spend three days on the streets of each, recording his impressions, then to slip away, the brevity of visit being explained by his desire to document his first impressions in unspoiled form. As well as photographs, a five-minute film is made on – or perhaps one should just say *in* – each city. These were exhibited alongside the still images in Paris (2004), then in Berlin (2007), but it is the photographs alone that are of interest here.

In many ways these are typical of Depardon's earlier work: the documentary drive; the sense of immediacy; the interest in capturing daily life and in photographing incognito. Such continuities aside, what distinguishes this as a city project? I shall suggest a number of features: Depardon's response to scale; his obsession with movement, speed, and transition; his foregrounding of the figure of the photographer; the way in which this involves an ironic reworking of *flânerie*; and the possibility that he opens for reading the position of the photographer as metaphorical, as signifying something beyond itself in terms of a comment on alienation in the global city. Depardon is, then, extremely self-conscious about the figure of the urban photographer. His short preface of January 2007 is emphatic about the tropes by which we are to understand not the cities he visits, but the cognitive and practical approach he adopts to come to grips with them. His key models are of the photographer as thief (his preface is entitled 'The Picture Thief') and as tourist, figures which, associated respectively with reprehensibly self-interested detachment, and with consumer activity and amateurism, seem divorced from the implications of critical interrogative edge inherent in previous models of *flânerie*. An emphasis on deciphering signs is supplanted by an emphasis on accumulation.

Depardon affirms his pleasure in briefly negotiating cityscapes, in succumbing to scale, and becoming the anonymous 'man of the Crowd',

imagining that 'For a few hours, a few days, I was an inhabitant, a special kind of local' (Depardon 2007: 2). Speed was the essence of his work: keeping up with the urban flow in its different categories – workers, the unemployed, students, passengers – as well as snapping on the move: 'I had', he says, 'to constantly *not* look as I photographed, smiled and disappeared' (Depardon 2007: 2) – a curious affirmation for a photographer. On the one hand 'never satisfied, always needing to go further', he also records how 'I would sometimes stop in a cafe or go back to the hotel . . . to wind down from the sounds of the street that had invaded me since early morning' (Depardon 2007: 2). Saturated and defeated by each city after a mere two days, Depardon loses the *flâneur*'s characteristic *disponibilité* ('openness') and retreats to quiet spaces: 'On the last day . . . I would often go for hours without taking photographs or filming, not only because of the fatigue from so much walking, but the city had overtaken me' (Depardon 2007: 2). He is overtaken too by memories of ambitions for a more politically influential photography: 'I was a kid . . . secretly hoping to change the world simply by reporting on it' (Depardon 2007: 2). Then, too, he was 'always on the move' but his current project marks a change in cityscapes, in the photographer, and in the relationship between them: 'Modern labyrinths, these cities were photographed in color, something that was new and unusual for me. No more stylistic white and gray, we are now in an existential present – maybe ultimately harsher – in which sidewalks and pedestrians, streams and bridges, seasides and harbors, rain and sun are starting to look the same on every continent' (Depardon 2007: 2). Depardon thus implicitly acknowledges Koolhaas' 'Generic City' (Koolhaas et al. 1994) and Durand's 'universal city which contaminates all space' (Durand 2006: 28–9).

What of the photographs themselves? The typology of subject matter and its treatment feel familiar, as if Depardon were less concerned with fresh interrogation of cityspace than with replication. Already clichés, these framings imply that we see urban environments through pre-formed prisms. Each city is photographed in the same way, so the images cannot be read as responses to its individuality; in addition – a feature that has more impact than it may at first appear – all the photographs are untitled. This produces a levelling and presents a single, broad subject: urban magma. A generic poetic of urban scale is reproduced as Depardon takes the measure of self and of anonymous protagonists against various backdrops. Image categories include studies in vertical monumentality (the cities' architectural statements, taken from high or low angles), planes of horizontality and sprawl and, more rarely, open horizons. Depardon veers between these images of the large scale, and briefly reflective close-ups of human-scale detail which recall us to the interstices of everyday urban flux (the cabby's hand on the steering wheel, a drink on a table, a decorative ventilation grid). The micro-histories and texture of individual lives are fleetingly alluded to, including in a series of 'stolen' street portraits which exemplify the kind of intrusive, 'soft murder' detected by Susan Sontag (Sontag 1979: 15). There are other categories of

city photograph: an occasional epiphany (the hieratic stance of a couple dancing on an otherwise empty Shanghai plaza), or something especially vernacular (a congested corner of junk in a Buenos Aires shop).

The main idioms the photographer propounds here are of flow and proliferation. His images emphasize movement on buses, underground trains, and pavements. Depardon is voluntarily caught up in the crowd, the blurry quality of certain images testifying to his position. Snapping on the move is, in fact, the signature theme of *Villes/Cities/Städte*, embodied not least by several photographs manifestly taken from taxis, hence endowed with a double frame (that of camera and of car window) and alluding to a speeded-up, discontinuous version of urban wandering. Through a further image category, that of beautiful young women whisking by, Depardon alludes to Baudelaire's yearning poem *A une passante* in so heavy-handed a fashion that it seems not only ironic but self-parodic. He remarks, 'I have, on occasion, surreptitiously come across the beautiful face of a woman, then another', and alludes to associated reveries of 'living in that city and finding happiness with that woman' (Depardon 2007: 2). This succession of *passantes* further testifies to the photographer's detached relationship to city matter. In short, Depardon's project evokes the third of Durand's questions about *flânerie*: Can the gaze of today's *flâneur* produce anything beyond an ironic nostalgia?

Clarke's statement on the city less as place than as condition ends: 'to capture that condition will be the challenge for the camera' (Clarke 1997: 98). The aspect of that condition emphasized by Depardon is not about dwelling in cities, but about what it means to consume cityspace. *Villes/Cities/Städte* seems to market the whistlestop tour as it offers up the shrinking world of global cities in a handily compact €38 format. There is an uncomfortable condensation as we pass practically without hiatus from the first and smallest port of call, Addis Ababa, through to the last and largest, Tokyo, and between them to Rio, Berlin, Dubai, and so forth. The conceit of the book is not only that it looks like a suitcase, but that it is mimetic of the abruptness of travel, and of the paradoxical foreclosure of knowledge resulting from travel's speed. This project thus raises an aspect of scale that is less to do with the physical dimensions of individual cityscapes than with the conceptual dimension of what it means to think between them. It does so at the expense of the cities photographed, perhaps doing violence to the integrity of place and people, for if one photograph equals another equals another, then it scarcely matters where we are.

Depardon's project maps well onto Marc Augé's observations on types of excess, the first two of which include, as Cairns paraphrases: 'an excess of events that simultaneously multiplies and flattens meaning effects' and 'an excess of space associated with radical changes in scale in which enhanced capacities of transport and communication technologies simultaneously interconnect and shrink larger global territories' (Cairns 2006: 200). Multiplicity, flattening, and shrinkage are all in evidence here: the saturation illustrated by Depardon – saturation of space, experience, stimulus, systems of information,

systems of movement – has a paradoxical effect, for in spite of our apparent capacity to span, absorb, move, and discover as never before, our world seems to be running out of the new experiences on which records of travel are predicated.

A final note on *Villes/Cities/Städte*: like Gursky, with whom I began, Depardon confirms that the contemporary quest for telling urban subject matter records the bewilderment *of* scale, and is international *in* scale. His images express a tension between sameness – the creeping homogenization of global cities – and a photographer's hunger to define the timbre of a particular place. There is, however, no answer here to Clarke's affirmation that ' "new" kinds of cities' (he mentions Bombay, Calcutta, Beijing, Shanghai, Hong Kong, and Tokyo) 'demand new kinds of images and a new approach by the photographer' (Clarke 1997: 99). In the end, Depardon's project underlines the violence that is done to any meaningful sense of being 'in place', not only by the rampant expansion and ever-metamorphizing scale of urban environments, but paradoxically by the facility with which the economically able – those who can express their identity through adherence to an international lifestyle – skim between cityscapes as an integral part of their broader patterns of consumption. Rather than *flânerie*, a new trope – that of 'urban skimming' – might be posited here, for a project whose images express a brief, superficial relationship to the city as speed. Key photographs include the following: a man crossing a road, his face blanked out by the windscreen wiper of the taxi from which the photographer shoots (the felicitous irony of the image is not lost on Depardon); and a shot that looks up into the sky, away from the cityscape, to the key facilitator of urban skimming – an aeroplane.

The corpus briefly analysed in this chapter gives some indication of how, with film-based or digital methods, photographers are currently manipulating and negotiating city scale in order to convey the anxieties associated with urban dwelling. They comment on what cities we are making, and on what cities make, violently, of us.

10 Globalization and cultural capital

Symbolic violence in recent filmic images of Paris

Ruth Cruickshank

Paris has long enjoyed a privileged place in the filmic imaginary. However, recent televisual images of violence in the Parisian suburbs create a dichotomous contrast with more than a century of cinematic clichés representing the cradle of cinema as city of light, lovers, and culture. Examining three recent internationally acclaimed French and French-co-produced features – Mathieu Kassovitz's *La Haine/Hate* (1995), Jean-Pierre Jeunet's *Le Fabuleux Destin d'Amélie Poulain/Amélie* (2001), and Michael Haneke's *Caché/Hidden* (2005) – this discussion adds a new perspective to the analysis of representations of Paris. It addresses the relationship between deliberate and unwitting representations of spatial and symbolic exclusion, and between the internalized experience of the city and France's involvement in an earlier phase of globalization: colonialism.

The distance – physical, economic, and cultural – between periphery and centre differentiates Paris from other global cities. In cities such as Paris's filmic Other, Los Angeles, poverty and exclusion are concentrated at the centre, the downtown, whilst wealth and privilege migrate to the peripheries. In Paris, however, the equivalent of the ghettoes – the *banlieues* – are beyond the city limits. Here blocks of social housing, *Habitations à Loyer Modéré* or HLM, were built in the 1950s and 1960s often with little thought to communications, services, or aesthetics, and a significant number were built on the sites of *bidonvilles*, the shantytowns inhabited by post-war colonial and postcolonial immigrants. Demonstrating the economic and cultural stasis endemic in these peripheral zones, many inhabitants of the *banlieues* are once-colonized subjects, their children, or grandchildren. With successive waves of immigration and the economic crises of the 1980s and 1990s these areas have become more and more racially segregated and dogged by unemployment and crime. Layers of economic and symbolic prejudice from the era of colonialism and from subsequent phases of globalization are sedimented and enduringly generated.

Life in the *banlieues* is not only determined by governmental policy (economic and social; colonial and postcolonial). It is also a question of cultural mobility, symbolically driven by lived experience and by images. As Mustafa Dikeç describes in his 2007 study of French urban policy, by the

1990s the term '*banlieue*' 'no longer serves merely as a geographical reference or an administrative concept, but stands for alterity, insecurity, and deprivation' (Dikeç 2007: 7–8). Alec Hargreaves emphasizes the role of the media in shaping turn-of-the-millennium images of the *banlieues* whereby:

> [a] term that at once served to simply denote peripheral parts of urban areas has become a synonym of alterity, deviance, and disadvantage. The mass media have played a central role in this reconstruction, in the course of which they have disseminated and reinforced stereotypical ideas of people of immigrant origin as fundamentally menacing to the established order.
>
> (Hargreaves 1996: 607)

If riots and car burning in the *banlieues* suggest that inhabitants do not passively accept their marginalization, these behaviours nevertheless bespeak a self-perpetuating performance of these media stereotypes. Indeed, as French sociologist Pierre Bourdieu would argue (Bourdieu and Passeron 1977; Bourdieu 1984), both television coverage of unrest in the *banlieues* and silver screen mythologies are eloquent expressions of the symbolic violence inherent in the differential distribution of cultural capital.

Bourdieu describes symbolic violence as the imposition of categories of thought upon dominated social subjects who then internalize these unthought structures and so are co-implicated in perpetuating them. Symbolic violence is, therefore, pervasively insidious because it imposes the idea of the legitimacy of the dominant order and embeds it in the lives and thoughts at once of those who are excluded from, and those who enjoy, cultural capital. Bourdieu identifies economic capital as command over economic resources, and social capital as resources based on group membership, relationships, and networks of influence and support. Cultural capital comprises forms of knowledge and skill: the advantages that give higher status in society. Bourdieu focuses on education to exemplify it, arguing that working-class children see the educational success of their middle-class peers – cultural capital that is often the fruit of class-based inequality – as legitimate, and often innate. Indeed all forms of cultural production influence the acquisition of knowledge and skills, and so simultaneously generate differential cultural capital and are vehicles for symbolic violence. In the era of globalized mass communication, then, the audiovisual media have particularly potent differentiating potential.

The following discussion of filmic representations of the physical and internalized experiences of Paris draws upon Bourdieu's insights alongside Foucault's (1977) figuring of the Panopticon as a mode of maintaining power relations through auto-surveillance; Michel de Certeau's (1984) description of the city as oppressive script and the potential of everyday activities to poach on the urban text; and Gilles Deleuze and Félix Guattari's (1987) deterritorializing *lines of flight* that may escape the coercive reterritorializing forces of late capitalism. Whilst this thought of the 1970s and 1980s offers

perspectives from which to consider recent cinematic representations of the urban experience, whether deliberately or not, the three films analysed here offer new insights into the spatial and symbolic experiences of turn-of-the-millennium Paris and its *banlieues*.

The perceived threat of globalization in France is stridently articulated in critiques (typically anti-American) of neoliberalism and the cultural neo-imperialism of multinational corporations and the mass media. If neoliberalism is held to be against the French Republican universalist ethos, that rhetoric of solidarity and inclusion sometimes occludes economic and cultural exclusion within France. Cinema was invented in France and, whilst it was one of the first globalized industries and is a worldwide vehicle of cultural capital, it is also a vehicle of French exceptionalism (a nexus of identity narratives in which literature, thought, and film play constitutive roles alongside protectionist economic, isolationist foreign, and purportedly universalist domestic politics). French cinema's conflictual relationship with the disproportionate dominance of Hollywood dates back to the eve of the First World War, when Hollywood overtook Paris as the industry's centre. Yet both Hollywood and French cinema contribute to the cultural capital of France and Paris through mythologizing images of romance, fashion, and intellectual and aesthetic elitism. What is more, cinematic representations also contribute (sometimes by elision) to the perpetuating of an uneven distribution of cultural capital between Paris and province and between Paris and its *banlieues*. So, whilst filmic images of Paris contribute to the city's value on the global market, at home they also contribute to symbolically violent discourses and mechanisms of exclusion.

Both intentionally and unwittingly *La Haine*, *Amélie*, and *Caché* all invite questions of the differential distribution of cultural capital and of the potential of cinema to represent, challenge, or perpetuate these patterns. Each evokes relationships between centre and peripheries, and between physical and symbolic violence, whilst affording insights into the way in which these tensions are internalized. With differing degrees of self-reflexivity these contrasting films also reveal how cultural capital is linked not only to globalization in the postcolonial moment, but also to the colonial phase of globalization which predates, but enduringly affects the experience – spatial and symbolic – of Paris and its *banlieues*.

Of the three films, Mathieu Kassovitz's 1995 black-and-white feature *La Haine* is most obviously concerned with those who live in the *banlieue* and with their relationship with the centre of Paris. The film follows a day in the life of three young *banlieusards*. Vinz is Jewish, Saïd's background is North African, and Hubert's sub-Saharan African, so they embody different waves of immigration and also point to the enduring effects of France's colonial past in the present. The *banlieue* where *La Haine* is filmed is beleaguered by poverty, unemployment, and rioting, ostensibly against police brutality, but also against physical and cultural exclusion. The film opens on television footage of rioting, which is then linked to the fatal injuries sustained by

banlieusard Abdel at the hands of the police. The following 'morning after' sequences give a picture of the lives of the three unemployed youths and the internalized effects on their community of prejudice and of economic and cultural stasis.

In these scenes critics have identified examples of what de Certeau describes as the tactic of poaching on the city script of oppressive power, or of the tracing of migratory routes figured by Deleuze and Guattari as *lines of flight* which may disrupt the flows of late capitalism (see Fielder 2001). However, potentially deterritorializing activities, such as the appropriation of a rooftop as a social space and the practising of impressively athletic dance moves in a gloomy basement, are reterritorialized, curtailed by the forces of order and by the physical and mental constraints of life in the *banlieue*. If in one sequence a disc jockey's multicultural mix floods the *cité*, he remains symbolically incarcerated in the frame of a window that looks across the concrete to the panoptic blocks that encircle his impromptu audience. Meanwhile, in performances of co-implication, physical violence underscores the internalized process of symbolic violence. The gym would-be boxer Hubert has worked to establish is destroyed in the rioting, as are the rare cars owned by inhabitants.

The narrative goes on to explore the relationship between periphery and centre when later in the day Vinz, Hubert, and Saïd travel into central Paris. Their compromised mobility (physical and cultural) is emphasized by the fact that the three have to travel by train (the Métro does not serve the *banlieue*). On the journey into Paris, Vinz reveals that he is carrying the police gun found during the previous night's riots. The weapon operates as a metaphor for symbolic violence as Vinz takes on the oppressive tools of the forces of order, only for the gun to be used in accordance with media images and police expectations of *banlieusards*. Possession of the gun leads inexorably to the physically violent end of this 'day in the life' of symbolic violence. When the three return to the *cité* in the early morning, Vinz is interpellated by the police and is shot dead. With a policeman in the sights of the weapon he had earlier confiscated from Vinz, Hubert then also fulfils the stereotype of the irreparably dangerous and self-destructive *banlieusard* despite his articulated desire to escape and his recurrent attempts to avert the physical violence associated with the *banlieue*.

Ten years later, Michael Haneke's 2005 French co-production *Caché* also explores a binary of centre and periphery, and of excluding and the excluded. Although ostensibly there seems to be little shift in the uneven distribution of cultural capital figured in *La Haine*, Haneke particularly foregrounds links between the symbolic violence of colonialism and that of Paris in the post-colonial moment. Indeed the film appears to seek to destabilize dichotomous representations of difference, and overtly links the exclusion of the present with France's colonial past and the role of cultural production in generating and sedimenting cultural differentiation. Georges, a television book show presenter, and his literary agent wife, Anna, live in unspoken marital discord

with their son, Pierrot, in a privileged enclave of the thirteenth *arrondissement*. Georges receives a series of videotapes of the exterior of his home. This panoptic CCTV-style footage is accompanied by crude drawings of blood pouring out of a child's mouth and out of a decapitated cockerel. After then receiving a video that features a grim low-rise HLM block beyond the city limits, Georges sets off in his car to follow the trail. This leads him to a now middle-aged Algerian, Majid. Flashbacks reveal that, at the age of six, Georges reported that Majid was coughing up blood and then induced him to hack the head off a cock in order to prevent his parents from adopting the six-year-old orphaned by the October 1961 Métro Charonne riot-police massacre of at least two hundred peacefully demonstrating Algerians.

Georges shows no contrition when Majid confronts him with the excluding effects of his mendacious childhood behaviour. A few days later when Pierrot goes missing, Georges gets Majid and his son arrested, but the two are released, and Pierrot's absence is accounted for benignly. The disruptive packages continue to violate Georges's home and his workspace, and he goes back to Majid's apartment, whereupon the latter commits suicide by slitting his throat. This forces Georges to tell Anna about the lies that led a boy already orphaned by the violence of colonialism to be denied the cultural capital of an education. Anna does not comfort Georges, but Majid's son penetrates the central Paris television station to confront the presenter about the effects of his acts of exclusion. Georges returns to his book-laden home, now a prisoner to the ramifications of the symbolic violence he perpetrated more than forty years earlier, and also, perhaps, to the weight of that which he continues to produce in the present.

Jeunet's 2001 worldwide hit *Le Fabuleux Destin d'Amélie Poulain* (henceforth *Amélie*) needs little introduction. Like *La Haine* and *Caché*, the film features journeys between Paris and the suburbs. However, this rose-tinted view of the French capital elides the inequitable relationships between centre and periphery, and the influence of the colonial past in the postcolonial present. Amélie was born in a suburb, but the kind with detached houses and gardens. She travels there via clean, spacious stations where commuters are white. Despite earning a barmaid's salary, Amélie lives in an idiosyncratically but opulently decorated apartment in Montmartre – a Montmartre where there is no ethnic diversity, save for the North African grocer's assistant, Lucien, troublingly represented as having learning difficulties. In this ethnically and physically whitewashed *quartier* (graffiti was painstakingly removed from walls for filming) Amélie has the cultural and economic mobility to get up to philanthropic and self-realizing activities. These culminate in her happy ending as she rides pillion on her love interest's scooter, at an immeasurable symbolic distance from *La Haine*.

In *Caché* Georges travels by car, though whether alone, with Anna, or Pierrot, the luxury vehicle is a space of unspoken conflict. Meanwhile Georges's unprovoked altercation with a young black man on a bicycle underpins not only their differential cultural capital but also Georges's

internalized (post)colonial superiority and the effects of generations of media stereotyping. The only mobility viewers see of Majid is when Georges has accused him and his son of kidnapping Pierrot, and they are filmed through the wire-meshed partition of a police van whilst Georges sits in the front. Spatial difference and its symbolic effects are also evoked by names. *La Haine* was filmed on location in Chanteloup-les-Vignes in an HLM called the *cité des Muguets*. However, the lived experience of the place clashes grimly with these bucolic names evoking vineyards and lilies of the valley. Majid's flat is on the Avenue Lénine in an HLM reminiscent of brutalist Soviet architecture. The secluded street where Georges, Anna, and Pierrot live has a commensurately attractive name: *Rue des Lilas*. Meanwhile Majid and his nameless son's home is described as beyond the *Mairie des Lilas*, the end of Métro line eleven (so beyond the city limits marked by the Porte des Lilas, a place where lilacs do not flourish, and gates of opportunity do not open). Thus names underscore the role of the symbolic in geographical exclusion.

Physical images of incarceration also underpin differential cultural capital. If Amélie first appears behind her tasteful iron bedstead, it is clear from the warm lighting of her apartment and her fluid trajectory between her childhood home and Montmartre that this will not prove a real barrier. By contrast, motifs of imprisonment underpin the symbolic violence of *La Haine*. The camera foregrounds the carceral verticals and horizontals and panoptic circles of the *cité des Muguets*, framing both the physical and mental constraints experienced by its inhabitants. Later, whilst their economic exclusion from central Paris is underpinned by the fact Vinz, Hubert, and Saïd have no money, the physical violence their symbolic status attracts is figured by attacks from both policemen and skinheads. Indeed, by the same token that physical space constrains them in the *cité*, the protagonists' experience of the centre of Paris is one of being kept outside, literally and figuratively. Interior spaces are difficult to penetrate or alienating and dramatize the symbolic exclusion of *banlieusards* within the city. When the three young men infiltrate a private viewing at a modern art gallery, the power of the bourgeois Parisians to gauge and inflect cultural capital is underpinned. In spite of the critical potential in the wry humour of the mocking assessments of the artworks made by Vinz, Hubert, and Saïd, internalizing the symbolically violent judgement of this inner Parisian circle, the three anticipate their rejection predicated on excluding distinctions of taste.

Vinz, Hubert, and Saïd also accurately anticipate the difficulty they have gaining entry to the apartment of a wealthy criminal contact. Vinz is chosen to speak into a video entry system because he is white, but the camera grotesquely distorts his performance of politeness. Later, marooned when they miss the last train out to the *banlieue*, and because none of them knows how to drive the car they try to steal, Vinz, Hubert, and Saïd wait in a deserted station. Here their lack of cultural and economic mobility and the futility of their attempts to penetrate the centre of Paris are reflected in their impotence within one of the alienating *any-space-whatsoever* of late

capitalism described by Deleuze and Guattari (1987). Thus interior spaces provide the stage upon which the internalized operation of symbolic violence is performed.

In *Caché* interior scenes predominate and suggest an implicit questioning of received cultural values. Whilst Georges and Anna's lives are enmeshed in high culture, the crude drawings and videos destabilize their living and mental space with the memory and repercussions of the symbolic violence perpetrated by Georges in the colonial past and ongoingly in the postcolonial present. Iron meshes, fences, grilles, bars, and serried ranks of plants spiking up outside the kitchen window invade shots of Georges and Anna's home. These figure the fear of the excluded Other and the cultural chains which keep Georges and Anna in their unhappy relationship, but the legacy of symbolic violence cannot be kept out.

Amélie's unproblematic relationship with interior (and exterior) space and the ostensible comfort but emotional dissonance of Georges's home contrast tellingly with the internalized experiences evoked by the living spaces of *La Haine*. Viewers meet Vinz as the camera pans round the tiny room where he is asleep, spread-eagled atop an uncomfortable-looking bed. The room, remarkable only by its outdated floral wallpaper, is strewn with Vinz's meagre possessions, which are testimony to his limited and self-limiting cultural capital. Hubert is seen in his identically dimensioned room, with similar wallpaper evident despite his own attempts to cover it, which also bespeak his equally limited and limiting cultural references: boxing and marijuana. The two extended families' cramped communal spaces serve multiple purposes, and the wallpaper that originally hung there remains, faded but with its paradoxically hopeful motifs still discernible. These interiors thus reflect the unrealized aspirations of immigrants who have been displaced from *bidonville* to *banlieue*, and those of subsequent generations, still unable to accrue cultural capital.

In *Caché* Majid's sparse flat is decorated in a strikingly similar anachronistic way, until he slits his throat and the discoloured floral wallpaper is stained with blood, graphically demonstrating how the symbolic violence of the past remains at the heart of that of the present. This is a far cry from *Amélie*, where interiors reflect a winsome character and pre-empt the uplifting diegesis. From the outset, the quirky bedroom decorated in rich colours and hung with art by Michael Sowa denotes the protagonist's cultural capital and projects how Amélie is going to move forward and get her guy. In this fantasy Paris, violence – symbolic and physical, colonial and postcolonial – is tellingly elided.

Contrasting scenes in that most intimate of interior spaces, the bathroom, offer further insights into cinematic reflections and inflections of symbolic violence. Soft-lit and surrounded by vintage flacons, Amélie's gaze in the mirror reflects back her potential, fulfilled by the end of the film. In *Caché*, tension reigns in the fashionably minimalist bathroom where Pierrot rejects Georges's offer to get an autograph from a favourite writer, bringing the

value of his cultural capital into question. Later Majid's son follows Georges into the television station bathroom to confront him, suggesting, perhaps, that the symbolically dominated may yet penetrate and destabilize the production of cultural capital. The unproblematized potential of *Amélie* and *Caché* contrast with *La Haine*. The stark surroundings of the bathroom are reflected in the mirror, unchanged since first decorated, save for a poster of a tropical beach, ironically denoting precisely the kind of cultural and economic mobility that is beyond the dreams of the inhabitants of the *banlieues*. Here, half-naked, and simultaneously aggressive and vulnerable, Vinz acts out in the mirror Travis's 'Are you lookin' at me?' gunpoint threat from *Taxi Driver* (1976), performing his confrontational response to his physical and symbolic experience, and underpinning his co-implication in the audiovisual stereotyping of the *banlieusard*.

With differing levels of self-reflexivity, Kassovitz, Jeunet, and Haneke also link interior spaces and internalized experiences with motifs of screens and with cinematic and televisual references. In both *La Haine* and *Caché* these are deployed to underpin imprisonment: mental and material. Kassovitz's protagonists avidly watch footage of the riots on a faulty portable television and have their faces distorted by the panoptic video entry screen. Later, stranded in the deserted station, they learn of Abdel's death on a quadrant of pixellated public information screens. Here, too, recalling the earlier reference to *Taxi Driver* and presaging the fatal shots at the end of the film, Vinz plays out a movie-inspired fantasy of killing policemen. Thus the physical violence endemic in the *cité* is recurrently linked to the symbolic violence of the audiovisual media.

In *Caché* the television screen brings the outside in. It is used to play the threatening videos, and when Pierrot's absence is discovered it shows a *Euronews* streaming of fighting in Gaza and American soldiers abusing prisoners in Iraq. These reports of global violence are ignored by the protagonists, but viewers' attention is drawn to the televisual images in the centre of the cinema screen. This underpins both protagonists' and viewers' co-implication in the repercussions of turning a blind eye to symbolic and physical violence, within France and beyond. The ethics of television production are also brought into question. From the perspective of the editing suite, viewers watch a take of Georges's literary talk show. Here the set is dressed with false shelves with false book spines, mirroring those that hem in the rooms of Georges's home, and suggesting that literature has been commodified into worthless units of cultural capital. In this 'film within a film' a critical work on Rimbaud is being savaged. In turn, the complexities of the discussion are cut, inviting the interpretation that editing and so, by extension, filmmaking – can operate as a mass-mediatized form of violence. Indeed here the implication is that both the audiovisual media and literature are symbolically violent and have the potential to negatively affect both the culturally dominant and dominated.

Jeunet does not exploit screens to similar critical potential in *Amélie*.

Indeed it is not without scopophilia that viewers watch a sympathetically lit, wide-eyed Amélie watching a romantic film in the cinema. The heroine falls asleep whilst watching a videotape of a horse breaking free to gallop along with racing cyclists, which on waking provides inspiration for her philanthropic activities and her own journey of self-realization. So, rather than bringing the role of the audiovisual media into question, or drawing attention to how the cinematographic pretence of bringing viewers inside in turn depends on the excluding functions of the frame, *Amélie* includes the viewer in the fantasy and keeps the excluded out.

So, deliberately and unintentionally, interiors, together with figures of incarceration and scenes of physical violence, reveal how successive layers of symbolic violence are internalized; how an endemic lack of cultural mobility is generated; and how media-generated stereotypes are serially fulfilled. To varying degrees, references to films, screens, and mirrors suggest a self-reflexive awareness of the role of cultural production, and the audiovisual media in particular, in producing, perpetuating, and perhaps challenging symbolic violence and the layers of colonial violence from an earlier stage of globalization that underlie and infiltrate it.

These insights into the effects of different phases of globalization in turn invite the question of the relationship between these films and the world beyond Paris and its *banlieues*. Jeunet's only reference to things global is via the snapshots of the garden gnome Amélie gets her air hostess friend to send to her father from world cities to incite him to revoke his hermetic life. This 'globognome' may raise a smile, but otherwise *Amélie* provides a further exceptionalist fillip to the mythology of Paris as cultural, romantic, and even philanthropic capital, whilst eliding the effects of France's colonial and postcolonial history – that is, apart from the representation of a North African retail assistant which shows, no doubt unintentionally, how ex-colonial subjects are enduringly treated as subaltern.

By contrast, Kassovitz and Haneke attempt to set their representations of the enduring impact of the colonial past on postcolonial Paris and its *banlieues* in a global context. *La Haine* opens with a satellite shot of the earth and a Molotov cocktail spinning down towards it. The planet motif is reprised three times on holiday club posters with the tagline 'Club Paradise: le Monde est à vous' ('Paradise Club: The World is All Yours'). The advertisement is in ironic juxtaposition with the lack of physical and cultural mobility of Vinz, Hubert, and Saïd. Turning their backs to the iconic cityscape from which they are physically and mentally excluded, Saïd spray-paints over 'à vous' on one billboard to read 'Le Monde est à nous' ('The World is All Ours'), then runs off. Whilst Saïd's provisional gesture of defiance invites interpretation as an example of de Certeau's notion of poaching on the oppressive city script, it is undercut by his flight. Moreover, whether defiled or not, the poster also underscores how Saïd and his companions lack the economic and cultural capital to live in the centre of Paris, let alone to travel beyond France or to participate in the economy of the global market.

In *Caché* Haneke also makes references to the world beyond France. Viewers learn that Anna is promoting a book on globalization, but the critical potential of any such work is undermined by the film's representations of the duplicity and pretentiousness of the literary sphere. However, when Pierrot disappears, the streaming television news reports successfully situate an individual drama of the ramifications of colonial and postcolonial symbolic and physical violence in a broader, implicitly neo-imperial global context.

Of course it would be a mistake to claim – or to expect – that films with more or less overtly critical stances have the agency to resist the forces of globalization, past or present. It is, however, legitimate to consider the extent to which these films may offer any critical leverage. The whitewashed Montmartre of *Amélie* boosts the equity of Paris on the tourist market, but in doing so further excludes the already marginalized. Whilst in its twenty-four-hour time frame *La Haine* reveals internalized mechanisms of exclusion in the *banlieues*, this unity of time leaves that situation unchanged, and the film's conclusion fulfils media-generated expectations. By contrast, the expertly shot videos of *Caché* – if made and sent by Majid's son – point both to the need to, and the potential for, the accruing of cultural capital by inhabitants of the *banlieues*. Indeed, despite his socio-economically connoted clothes, Majid's son introduces a hint of the possibility of shifts in cultural mobility when he penetrates George's glass-clad office block and disrupts the power relations of colonial patterns of pronoun usage. The final frame of the film, in which, without explanation, Majid's son is seen speaking to Pierrot on the steps of his school, implicitly invites the question of whether some inhabitants of the *banlieues* may be on the cusp of destabilizing inequitable distributions of cultural capital. Nonetheless, the leverage inferred here and in the aforementioned scenes is hypothetical and involves a threatening rather than a positive potential for penetration of exclusive and symbolically excluding spaces.

To what extent, then, do these examples of cinematic art risk producing imitation in reality? Jeunet's feel-good factor has created a new brand of French exceptionalism on the international market that underpins the exclusion of the inhabitants of the *banlieues*. Kassovitz has been criticized for a voyeuristic fascination with the plight of the marginalized, and by transposing the tropes of the American 'hood' film into a French idiom has contributed to the commodification of a new genre, the '*cinéma du banlieue*' or '*banlieue*-film', that adds a negative image of the *banlieues* to existing cinematic clichés of Paris (Powrie and Reader 2002; Jousse 1995). Haneke uses tropes from noir movies, but like Kassovitz and Jeunet risks perpetuating symbolically violent stereotypes that date back to French colonial rule.

Since in the last decade the most prevalent small-screen image of Paris is that of *banlieue* violence, these films risk further sedimenting at home and on an international stage the belief that the *banlieue* and its inhabitants are irretrievably (self-)destructive. Thus these three films at once contribute to the

construction of collective imaginaries and perform how, to quote Fredric Jameson, 'form is immanently and intrinsically an ideology in its own right' (Jameson and Miyashi 1998: 63). Moreover, albeit at times in spite of themselves, Kassovitz, Jeunet, and Haneke raise the question of viewers' co-implication in symbolic violence. Indeed, not only do *La Haine*, *Amélie*, and *Caché* contribute to solidifying excluding stereotypes of the *banlieues*, but the very nature of their audiences is also problematic. Whether 'selling' tourist Paris or seeking to expose the gap between *banlieue* and centre, Kassovitz, Jeunet, and Haneke are preaching to the converted, that is, to those with cultural capital and to those who are served by so-called global cinematic distribution networks which so rarely touch the *banlieues*, let alone the developing world. So, although *Caché* and *La Haine* seek to foreground the physical mechanisms of exclusion in postcolonial Paris, both these films and *Amélie* add to the symbolic violence of the earlier phase of globalization: colonialism.

11 Conspiracy, surveillance, and the spatial turn in the Bourne Trilogy

Sue Harris

The conspiracy thriller is a staple genre of popular cinema and, as the commercial success of the Bourne Trilogy has proved, one for which twenty-first-century audiences still have an appetite. A narrative descendant of the post-war film noir, sharing its taste for moral corruption, criminal action, and principled investigation in menacing urban settings, the genre gained landmark status in American independent production of the 1970s. As liberal directors and actors sought to come to terms with issues of representation in an era of political assassination, escalating Cold War tension, and the growth of civil rights movements, three films in particular – *The Parallax View* (Alan J. Pakula, 1974), *Three Days of the Condor* (Sydney Pollack, 1975), and *All the President's Men* (Pakula, 1976) – gained emblematic status. These films were influential in establishing a narrative template linking thematic questions about the legitimacy and reach of political power with a visual style founded on a paranoid encounter with the domestic environment. On the one hand, the bleak thematics were consistent with an era in which mistrust of government was a topical reality. On the other, the use of authentic locations established the cinematic site of conspiracy as resolutely urban, resolutely familiar, and resolutely legible: the choice of Seattle, New York, and Washington, DC in the case of the three films cited above exemplified the genre's direct correspondences between the identifiable modern city and plot lines concerned with finance, industry, and politics. These correspondences between national space and supranational forces were largely consistent throughout genre films of the era, and underpin the core dramatic concepts which have prevailed in more contemporary works, including the Bourne Trilogy. These include variations on: i) corruption within a high-ranking political agency (often an extension of American intelligence services); ii) a lone individual (often a journalist or writer armed only with words) in conflict with an organization with vast financial and material resources; iii) a discourse of surveillance in which the maverick hero is tracked through space and time by the organization; and iv) the constant threat of violent action (most commonly assassination) to eliminate the hero in the interests of a cover-up. But while the key dramatic elements of plot and characterization have remained steady, a significant narrative shift centred on the spatial

environment has occurred in the early twenty-first-century conspiracy thriller, a shift that reflects visually the impact of new technologies on cinema aesthetics, and thematically the post-9/11 experience of the USA in global politics and global violence. As this chapter will argue, the aesthetic and spatial shifts that we see in the Bourne Trilogy (*The Bourne Identity*, Doug Liman, 2002; *The Bourne Supremacy*, Paul Greengrass, 2004; *The Bourne Ultimatum*, Greengrass, 2007) renew the genre in terms of an attention to conventions and visual style, while offering a powerful dramatization of the geographical reach, technological capability, and violent potential of globalized systems. Key to the narrative trajectory of Jason Bourne in space and time is the trope of the destabilization of individual identity engendered by the experience of globalization.

Critic Fredric Jameson (1992) has argued that the conspiracy thriller is an allegorical cinematic form offering a reflection not simply on topical affairs (as is evident in content), but more significantly on the functioning of world systems, and he has argued that the genre is a privileged vehicle for accessing new understandings about the geopolitical realities of postmodern cinema. Jameson sees the figuration of conspiracy in the 1970s in particular as being historically new and original, 'an attempt to think a system so vast that it cannot be encompassed by the natural and historically developed categories of perception with which human beings normally orient themselves' (Jameson 1992: 1–2). Jameson's concern with the impossibility of representing the totality of 'the whole unimaginable, decentred global network itself' (Jameson 1992: 13) is most apparent in the active demonstration of cognitive mapping that the genre incorporates, with the investigative action of the films demonstrating a literal confrontation with landscapes and forces. Major plot points, such as the series of meetings with the informant Deepthroat in *All the President's Men*, are typically developed in peripheral urban spaces (shopping malls, anonymous hotels, transport hubs, windowless offices, underground and rooftop car parks), anonymous sites that evoke physical constraint and enclosure, and intensify the overall sense of alienation communicated by the clean modernist façades of powerful organizations. This dramatic privileging of the transitory 'non-places' of modern life (Augé 1995) is key to the paranoid premise of the genre: these are dynamic rather than static spaces in which the protagonist (and the implicated viewer) remains alert, mobile, and vulnerable. What the action and key environments of these films confirm is the generic city's inevitable panoptic function, its status as a space of perceptual control in which no one, least of all the accidental hero, is safe from the reach of surveillance and its violent consequences. The narrative tension between the hero's attempts to conceal himself in the city and the risk he runs of exposure within a fundamentally legible space is both a source of pleasure to the viewer and an integral component of the narrative arc of any given film: the predictability of detection sustains plot detail while offering a visual spectacle of a dislocated modern world in which any place of potential safety is peripheral and temporary, rather than central and permanent.

The notion of totality that underpins Jameson's thesis seems yet more apposite in the light of the strategies adopted by the conspiracy thriller of the early twenty-first century, in which the spectre of the global network to which he alludes comes forcefully to the surface. While the genre in the 1970s internalized a climate of Cold War paranoia by imagining the threat to democracy at loose in the heartlands of civilized American cities – a coherent visual field of streets and districts organized on a grid system, towering blocks of glass and concrete, vast open concourses connecting relevant downtown agencies such as newsrooms and corporate centres – conspiracy thrillers in the 1990s and 2000s tended to be much more inflected towards the action movie, frequently offering a more geographically extensive range of action spaces, including foreign locations. While a number of high-profile espionage-themed films give evidence of this formal shift (for example, *Enemy of the State*, 1998; *Spy Game*, 2001; *Syriana*, 2005; *Mission Impossible 3*, 2006), it is the Bourne Trilogy, a three-film franchise from Universal Studios based on the Cold War series of bestsellers written by Robert Ludlum in the late 1970s and 1980s (Ludlum 2004a, 2004b, 2004c), that has been the most critically successful example of the genre in contemporary production. Credited with introducing a new aesthetic that has influenced the mainstream Hollywood action thriller (most notably the 2006 James Bond movie *Casino Royale*, which featured world *parkour* champion Sebastien Foucan in the Madagascar-set opening scene), the Bourne Trilogy has gone from being a sleeper success in 2002 (*Identity*: budget of $60 million, with a US opening weekend earning $27 million from 2,638 screens) to a major studio release in 2007 (*Ultimatum*: budget of $130 million, with a US opening weekend earning $69 million from 3,660 screens).

In the novels, Jason Bourne is a military agent specifically located as a product of American history: an amnesiac black ops Vietnam operative with a bona fide Cold War enemy, international terrorist Illich Ramirez Sanchez, alias Carlos the Jackal. Bourne's ability to infiltrate foreign networks has earned him the sobriquet of 'the chameleon' (Ludlum 2004a: 156), and his missions (only the first of which is to establish his identity, thereafter established as David Webb) take him to Europe, Hong Kong, Macao, and the Caribbean. In the course of the three novels, in a twenty-year span of time, Bourne is faced with tangible enemies, ranging from Chinese taipans and Asian warlords, to KGB agents and former 'hotheaded junior staffers in Command Saigon', now 'global powerbrokers' in the White House and State department (Ludlum, 2004c: 44). The denouement of the novels is a showdown between ageing enemies Bourne and Carlos the Jackal in the Russian complex of Novgorod, a series of nine major compounds replicating major nations, and linked by a series of tunnels. Described as 'scaled-down replicas of towns and cities, waterfronts and airports, military and scientific installations from the Mediterranean to the Atlantic, north to the Baltic and up the Gulf of Bothnia . . . all in addition to the American acreage' (Ludlum 2004c: 673), the compound is an elaborate simulacrum of the countries to which the

fictitious KGB operatives might be deployed, accurate to the point that 'candidates who complete the training are literally at home wherever they're initially sent' (Ludlum 2004c: 683). Bourne's wry remark that 'the whole complex sure beats the hell out of Disneyland' (Ludlum 2004c: 668) acts as a prelude to a fantasy of terrorist attack on a global scale: Carlos the Jackal, increasingly deluded and vengeful, simultaneously destroys the replicas of the Eiffel Tower (Paris), Paseo del Prado (Madrid), and Big Ben and the Houses of Parliament (London), swiftly followed by the Capitol dome, the Washington Monument, and the White House. The Novgorod complex parallels Baudrillard's postmodern conception of the world as a succession of endless surfaces, a depthless, cultureless world in which only an appearance of the real remains. In Ludlum's novel, urban space is an 'hallucination of reality' (Baudrillard 1983), an abundance of simulated models whose apocalyptic destruction is profoundly cinematic in its spectacular intent, but also in its conceptual collapsing of the real and the imaginary. Although the film trilogy eschews the large-scale destruction of urban space, the correspondences between the condensed pastiche of the novels (in which geographical criteria are eliminated) and the compressed world of the films (rendered a temporal and spatial totality by the synchronicity of screens and other surveillance apparatus) are potent. In the globalized world of the films, the accuracy and immediacy of digital reproduction have superseded elaborate material pastiche as the primary index of the hyperreal.

The violent conclusion of the Bourne novels takes us deep into a fantasy of globalization in which space and time are excessively compressed, and world space itself is without topographical fidelity. The novelistic Bourne's engagement with the world is predicated, as in the films, on violent encounter; however, the dramatic motor is not the fathoming of individual identity (this is known by the end of the first book), but rather the state-sanctioned deployment of an effective weapon (Bourne himself) in the defence of global security. The fictional Carlos is at war with all nations and all political groups, and Bourne's mission is to eliminate him in order to maintain the geopolitical balance he threatens to undermine. Graphically and prophetically, this is a world where ultimate chaos takes the form of an attack on populated 'world centres' and their iconic cultural markers. The Jason Bourne of the film trilogy, however, is a contemporary figure, a man divorced from historical and political agendas, whose story is played out at the level of an existential journey which brings him to self-knowledge, political enlightenment, and emotional redemption. The dramatic motor of the films is on the one hand Bourne's need to understand who and what he is (a highly trained state assassin in the pay of covert security), and on the other his grief at the loss of his only ally (Marie, his companion in *Identity*, who is killed in the opening moments of *Supremacy*). The endeavour to find answers to these questions and hold to account those responsible for his condition begins in the open water of the Mediterranean, and proceeds through a series of major world cities (Paris, Berlin, Moscow, Madrid, London, Tangiers, New York). But

unlike a James Bond-style 'professional tourist' (Chapman 2003: 97), who shares the pleasures of screen tourism with his audience, Bourne's experience of the city is characterized not by familiarity and a sense of prior acquaintance, but by an instinct for orientation within a relentlessly hostile environment. These destinations hold no pleasure or leisure for him, and no encounter with difference, with 'the other'. Instead, Bourne blends chameleon-like into cities traditionally rendered exotic by cinematic codes of pictorialism, speaking international languages with unexplained ease, and using cultural knowledge (transport options) as a tool. He emerges as a curious modern amalgam of the literary *flâneur* and the urban free-runner, a transient figure who negotiates the city according to the alternating narrative demands of concealment and exposure, but who also somehow 'owns' urban space.

Although the identification of cities as specific action spaces is highly significant – the axis of London, Madrid, New York as the topography of *Ultimatum* inevitably resonates as a topography of terrorist attack beyond the fictional narrative, and the choice of Berlin and Moscow in *Supremacy* evokes cities whose urban memories are inseparable from a history of ideological splits and the violence of urban development – the films avoid the overdetermination of screen space generally achieved by classical pictorial composition and codes of exoticism. What commands our attention as viewers is not the locations themselves – which are held in check by an 'impact aesthetic' (King 2006: 335) of frantic editing and dislocated composition – but rather the momentum of action as Bourne deploys the most basic physical and intellectual skills against faceless bureaucrats, international communications networks, and global security systems. The dizzying succession of international spaces announced by live text on the screen (for example, the rapid montage of Barcelona, Rome, and Hamburg in *Identity* as sleeper assets are called up) confounds linear narrative logic as well as conventional viewing strategies. One city becomes indistinguishable from the next, and their relationships are presented as based on contingency of action rather than geographical distance. As the action of the films tracks Bourne across some dozen countries, national frontiers and cultural specificities become increasingly irrelevant, thereby expanding and magnifying the dystopian trope of integrated surveillance. In Liman and Greengrass's menacing fantasies, the globalized electronic world is a superpanopticon in which a malevolent system of authoritative control renders borders porous and insecure. In as much as every encounter with space leaves a technological trace, cities that are nationally, architecturally, and historically distinct are rendered uniform and hyper-legible. It is this hyper-legibility that the Bourne Trilogy explores and problematizes in its distinctive visual style and urgent pace, in the trademark mobility of the character of Bourne, and in the potent threat of random eruptions of violence in modern urban space.

Furthermore, Bourne's categorization as an 'asset' invites a direct reading of him as the focus for both the process and the condition of globalization. Bourne, and his peer 'assets' (the Professor in *Identity*; Kirill in *Supremacy*;

Paz and Desh in *Ultimatum*), are the ultimate commodities: unique, ever-primed weapons with a high economic value, exceptional military skills, limitless local knowledge, and no free will; and, as the action of all three films reveals, these commodities are both dispensable and replicable according to the whim of the controlling power. In this context, the frequent use of corporate rooftops and advertising hoardings as dramatic vantage points is highly significant: Bourne's appearance on the rooftop of Paris's elegant Samaritaine department store (*Identity*), his targeting of Pamela Landy from behind a giant Bosch logo on a Berlin rooftop (*Supremacy*), and Paz's concealment behind the mechanical billboard at London's Waterloo Station (*Ultimatum*) are cases in point. The assets are not just violent in their status as lethal weapons; they are also a literal embodiment of the deep penetration of multinational interests across the globe, functioning as a uniform presence that enacts the corporate agenda in multiple environments, separated in space and time.

At its most basic level, the action of the Bourne Trilogy is structured around the motif of pursuit (of people, of information, of justice) across metropolitan space, and the dramatic relations that inform the film are conceptually organized in terms of a literal and figurative 'flow' from place to place. The geographical range of locations (both actual and suggested within the diegesis) is extensive, and places are visited in rapid succession as the films progress. The films dwell little on the actual transitions between action spaces (Jason and Marie's car journey from Zurich to Paris in *Identity* is a rare exception), thereby exaggerating the sense of spatial connectedness that underpins the narrative. The films were extensively shot on location, with the range of sites extended in line with increasing budgets and commercial success and deployed local crew and technicians according to site (for example, Dan Weil, who has worked extensively with French director/producer Luc Besson, was the production designer for *Identity*) (Hazelton 2007: 19). The use of major European studios to shoot and process film stock (Barrandov in the Czech Republic, Babelsberg in Germany, and Pinewood Studios in the UK) was a significant extension of the international conception of the series, and conferred certain local advantages on the project: 'besides adding to the films' vivid style, the extensive location work [has] also pumped millions of dollars into several European production hubs and allowed Universal to tap into a growing list of international financing mechanisms' (Hazelton 2007: 18).

All three films follow a consistent pattern: *Identity* opens off the south coast of France, before transferring the action via Zurich (for which Prague stands in), to Paris, the French countryside, and Greece, while offering brief punctuating shots of Rome, Barcelona, and Hamburg. Serving as a counterpoint to this expansive topography is the comparatively one-dimensional interior space of the US intelligence services, which is reduced to a series of dark, neon-lit offices at Langley, Virginia and in corporate Manhattan. As in Paul Greengrass's docu-drama *United 93* (2006), this signature use of mobile space versus static counterspace structures much of the tension in the films,

revealing the apparatus of surveillance to be omniscient and impotent in equal measure. In *United 93*, the air traffic controllers can see every plane in the American skies on their radar screens on the morning of 11 September 2001; they also witness the World Trade Center towers being hit live on a CNN transmission. But their precise perceptual control of the totality of simultaneous action in multiple locations gives them no power to intervene and change the course of unfolding events. Similarly, in the film trilogy, the urgent shifts back and forth from European city streets to a faceless hub replete with monitors and gadgets pits absolute – but static – power against a distant – but dynamic – target.

Supremacy opens in Goa, with an elaborate set-piece chase, and the subsequent action is played out in Berlin and Moscow. Again, glimpses of other relevant action sites are incorporated: Naples, New York City. As in the first film, spatial content (exotic Asia, major world cities) is overshadowed by dynamic form (rapid editing, handheld camera, multiplication of points of view), and the focus of action again alternates between Bourne in Europe and a trademark surveillance hub, here relocated to Berlin. *Ultimatum* was the most ambitious outing of the trilogy in terms of its location shooting, which took place in six countries in some hundred days (Hazelton 2007: 19). In this film the action, which fills the narrative gaps left by Bourne's appearance on a Manhattan rooftop opposite CIA deep cover offices at the end of *Supremacy*, takes us to Berlin, Turin, Paris, London, Madrid, Tangiers, and back to New York City. As a dramatic premise, the putative exoticism of the locations reflects the appeal of the original novels, while in cinematic terms the strategy echoes that of mainstream 'event' movies like the popular Bond series. The shift away from America serves a number of clear dramatic and aesthetic functions, and fundamentally changes the spatial frame of reference of the genre compared with films of the 1970s: the man-on-the-run here is doubly displaced by his need to negotiate the more quirky architecture and non-linear streets of European capitals. However, the displacement occasioned by the relocation in Europe, India, and North Africa does not – as is conventional – reward the viewer with picturesque compositions and omniscient vistas, nor indeed with the dramatic staple of crosscultural misunderstandings (linguistic confusion, incomprehension in the face of cultural phenomena). Instead, the films establish a visually frustrating, anti-touristic idiom: conventional establishing shots are denied their expository function by being excessively compressed in terms of screen duration, and the viewer's instinct to recognize and identify cultural markers is repeatedly thwarted.

In *Identity*, for example, the arrival of Jason and Marie on the Quai de la Tournelle, behind Notre Dame cathedral and directly below the statue of the Parisian patron, St Geneviève, immediately signals the iconic Paris of the movies: this is a site seen in multiple films from classics like *An American in Paris* (Vincente Minnelli, 1954) and crosscultural comedies like *Everyone Says I Love You* (Woody Allen, 1996), and maintained by Richard Linklater in *Before Sunset* (2004). Yet the cinematography allows us no more than the

reassurance that we have arrived at the intended destination, remaining low-angled and mobile, and shutting out the view of the two immense monuments in favour of a close shot of the two characters and their battered vehicle. The film later offers a series of apparently random punctuating shots of the Parisian cityscape, scenes which one critic has described as 'four passages of exceptional beauty' (Durham 2007: 78). These high-angled shots, divorced from character point of view, indeed offer a spectacular perspective on Paris: the searchlight streaming out from the Eiffel Tower and the boulevards radiating in a star from the Arc de Triomphe are unmistakable locations cues. But the extreme brevity of their presentation (these shots last no more than two seconds) gives the city a barely glimpsed, fleeting quality, denying any quality of visual plenitude for our appreciation, and this technique is repeated throughout the trilogy in the form of visually elaborate but unusually brief establishing shots. The iconic city is thus presented as a dislocated entity, a visual totality, but too extensive in scope to be scrutinized in any meaningful way. The extreme concision of the image of the familiar city frustrates the viewer's desire for suture, rendering it decentred and hostile rather than inviting and reassuring, and creating an aura of anxiety consistent with generic expectations.

While landmark buildings are generally treated as almost incidental elements of decor (in the montage of city shots that introduce the sleeper agents, Barcelona's Sagrada Familia cathedral and the Rome Collosseum are barely glimpsed), the topographical distinctiveness of the city locations is intrinsic to major dramatic scenes in all three films. Three chase scenes in the hilly cobbled streets and back alleys of northern Paris (*Identity*), around the multi-level Friedrichstrasse railway station and working Spree River in Berlin (*Supremacy*), and within the labyrinthine corridors and flat rooftops of the Tangiers Medina quarter (*Ultimatum*) are all carefully choreographed in ways that maximize the architectural features and physical layout of the sites. Similarly, major plot points are enacted in identified public sites in central locations: the Pont-Neuf bridge in Paris (*Identity*), the Alexanderplatz in Berlin (*Supremacy*) and Waterloo Station in London (*Ultimatum*). These large set-piece scenes in recognizable public spaces add to the realism of the films, but at the same time intensify the fragmentation of perspective and the atmosphere of confusion that characterizes all three films. For, while Bourne's success in moving from one plot point to the next confirms his ability to map space like a jigsaw in which seemingly disconnected pieces come together as a legible whole, the viewer's experience, like that of Bourne's pursuers, is one of incoherence and unusual edginess. The distinctive cinematographic style of the films keeps us in proximity to Bourne emotionally and corresponds to the narrowness of focus and increasing sense of urgency that both he and those tracking him experience; the more pressing the threat, the more we share their reduced perspective, to the extent that we are unable to step back from it and satisfy our instinct to map and thereby establish order.

The tension established around the abduction of junior operative Nicky Parsons (Julia Stiles) by Bourne from the Alexanderplatz in full view of the CIA surveillance teams and snipers exemplifies this. The scene begins with a series of jerky scanning shots of the commercial square (including the landmark *Fernsehturm* TV tower) and reveals Nicky waiting directly beside the ornate *Weltzeituhr* or 'World Time Clock'. Point of view is indeterminate, cutting between views of Nicky, the rooftop agents, the movement of traffic (trams, trains, cars) and people (shoppers and young people gathering for a protest march), and alternating back to Landy's operational hub, where the square is being monitored on multiple screens. The frantic searching movement of the various cameras denies us any overview of the site, and yet is too fast to allow close scrutiny, placing us in the position of the surveillance team. By the time the camera pulls back to offer a panoramic view of the site, the protest march has gathered full momentum, Nicky has been lost from sight, and Bourne has evaded detection: the surveillance team recognizes the square, but the view offers no useful information about cause, effect, or consequence. What we have in fact witnessed, independently of character point of view, is a cinematic visualization of cognitive mapping in action, with Bourne ultimately controlling both place and events, and audaciously thwarting a seemingly omnipotent perceptual authority.

A similar effect is achieved in the Waterloo Station sequence, in which the logistics of mapping are precisely enacted by Bourne as he attempts to keep both himself and journalist Simon Ross (Paddy Considine) out of the line of surveillance. Greengrass notes that it was impractical both financially and logistically to clear a working site like Waterloo Station, one of London's busiest commuter hubs, and at that time still home of the Eurostar connections to Paris, and thus the scenes were shot with the public on site. This, combined with Steadicam filming and the dramatic incorporation of actual CCTV footage from the station, gives the cat-and-mouse action at Waterloo an unrehearsed, live quality more associated with documentary and reportage. The seemingly improvised circulation on the crowded concourse, and the disorientating shifts in camera perspective and character point of view create a quality of spontaneous action that is quite distinct in tone and visual priorities from the generic action thriller, and has led Greengrass to identify his film as 'a Hollywood movie with an indie mentality' (Hewitt 2007: 70). In the sequence, Bourne uses audio technology to confuse the surveillance operation (which demands 'eyeballs on the street' and 'eyes at Waterloo station'), using a disposable mobile phone to relay a stream of instructions to an increasingly paranoid and panicked Ross. Bourne's engagement with the environment is based on a seemingly instinctive grasp of the infrastructure: entrances and exits, position of CCTV cameras, layout of the commercial premises that surround the concourse. In this case, Bourne's grasp of the extent of Noah Vosen's surveillance operation (people, cameras, vehicles, vantage points) and his militaristic instructions ('10 o'clock to your left', 'bus stop at 50 metres', 'the bus will be there in 10 seconds', 'negative') are directly

shared with the viewer, but our ability to map space is very much more partial. What is privileged on the screen is not spatial organization, but rather an accumulation of shop names, brand logos, and generic franchises common to any railway station in any city in any part of the world. A profoundly postmodern space in its qualities of duplication, circulation, and aesthetic fragmentation, the sequence reinforces the malevolence of abstract global systems by taking us more specifically into a space where violent threat (Ross is killed, and various agents are disabled by Bourne) is embedded in the normal everyday life of urban citizens.

The films of the Bourne Trilogy creatively reinvent some staple cinematic formulae to raise questions about state sovereignty, the reach of governance, and the nature of political organization in a globalized era. Both individually, and as linked series, they offer a compelling visual demonstration of the intangibility of global systems in a world in which the pace and function of individual action is determined by the pervasiveness and rapidity of technological communication. At the same time, the films offer all the routine spectacular pleasures of the modern action movie – car chases, hand-to-hand combat, smart locations – while also serving up the brooding atmosphere of menace typical of the classic conspiracy film. The framing of Bourne's damnation and redemption within a communications network with a limitless capacity for intelligence collection clearly draws on contemporary concerns about invasion of privacy: as recently as July 2008, a report about the covert tracking of individuals via Bluetooth signals emanating from mobile phones, laptops, and digital cameras made headlines in the UK. Researchers at Bath University in England claimed the project was not linked to the development of surveillance systems, but rather was a social investigation into 'the aggregate behaviour of citydwellers as a whole' (Lewis 2008: 11). However, as the *Guardian* newspaper reported (incidentally, the same newspaper for which the fictitious Simon Ross in *Ultimatum* wrote), 'pedestrians are not being told that the devices they carry around in their pockets and handbags could be providing a permanent record of their journey, which is then stored on a central database' (Lewis 2008: 11). The films may offer an extravagant fantasy of panopticism on a global scale, but it is a fantasy that finds an echo in a wholly banal experience of contemporary urban living.

The films' dramatic investigation of the global reach of malevolent forces chimes not only with a generalized tide of unease that underpins the contemporary experience of globalized security systems, but also with more quotidian fears about the random eruption of violence in world cities in a post-9/11 world. The location of the violent action of the films in the familiar, functional centres of urban life creates a particular kind of tension for the viewer, forcing us to question who is among us as we go about our business – of work, leisure, consumption; who is beside us on our streets, our trains, our high-rise towers? The unremarkable, unnoticed passer-by thus becomes an object of quiet menace, and by extension all passers-by are potentially suspect. Violence in the films stretches over four continents, with its uniform

pattern (surveillance, deployment of asset, local police support, assassination) indicative of an identical threat lurking in each and every populated conurbation. In Bourne's world, all world cities eventually resemble each other; the experience of the next is a variation on the encounter with the last. For all their iconicity and exoticism, distinct international cityspaces in the films are rendered hyper-legible; they are flattened, in the face of unique cultural markers and national visual cues, into undifferentiated and indistinguishable canvases for the display of material and symbolic violence.

Bibliography

al-Badrani, F. (2004) 'US Bombards Fallujah Bastion', *The Age*, 7.
Associated Press (2001) 'Police Say Brazil's Top Drug Lord Telling All', 27 May. URL: <http://www.latinamericanstudies.org/brazil/brazil-druglord.htm> (accessed 7 January 2008).
Attie, S. (2003) 'The Writing on the Wall, Berlin, 1992–93: Projections in Berlin's Jewish Quarter', *Art Journal* (Fall): 74–83.
Augé, M. (1992) *Non-lieux: introduction à une anthropologie de la surmodernité*, Paris: Editions du Seuil.
—— (1995) *Non-places: Introduction to an Anthropology of Supermodernity*, trans. J. Howe, London: Verso.
Baqué, D. (2004) 'Pour un lieu où vivre?', in *Photographie plasticienne, l'extrême contemporain*, Paris: Éditions du Regard, 167–83.
Barlow, T. (2005) 'The Pornographic City', in J. Wang and D. Goodman (eds) *Locating China: Space, Place and Popular Culture*, London: Routledge, 190–209.
Barnard, A. (2004) 'Inside Fallujah's War', *Boston Globe*.
Baudrillard, J. (1983) *Simulations*, trans. Foss, Patton and Beitchman, New York: Semiotext(e).
—— (1988) 'The Hyper-Realism of Simulation', in M. Poster (ed.) *Jean Baudrillard: Selected Writings*, Stanford: Stanford University Press, 143–7.
—— (1995) *The Gulf War did not Take Place*, Bloomington, Indiana: Indiana University Press.
—— (2002) 'Requiem for the Twin Towers', in *The Spirit of Terrorism*, trans. C. Turner, London: Verso, 41–52.
Bauman, Z. (2001) 'Wars of the Globalization Era', *European Journal of Social Theory*, 4: 11–28.
Beiser, V. (June 2006) 'Baghdad, USA', *Wired Magazine* 14(6).
Beller, J. L. (2002) 'Kino-I, Kino-World: Notes on the Cinematic Mode of Production', in N. Mirzoeff (ed.) *The Visual Culture Reader*, London: Routledge, 60–85.
Benjamin, W. (1955) *Charles Baudelaire. Un poète lyrique à l'apogée du capitalisme*, trans. J. Lacoste, Paris: Payot.
—— (1982) *Paris, capitale du XIXe siècle. Le Livre des passages*, trans. J. Lacoste, Paris: Éditions du Cerf.
—— (1989) 'Das Kunstwerk im Zeitalter seiner technischen Reproduzierbarkeit', in R. Tiedemann and H. Schweppenhäuser (eds) *Gesammelte Schriften*, Frankfurt: Suhrkamp, 471–508.

Bentes, I. (2002) ' "Cidade de Deus" Promove Turismo no Inferno', *Estado de S. Paulo*. URL: <http://www.consciencia.net/2003/08/09/ivana.html> (accessed 11 May 2008).
Bian, Y. (1997) 'Bringing Strong Ties Back In', *American Sociological Review*, 62: 366–85.
Bourdieu, P. (1984) *Distinction: A Social Critique of the Judgment of Taste*, trans. Richard Nice, London: Routledge.
Bourdieu, P. and Passeron, J. (1977) *Cultural Reproduction in Education, Society and Culture*, trans. R. Nice, London: Sage.
Brant, B. (2002) *O invasor*, Europa Filmes.
Butler, J. (2004) *Precarious Life: The Powers of Mourning and Violence*, London: Verso.
Cairns, S. (2006) 'Cognitive Mapping the Dispersed City', in C. Lindner (ed.) *Urban Space and Cityscapes*, London and New York: Routledge, 192–205.
Caldeira, T. (2000) *City of Walls: Crime, Segregation and Citizenship in São Paulo*, Berkeley: University of California Press.
Campbell, D. (2007) 'Geopolitics and Visuality: Sighting the Darfur Conflict', *Political Geography*, 26: 357–82.
Carvalho, M., George, R. and Anthony, K. (1997) 'Residential Satisfaction in *Condominios Exclusivos* (Gate-Guarded Neighbourhoods) in Brazil', *Environment and Behaviour*, 29: 734–68.
Castells, M. (1996) *The Rise of the Network Society*, Oxford: Blackwell.
—— (1998) *End of Millennium*, Oxford: Blackwell.
Chapman, J. (2003) 'A Licence to Thrill', in C. Lindner (ed.) *The James Bond Phenomenon: A Critical Reader*, Manchester: Manchester University Press, 93–8.
Chiarelli, P. and Michaelis, P. (2005) 'Winning the Peace: the Requirement for Full-Spectrum Operations', *Military Review*, July–August. URL: <http://www.army.mil/professionalwriting/volumes/volume3/october_2005/10_05_2.html> (accessed 28 June 2008).
'China Stand Up' (2008) *Sina-Youtube*. URL: <http://www.net666.cn/thread-32370-1-1.html> (accessed 1 September 2008).
Chouliaraki, L. (2006) 'The Aestheticization of Suffering on Television', *Visual Communication*, 5: 261–85.
Chow, R. (2006) *The Age of the World Target: Self-Referentiality in War, Theory and Comparative Work*, Durham: Duke University Press.
Chu, S. (2004) 'Fight for Equality in a Transforming China: Community Development in Urbanization', *International Review of Administrative Sciences*, 70: 673–84.
Clarke, G. (1997) 'The City in Photography', in *The Photograph*, Oxford: Oxford University Press, 75–99.
Coelho, T. (2001) *Niemeyer: Um Romance*, São Paulo: Teixeira Coelho Preço.
Comment, B. (1999) *The Panorama*, London: Reaktion.
Core, M., Traum, D., Lane, C., Swartout, W., Gratch, J., van Lent, M., and Marsella, S. (2006) 'Teaching Negotiation Skills Through Practice and Reflection with Virtual Humans', *Simulation*, 82: 685–701.
Corner, J. (2005) 'Lifescape – Fresh Kills Parkland', *Topos: The International Review of Landscape Architecture and Urban Design*, 51: 14–21.
Cotton, C. (2004) *The Photograph as Contemporary Art*, London: Thames and Hudson.
Coward, M. (2006) 'Against Anthropocentrism: The Destruction of the Built

174 Bibliography

Environment as a Distinct Form of Political Violence', *Review of International Studies*, 32: 419–37.

Crooks, H. (1993) *Giants of Garbage: The Rise of the Global Waste Industry and the Politics of Pollution*, Toronto: Lorimer.

Croser, C. (2007) 'Networking Security in the Space of the City: Event-ful Battlespaces and the Contingency of the Encounter', *Theory and Event*, 10(2).

Cullaher, N. (2003) 'Bombing at the Speed of Thought: Intelligence in the Coming Age of Cyberwar', *Intelligence and National Security*, 18: 141–54.

Darzacq, D. (2007) *La Chute*, Paris: Editions Filigranes.

Davila, T. (2002) *Marcher, créer, déplacements, flâneries, dérives dans l'art de la fin du XXe Siècle*, Paris: Editions du Regard.

Davis, M. (1992) *City of Quartz*, London: Verso.

—— (2006) *Planet of Slums*, New York: Verso.

de Certeau, M. (1984) *The Practice of Everyday Life*, trans. S. Rendall, Berkeley: University of California Press.

Debray, R. (1996) *Media Manifestations*, London: Verso.

Deleuze, G. and Guattari, F. (1987) *A Thousand Plateaus: Capitalism and Schizophrenia*, vol. 2, trans. B. Massuni, Minneapolis: University of Minnesota Press.

DePalma, A. (2004) 'Landfill, Park ... Final Resting Place? Plans for Fresh Kills Trouble 9/11 Families Who Sense Loved Ones in the Dust', *New York Times*, 14 June.

Depardon, R. (2007) *Villes/Cities/Städte*, Arles: Actes Sud.

Desplechin, M. and Darzacq, D. (2006) *Bobigny Centre Ville*, Arles: Actes Sud.

Dikeç, M. (2007) *The Badlands of the Republic: Space, Politics and Urban Policy*, Oxford: Blackwell.

DiMarco, L. (2004) *Traditions, Changes and Challenges: Military Operations and the Middle Eastern City*, Fort Leavenworth: Combat Studies Institute Press.

Donald, S. H. (2008) 'No Place for Young Girls [in the Chinese Market]?' *Marketization in China: A Contested Project from the Communication Perspective*, Conference at Hong Kong Baptist University, 14 March.

Donald, S. H. and Zheng, Y. (2008) 'Richer than Before – The Cultivation of Middle-Class Taste: Education Choices in Urban China', in D. Goodman (ed.) *The New Rich in China: Future Rulers, Present Lives*, London: Routledge, 71–84.

Duffield, M. (2008) 'Global Civil War: The Non-Insured, International Containment and Post-Interventionary Society', *Journal of Refugee Studies*, 21: 145–65.

Durand, R. (2006) 'Arpentage, "colportage", archivage de l'espace urbain: le flâneur comme artiste', in *L'Excès et le reste. Essais sur l'expérience photographique*, Paris: Editions de la Différence, 15–33.

Durham, C. A. (2007) 'Sighting/Siting/Citing the City: The Construction of Paris in Twenty-First Century Cinema', *PostScript*, 27: 72–89.

Eduardo, C. (2002) 'A Cosmética da Fome', *Epoca*, 223. URL: <http://revistaepoca.globo.com/Revista/Epoca/0,,EDG50701-6011,00.html> (accessed 11 May 2008).

Federal Bureau of Investigation (2006) 'FBI Statistics for 2006'. URL: <http://www.fbi.gov/ucr/cius2006/index.html> (accessed 8 June 2008).

Fielder, A. (2001) 'Poaching on Public Space: Urban Autonomous Zones in French *Banlieue* Films', in Mark Shiel and Tony Fitzmaurice (eds) *Cinema and the City: Film and Urban Societies in a Global Context*, Oxford: Blackwell, 270–81.

Filkins, D. and Burns, J. (2006) 'Mock Iraqi Villages in Mojave Prepare Troops for Battle', *New York Times*, 1 May.

Forty, A. and Andreoli, E. (eds) (2004) *Brazil's Modern Architecture*, London: Phaidon Press.
Foucault, M. (1977) *Discipline and Punish*, trans. A. Sheridan, New York: Pantheon.
Franco, J. (2002) *The Decline and Fall of the Lettered City: Latin America in the Cold War*, Cambridge, MA: Harvard University Press.
'Fresh Kills Park: Draft Master Plan' (2006) New York City Department of City Planning. URL: <http://www.nyc.gov/html/dcp/html/fkl/fkl3a.shtml> (accessed 8 July 2008).
Freud, S. (1977) *Inhibitions, Symptoms and Anxiety*, New York: Norton.
Frisby, D. (1985) 'Exemplary Instances of Modernity', in *Fragments of Modernity*, Cambridge: Polity Press, 109–86.
García Canclini, N. (1995) *Consumidores y Ciudadanos: Conflictos Multiculturales de la Globalización*, Mexico City: Grijalbo.
Gaviria, V.M. (1989a). 'Un Ojo de Nadie (Reflexiones en Torno a "No futuro")', *Gaceta Cine*, 1: 3–4.
—— (1989b) *Rodrigo D. No futuro*, FOCINE.
—— (1998a) 'Los Días de la Noche', *Kinetoscopio*, 9(45): 37–42.
—— (1998b) *La vendedora de rosas*, Nirvana Films/Wanda Distribución.
—— (2004) *Sumas y restas*, La Ducha Fría.
Giraldo Isaza, F. and López, A. F. (1991) 'La Metamorfosis de la Modernidad', in F. Viviescas and F. Giraldo Isaza (eds) *Colombia: El Despertar de la Modernidad*, Bogotá: Foro Nacional por Colombia, 248–310.
Goertzel, T. and Kahn, T. (2007) 'Brazil: The Unsung Story of São Paulo's Dramatic Murder Rate Drop', *Brazzil Magazine*, 18 May. URL: <http://www.brazzil.com/articles/179-may-2007/9881.html> (accessed 8 June 2008).
Gonzalez, R. (2008) 'Human Terrain: Past, Present and Future Applications', *Anthropology Today*, 24: 21–6.
González Iñárritu, A. (2000) *Amores perros*, Nu Vision.
Graham, S. (2004) 'Introduction: Cities, Warfare, and States of Emergency', in S. Graham (ed.) *Cities, War, and Terrorism: Towards and Urban Geopolitics*, Oxford: Blackwell, 1–25.
—— (2007) 'War and the City', *New Left Review*, 44: 121–32.
—— (2008) 'Robowar™ Dreams', *City*, 12: 25–49.
Grant, R. (2005) 'The Fallujah Model', *Air Force Magazine*, February, 48–53.
Gregory, D. (2006) ' "In Another Time Zone, the Bombs Fall Unsafely": Targets, Civilians and Late Modern War', *Arab World Geographer*, 9: 88–111.
—— (2008) 'The Biopolitics of Baghdad: Counterinsurgency and the Counter-City', *Human Geography*, 1: 6–27.
Guo, Y. (2008) 'Class, Stratum and Group: the Politics of Prescription and Description', in D. Goodman (ed.) *The New Rich in China: Future Rulers, Present Lives*, London: Routledge, 38–52.
Gusterson, H. (2008) 'The US Military's Quest to Weaponize Culture', *Bulletin of the Atomic Scientists*, 20 June.
Hamilton, J. (2006) 'Battle-Hardened in California', *Hartford Courant*, 12 March.
Hamilton, W. L. (2006) 'A Fence with More Beauty, Fewer Barbs', *New York Times*, 18 June.
Hanssen, B. (1998) 'Christo's *Wrapped Reichstag*: Globalized Art in a National Context', *Germanic Review*, 73: 264–77.

Hargreaves, A. (1996) 'A Deviant Construction: The French Media and the "Banlieues"', *New Community*, 22: 607–18.
Harris, C. (2006) 'The Omniscient Eye: Satellite Imagery, "Battlespace Awareness" and the Structures of the Imperial Gaze', *Surveillance and Society*, 4: 101–22.
Harvey, D. (2003) *The New Imperialism*, Oxford: Oxford University Press.
Hayden, T. (2002) 'Fields of Dreams: Turning "Brownfields" and Dumps into Prime Real Estate', *US News & World Report*, 132: 62.
Hazelton, J. (2007) 'World in Action', *Screen International*, 1605: 16–19.
Herbert, A. (2003) 'Compressing the Kill Chain', *Air Force Magazine*, 86: 50–5.
Hewitt, C. (2007) 'Don't You Forget About Me', *Empire*, 218 (August): 66–73.
'High Line: Team Statement' (2006) URL: <http://www.thehighline.org/design/fieldop.html> (accessed 12 July 2008).
Hollis, P. (2005) 'The 1st Cav in Baghdad: Counterinsurgency EBO in Dense Urban Terrain', *Field Artillery*, September–October, 3–8.
Holston, J. (1989) *The Modernist City: An Anthropological Study of Brasilia*, Chicago: University of Chicago Press.
Huyssen, A. (1995) *Twilight Memories: Marking Time in a Culture of Amnesia*, New York: Routledge.
Irvine, K. (2008) 'Building Pictures: Exhibition Catalogue', Chicago Museum of Contemporary Photography, Chicago: Columbia College.
Jacobs, S. (2006) *Spectacular City. Photographing the Future*, Rotterdam: NAi Publishers.
Jameson, F. (1992) *The Geopolitical Aesthetic: Cinema and Space in the World System*, London: British Film Institute.
—— (1994) *The Seeds of Time*, New York: Columbia University Press.
Jameson, F. and Miyoshi, M. (1998) *The Cultures of Globalization*, Durham and London: Duke University Press.
Johnson, P. (1978) *Mies van der Rohe*, 3rd ed., New York: MoMA.
Jousse, T. (1995) 'Le Banlieue-film existe-il?', *Cahiers du cinéma*, 492: 37–9.
Jouve, V. (2002) 'The City', in Dean Inkster, *Valérie Jouve*, Paris: Editions Hazan, 4.
Kaldor, M. (2006) *New and Old Wars: Organized Violence in a Global Era*, Cambridge: Polity Press.
Kaplan, R. (2006) 'Hunting the Taliban in Las Vegas', *The Atlantic Monthly*. URL: <http://www.theatlantic.com/doc/200609/taliban-vegas> (accessed 1 August 2008).
Kennedy, D. (2008) 'Mexico Gang Had "James Bond" Car', *BBC News*. URL: <http://news.bbc.co.uk/2/hi/americas/7305943.stm> (accessed 8 May 2008).
Kenny, P., Hartholt, A., Gratch, J., Swartout, W., Traum, D., Marsella, S., and Piepol, D. (2007a) 'Building Interactive Virtual Humans for Training Environments', *Interservice/Industry Training, Simulation and Education Conference*, Orlando, FL.
Kenny, P., Hartholt, A., Gratch, J., Traum, D., Marsella, S., and Swartout, B. (2007b) 'The More the Merrier: Multi-Party Negotiation with Virtual Humans', *Association for the Advancement of Artificial Intelligence Conference*, Vancouver. URL: <http://ict.usc.edu/projects/integrated_virtual_humans/C40> (accessed 20 July 2008).
Kilcullen, D. (2005) 'Countering Global Insurgency', *Journal of Strategic Studies* 28: 597–617.
—— (2006a) 'Counterinsurgency *Redux*', *Survival: Global Politics and Strategy*, 48: 111–30.
—— (2006b) '28 Articles: Fundamentals of Company-Level Counterinsurgency', *Military Review*, May–June, 103–8.

—— (2007a) 'Anatomy of a Tribal Revolt', 27 August. URL: <http://www.smallwarsjournal.com/blog> (accessed 20 July 2008).
—— (2007b) 'Counterinsurgency in Iraq: Theory and Practice, 2007', Seminar at the US Marine Corps Base, Quantico, VA, September. URL: <http://smallwarsjournal.com/blog/2007/10/coin-seminar-summary-report> (accessed 20 July 2008).
—— (2007c) 'Religion and Insurgency', 12 May. URL: <http://www.smallwarsjournal.com/blog> (accessed 20 July 2008).
King, G. (2006) 'Spectacle and Narrative in the Contemporary Blockbuster', in L. R. Williams and M. Hammond (eds) *Contemporary American Cinema*, London and New York: Open University Press/McGraw-Hill Education, 334–55.
Kipp, J., Grau, L., Prinslow, K., and Smith, D. (2006) 'The Human Terrain System: a CORDS for the 21st Century', *Military Review*, September–October, 8–15.
Koolhaas, R. (2002) 'Junkspace', in C. Chung, J. Inaba, R. Koolhaas, and S. Leong (eds) *Harvard Design School Guide to Shopping*, New York: Taschen.
Koolhaas, R., Werlemann, H., and Mau, B. (1994) *S,M,L,XL*, New York: The Monacelli Press.
Krause, L. and Petro, P. (eds) (2003) *Global Cities: Cinema, Architecture, and Urbanism in a Digital Age*, New Brunswick: Rutgers University Press.
'Künstler und der Senat erinnern an den 2 Mai 1945' (2005) *Der Tagesspiegel*, 5 March.
Ladd, B. (2000) 'Center and Periphery in the New Berlin: Architecture, Public Art, and the Search for Identity', *PAJ: A Journal of Performance and Art*, 22: 7–21.
Laurent, A. (2007) 'Virtually There', *GovernmentExecutive.com*, 17 October. URL: <http://www.govexec.com/story_page.cfm?filepath=/features/1007-01/1007-01na1.htm> (accessed 18 June 2008).
Lawrence, T. E. (1917) 'The 27 Articles of T. E. Lawrence', *Arab Bulletin*, 20 August.
Lefebvre, H. (1991) *The Production of Space*, Oxford: Blackwell.
Lenoir, T. (2000) 'All But War is Simulation: the Military-Entertainment Complex', *Configurations*, 8: 238–35.
Leopard, D. (2005) 'Micro-Ethnographies of the Screen: FlatWorld', *FlowTV: A Critical Forum on Television and Media Culture*, 3. URL: <http://flowtv.org> (accessed 20 July 2008).
Lévi-Strauss, C. (1976) *Tristes Tropiques*, London: Penguin.
Lewis, P. (2008) 'Bluetooth is Watching: Secret Study Gives Bath a Flavour of Big Brother', *Guardian*, 21 July, 11.
Libeskind, D. (1997) *radix-matrix*, Munich: Prestel.
Lindner, C. (2005) 'New York Vertical: Reflections on the Modern Skyline', *American Studies*, 47(1): 31–52.
—— (ed.) (2006) *Urban Space and Cityscapes: Perspectives from Modern and Contemporary Culture*, London and New York: Routldege.
Lipkin, J. (2005) *Photography Reborn: Image Making in the Digital Era*, New York: Abrams.
Logan, S. (2006) 'Riots Reveal Organized Crime Power in Brazil', *Ezine @rticles*. URL: <http://ezinearticles.com/?Riots-Reveal-Organized-Crime-Power-in-Brazil&id=209847> (accessed 8 January 2008).
Losh, E. (2005) 'In Country with *Tactical Iraqi*: Trust, Identity and Language Learning in a Military Video Game', *Digital Experience: Proceedings of the Digital Arts and Culture Conference*, Copenhagen, 69–78.
Ludlum, R. (2004a) *The Bourne Identity*, London: Orion.

—— (2004b) *The Bourne Supremacy*, London: Orion.
—— (2004c) *The Bourne Ultimatum*, London: Orion.
Lynch, K. (1960) *The Image of the City*, Cambridge, MA: MIT Press.
Lyotard, J. (1988) 'Scapeland', *Revue des sciences humaines*, 209: 39–48.
Maffi, M. (2004) *New York City: An Outsider's Inside View*, trans. D. Allen, Columbus: Ohio State University Press.
Marcuse, P. and van Kempen, R. (2000) 'Introduction', in P. Marcuse and R. van Kempen (eds) *Globalizing Cities: A New Spatial Order?* Oxford: Blackwell, 1–21.
Marston, J. (2004) *María, llena eres de gracia*, HBO Films.
Martin, R. (2007) *An Empire of Indifference: American War and the Financial Logic of Risk Management*, Durham: Duke University Press.
Martín Barbero, J. (2000) 'La Ciudad: Entre Medios y Miedos', in S. Rotker (ed.) *Ciudadanías del Miedo*, Caracas: Nueva Sociedad, 29–35.
—— (2001) *Al Sur de la Modernidad: Comunicación, Globalización y Multiculturalidad*, Pittsburgh, PA: Instituto Internacional de Literatura Iberoamericana.
—— (2005) 'Cultura y Nuevas Mediaciones Tecnológicas', in J. Martín Barbero (ed.) *América Latina: Otras Visiones desde la Cultura*. Bogotá: Convenio Andrés Bello, 13–38.
Maspero, F. and Frantz, A. (1990) *Les Passagers du Roissy-Express*, Paris: Seuil.
Mayo, M., Singer, M., and Kusumoto, L. (2006) 'Massively MultiPlayer (MMP) Environments for Asymmetric Warfare', *Journal of Defense Modelling and Simulation*, 3: 155–66.
Maza, S. (2002) 'The Social Imaginary of the French Revolution: The Third Estate, the National Guard and the Absent Bourgeoisie Jones', in C. Jones and D. Wahrman (eds) *The Age of Cultural Revolutions: Britain and France 1750–1820*, Berkeley: University of California Press, 106–23.
McFate, M. (2005a) 'Anthropology and Counterinsurgency: The Strange Story of Their Curious Relationship', *Military Review*, March–April, 24–38.
—— (2005b) 'The Military Utility of Understanding Adversary Culture', *Joint Force Quarterly*, 38: 42–48.
McFate, M. and Jackson, A. (2005) 'An Organizational Solution for DOD's Cultural Knowledge Needs', *Military Review*, July–August, 18–21.
Meirelles, F. and Lund, K. (2002) *Cidade de Deus*, O2 Filmes/Miramax.
Moreton, M. (2000) *Fragile Dwelling*, New York: Aperture.
Münkler, H. (2005) *The New Wars*, Cambridge: Polity Press.
Nagl, J. (2005) *Learning to Eat Soup with a Knife: Counterinsurgency Lessons from Malaya and Vietnam*, Chicago: University of Chicago Press.
Nietzsche, F. (1977) 'Vom Nutzen und Nachteil der Historie für das Leben', in Karl Schlechta (ed.) *Werke in drei Bänden*, München: Hanser, 230–7.
Nordstrom, C. (2004) *Shadows of War: Violence, Power and International Profiteering in the Twenty-First Century*, Berkeley: University of California Press.
'Operation Dawn: al Fajr; Brief Comments on Air Power in Urban Warfare' (2005) *Talking Proud*, 28 April. URL: <http://www.talkingproud.us/Military042805D.html> (accessed 25 July 2008).
Packer, G. (2005) *The Assassins' Gate: America in Iraq*, New York: Farrar, Strauss and Giroux.
Pearman, H. (2007) 'How Many Stars Can the Skyline Take?', *The Sunday Times*, July, 1.

Peck, M. (2007) 'Gaming Hearts and Minds', *Defense Technology International*, November, 14.
Petraeus, D. (2008) Report to Congress, 8–9 April.
Pickles, J. (2004) *A History of Spaces*, London: Routledge.
Powrie, P. and Reader, K. (2002) *French Cinema: A Student's Guide*, London: Arnold.
Rama, Á. (1984) *La Ciudad Letrada*, Montevideo: Comisión Uruguaya pro Fundación Internacional.
Reuters (2007) 'Crime Ring Run by Jailed Drug Lord Smashed: Brazil'. URL: <http://www.reuters.com/article/topNews/idUSN2225716520071122> (accessed 8 January 2008).
—— (2008) 'Booming Brazil Struggles to Get a Grip on Crime', *Reuters AlertNet*. URL: <http://www.alertnet.org/thenews/newsdesk/N09507198.htm> (accessed 12 May 2008).
Rez, Guy (2007) 'Simulated City Preps Marines for Reality of Iraq', National Public Radio, 13 April.
Ricks, T. (2007) 'Officers with PhDs Advising War Effort', *Washington Post*, 5 February.
Riegl, A. (1996) *Gesammelte Aufsätze*, Vienna: Walter de Gruyter.
Rocha, G. (1965) 'Uma Estética da Fome', *Revista Civilização Brasileira*, 1.3. URL: <http://tropicalia.uol.com.br/site_english/internas/leituras_gg_cinenovo.php> (accessed 11 May 2008).
Said, E. (1978) *Orientalism*, London: Penguin.
—— (1993) *Culture and Imperialism*, New York: Knopf.
Sandhu, S. (2007) 'Why You'll Soon Be Avant-Gardening', *Telegraph*, 16 June.
Scales, R. (2004) 'Culture-Centric Warfare', *Proceedings of the Naval Institute*, 130. URL: <http://www.military.com/NewContent/0,13190,NI_1004_Culture-P1,00.html> (accessed 1 August 2008).
Schroeder, B. (2000) *La virgen de los sicarios*, Vértigo Films.
Shachtman, N. (2007) 'How Technology Almost Lost the War', *Wired Magazine*, 15(12).
Shiel, M. and Fitzmaurice, T. (eds) (2000) *Cinema and the City: Film and Urban Societies in a Global Context*, Oxford: Blackwell.
Silberman, S. (2004) 'The War Room', *Wired Magazine*, 12(9).
Soja, E.W. (2000) *Postmetropolis: Critical Studies of Cities and Regions*, Oxford: Blackwell.
Solinger, D. (2006) 'The Creation of a New Underclass in China and its Implications', *Environment & Urbanization*, 18(1): 177–93.
Sontag, S. (1979) *On Photography*, London: Penguin Books.
Sorkin, M. and Zukin, S. (eds) (2002) *After the World Trade Center: Rethinking New York City*, New York: Routledge.
Spinatsch, J. (2004) 'Interview', *Lens Culture*. URL: <http://www.lensculture.com/spinatsch_interview.html> (accessed 7 July 2008).
—— (2005a) *Temporary Discomfort Chapters I–V*, Baden: Lars Muller.
—— (2005b) 'Heisenbergs Offside'. URL: <http://www.jules-spinatsch.ch/images/light/dez2007/Heisenbergs_Offside/Heisenberg_wBook_Monitor_72dpi.pdf> (accessed 7 July 2008).
Stille, A. (2002) 'Violence at Genoa – A "Question of Detail"?', in Joel Sternfeld (ed.) *Treading on Kings, Protesting the G8 at Genoa*, Gottingen: Steidl, 1–17.

Stoler, A. L. and Bond, D. (2006) 'Refractions off Empire: Untimely Comparisons in Harsh Times', *Radical History Review*, 95: 93–107.

Szerszynski, B. and Urry, J. (2006) 'Visuality, Mobility and the Cosmopolitan: Inhabiting the World from Afar', *British Journal of Sociology*, 57: 113–31.

Taw, J. and Hoffman B. (1994) *The Urbanization of Insurgency: the Potential Challenge to US Army Operations*, Santa Monica: RAND Corporation.

Tester, K. (1994) *The Flâneur*, New York and London: Routledge.

Thrift, N. (2005) 'Panicsville: Paul Virilio and the Esthetic of Disaster', *Cultural Politics*, 1(3): 337–48.

Tower, W. (2006) 'Letter from Talatha: Under the God Gun', *Harper's Magazine*, January.

US Army (2006a) 'Field Manual 3-06: Urban Operations'.

—— (2006b) 'Field Manual 3-24: Counterinsurgency', §1–80, 1–125, A-45, 1–150.

Vidal, J. (2001) 'Streets are Empty . . . Like a Bomb has Gone Off', *Guardian*, 20 July. URL: <http://www.guardian.co.uk/world/2001/jul/20/politics.globalisation> (accessed 7 July 2008).

Virilio, P. (2005) *City of Panic*, trans. J. Rose, Oxford: Berg.

Wahrman, D. (1995) *Imagining the Middle Class: the Political Representation of Class in Britain c. 1780–1840*, Cambridge: Cambridge University Press.

—— (2004) *The Making of the Modern Self: Identity and Culture in Eighteenth Century England*, New Haven: Yale University Press.

Weber, S. (2005) *Targets of Opportunity: On the Militarization of Thinking*, New York: Fordham University Press.

Weschler, L. (1988) 'True to Life', in D. Hockney (ed.) *Cameraworks*, New York: Knopf, 1–31.

Wigley, M. (2002) 'Insecurity by Design', in M. Sorkin and S. Zukin (eds) *After the World Trade Center: Rethinking New York City*, New York: Routledge, 69–85.

Williams, R. J. (2004) *The Anxious City*, London: Routledge.

—— (2007a) 'Paulo Mendes da Rocha', *Blueprint*, 251: 36–43.

—— (2007b) 'Towards an Aesthetics of Poverty: Architecture and the Neo-Avant-Garde in 1960s Brazil', in D. Hopkins (ed.) *The Neo-Avant Garde*, Amsterdam: Rodopi, 197–229.

Wunderle, W. (2007) *Through the Lens of Cultural Awareness: A Primer for US Armed Forces Deploying to Arab and Middle Eastern Countries*, Fort Leavenworth: Combat Studies Institute Press.

Yglesias, M. (2008) 'Culture Clash', *Atlantic*, 5 May. URL: <http://matthewyglesias.theatlantic.com> (accessed 20 July 2008).

Zakaria, F. (2001) 'The Politics Of Rage: Why Do They Hate Us?' *Newsweek*, 15 October. URL: <http://www.newsweek.com/id/75606> (accessed 15 July 2008).

Zang, X. (2006) 'Social Resources, Class Habits and Friendship Ties in Urban China' *Journal of Sociology*, 42: 79–92.

Zweig, S. (1942) *Brazil: Land of the Future*, London: Cassell.

Index

Abbott, Berenice 142
absolute space 89
abstract space 89–90
Abu Ghraib 83
adaptive targeting 69
Addictions and Subtractions 33, 38–9, 40, 47
age value 88
Alexanderplatz, Berlin 168, 169
All the President's Men 161, 162
Alphaville 9, 26–9
Alte Potsdamer Strasse 91
Amélie 12, 150, 152–60
American in Paris, An 167
Amores perros (*Love's a Bitch*) 33, 44
anthropology 75–6
Aquino, Marçal 45
architecture: and economies of violence in São Paulo 8–9, 19–26; monumental scale photographs 139–43
'armed social work' 75
artificial intelligence 79–80
Artigas, Vilanova 23–4, 25
assets 165–6
Attie, Shimon 11, 100–1
Augé, Marc 38, 122, 123, 124, 138, 148

Backhaus, Marcel 98–9, 100
Baghdad 74–5
Bahn Tower 91
banlieue-film genre 159
banlieues 12, 143–5, 150–60
Baqué, Dominique 137, 145
Barlow, Tani 132
bathrooms 156–7
Baudelaire, Charles 148
Baudrillard, Jean 17, 107, 111–12, 113
Beckett, Samuel 49, 65–6
beehive effect 141

Before Sunset 167
Beijing 11–12, 122–34
Beira Mar, Fernandinho 42
Beisheim Center 94, 95
Beller, Jonathan 35
Benjamin, Walter 88–9, 138
Berlin 168, 169; remembrance of violence 10–11, 87–106
Berlin Wall fragments 90, 93–4, 95, 96
Bloomberg, Michael 17, 113
Bluetooth signals 170
Bobigny project (Darzacq) 143–5
Boltanski, Christian 11, 100, 101–3
Bourbaki panorama, Lucerne 65
Bourdieu, Pierre 12, 151
Bourne trilogy 12–13, 161–71
Brandenburg Gate 11, 98–9
Brant, Beto 45
Brazil: film-making 32–3, 42–8; São Paulo *see* São Paulo
breakdance 145
Broomberg, Adam 50
Brutalism 22–6, 27
Buddy Bear Pariser Platz 104, 105
Bundestag 140–1
Bush, G.W. 67

Caché (*Hidden*) 12, 150, 152–60
Cairns, Stephen 138, 148
Caldeira, T.P.R. 20
Capa, Robert 49
Capoeira 145
Carandiru 19
Cartier-Bresson, Henri 49, 50
Cascaldi, Carlos 23
Casino Royale 163
Castells, Manuel 32
Celebration, Florida 27

centre-periphery relations 153–4
Chanarin, Oliver 50
Chanteloup-les-Vignes 155
checkpoint simulation 78, 79
Chiarelli, Peter 74–5
Chouliaraki, Lilie 70
Christo 11, 99
Chute, La (*The Fall*) (Darzacq) 143, 145
Cidade de Deus (*City of God*) 9, 19, 33, 42–4, 47
cinema: Bourne trilogy 12–13, 161–71; and globalization in Latin America 34–5; Latin America 9, 32–48; Paris 12, 150–60
circulation 39
City of God 9, 19, 33, 42–4, 47
City Palace, Berlin 103
civilian role players 77–9
Clarke, Graham 137–8, 146, 149
class 11–12, 123–33
Coates, Nigel 2–5
Coelho, Teixeira 18
Collyer, Robin 142
Colombia 32–3, 35–41
colonialism 12, 150, 153–4, 160
combat training centres 77
Comment, Bernard 64
computer simulations 70–1, 77–80, 81
Conference on Adversary Cultural Knowledge and National Security 76
conflict ethnography 75
conspiracy thrillers 12–13, 161–71
construction workers 122–3, 133, 134
consumerism 2–3
Corbusier, Le 22
Corner, James 115–17, 120
Cotton, Charlotte 140, 141
counter-insurgency 10, 72–3, 74–6; biopolitics of 82–4
Counterinsurgency Academy, Baghdad 73
covert tracking 170
crime rates 31; Alphaville 29; New York 30; São Paulo 18, 30
critical memory value 11, 97, 103
critical reframing 100–4
cultural capital 12, 150–60
cultural heterogeneity 112
cultural intelligence 76
cultural morphology 73–6
cultural turn (US military) 10, 67–84; genealogies of 72–3
culture-centric warfare 67–8
culture of death 9, 33

Darzacq, Denis 12, 139, 143–5
Davis, Mike 9, 13, 17, 19
Davos summits: 2001 50–1; 2003 56–61
de Certeau, Michel 110–11, 113, 120, 151
death, culture of 9, 33
Debray, Régis 35
defacement strategies 100–3
Deleuze, Gilles 151
deliberative targeting 69
DePalma, A. 107–8
Depardon, Raymond 12, 139, 145–9
Desplechin, M. 143–4
digital cameras 170
digitally enhanced photographs 139–43
Dikeç, Mustafa 150–1
DiMarco, Louis 73–4
dissolvency 39, 40
doorways 144–5
Downfall 88
drugs industry 9, 32–48
Durand, Régis 138, 147

earthwork monument for 9/11 11, 108, 114, 118–20
economies of violence 8–9, 17–31; architecture and 8–9, 19–26; São Paulo as changing economy of violence 30
education 151
Eisenman, Peter 11, 99–100
Eisenstein, Sergei 141
Empty Centre, The 96, 97
envisioning, urban 139–43
epic scale 139–43
estrangement 121
ethnic heterogeneity 112
event landscape 61
Everyone Says I Love You 167
excess 138, 148–9
exchange value 88, 89, 90
exclusion 155; *see also* non-places
exhibition value 88–9

Fabuleux Destin d'Amélie Poulain, Le (*Amélie*) 12, 150, 152–60
Fallujah 67, 70–2
FARC (Revolutionary Armed Forces of Colombia) 42
Fastenaeken, Gilbert 144
FAU-USP (University of São Paulo school of architecture) 23–4, 25
fear 8–10; global summits and security 10, 49–66; Latin American cinema and narcotics industry 9, 32–48; and the

media 47–8; São Paulo as economy of violence 8–9, 17–31; US military and Iraqi cities 10, 67–84
Fenton, Roger 50
Field Manual on Counterinsurgency (FM 3–24) 73, 83
Field Manual on Urban Operations (FM 3–06) 70, 73
Field Operations 115
film *see* cinema
First Capital Command 18–19, 42
Fitzmaurice, T. 1
flânerie 45–6; urban photography and 12, 138, 142–3, 146
flattening 148
FlatWorld 79, 82
Forterra Systems 78–9
fortress mentality 9, 13, 17
Foster, Norman 11, 99
Foucault, Michel 151
France 128; Paris *see* Paris
Frantz, Anaïk 143
Freedom Tower 119
Fresh Kills Landfill, Staten Island 11, 107–21
Frisby, David 131

G8 10, 49; Geneva (Evian) summit 55–6; Genoa summit 51–3
Galeria Leme 26
García Canclini, Néstor 34, 45–6
gated communities 9, 26–9
Gaviria, Victor 33, 35–9, 47
Geneva (Evian) summit 54, 55–6
Genoa summit 51–3
Germany 131; Berlin *see* Berlin
Giraldo, Fabio 38
Giuliani, Rudy 17
global cities 1
'Global Cities' exhibition 2–8, 9; posters 5–8
global summits 10, 49–66
Goertzel, T. 18, 30
González, Dionisio 141–2
Graham, Stephen 112
Greengrass, Paul 166, 169
Griffiths, Philip Jones 49
growth 6, 7
Guattari, Félix 151
Gursky, Andreas 2, 12, 139, 139–41

Habitations à Loyer Modéré (HLM) 150; *see also* banlieues
Haine, La (*Hate*) 12, 150, 152–60

Handbook for Joint Urban Operations 70
Haneke, Michael 150
Hanssen, Beatrice 99
Hargreaves, Alec 151
harmonious society 128–30
Harris, Chad 69
Hatakeyama, Naoya 12, 139, 142
Hate 12, 150, 152–60
Haw, Brian 106
Heimat3 94
Hernandez, Anthony 145
heterogeneity 112
Hidden 12, 150, 152–60
high-income people and families 131–2
High Line, The 115, 116
Hirschbiegel, Oliver 88
historical value 88
Hockney, David 10, 63–4, 65
Holdsworth, Dan 142
Hollywood 152
Holocaust Memorial, Berlin 11, 99–100
Holston, James 20
Hotel Esplanade, Potsdamer Platz 90, 91–2
House of Tourism 105
human scale 143–5
Human Terrain System (HTS) 76, 81
Huyssen, Andreas 88–9
hyper-legibility 165

Illuminated Muse Matrix 97
incarceration 155
Institute for Creative Technologies (ICT) 79–80
interior spaces 156–7
interstitial fragments, photographs of 12, 143–5
interstitial non-places 123, 125, 127, 132–3
Invasor, O (*The Trespasser*) 33, 45–7
Iraq 10, 67–84; remodelling and re-scripting 77–80
Iraq Culture Smart Card 72
Iraq Visual Language Survival Guide 72

Jacobs, S. 140
Jameson, Fredric 38, 159–60, 162
Jeunet, Jean-Pierre 150
Jewish Museum, Berlin 97
Jia Zhangke 11, 122, 123, 126–8, 133, 134
Joint Readiness Training Center, Fort Polk 77

Jouve, Valérie 142
junkspace 138

Kahn, T. 18, 30
Kassovitz, Mathieu 150
Kiefer, Anselm 22
Kilcullen, David 75
Koch, Eva 2
Koolhaas, Rem 2, 138, 139, 147
Kracauer, Siegfried 131
Krause, L. 1

Ladd, Brian 103
landscape (view): and estrangement 121; New York City 110–13; São Paulo 20–2
laptops 170
late modern war 69–72
Latin American film-making 9, 32–48; Brazil 32–3, 42–8; Colombia 32–3, 35–41; globalization and 34–5
Lawrence, T.E. 81
Lefebvre, Henri 44, 88, 89–90, 91
Leibowitz, Annie 64
Lévi-Strauss, Claude 21–2
Lewis, Ben 141
Lewis, P. 170
Libeskind, Daniel 11, 87, 90, 97
libidinalization of social otherness 44–5, 46–7
Lifescape project 11, 107–21
Lilith (Kiefer) 22
lines of flight 151, 153
Linha de Passe 19
Lins, Paulo 42
Lipkin, Jonathan 143
Liu, Mr and Mrs 132
London: Thames Gateway 2–5; Waterloo Station 168, 169–70
Los Angeles 9, 13, 17
Losh, E. 80, 81
Ludlum, Robert 12, 163–4
'Luncheon at the British Embassy' (Hockney) 64, 65
Lund, Kátia 42
Luxehill 132
Lyotard, Jean-François 121

Machine for Living, A (Holdsworth) 142
Maffi, M. 107
Magnum photo agency 49–50
Mahdi Army 74–5
Manchester 22
mapping 170–1

Marcuse, Peter 109
María, llena eres de gracia (*Maria, Full of Grace*) 9, 33, 40
Marsden, Joshua 40
Martín Barbero, Jesús 34, 41, 47
Maspero, François 143
mass media *see* media
massively multiplayer online games 78–9
Maza, S. 128
McFate, Montgomery 75–6
Medellín 32, 35–41
media 44, 157–8; fear and 47–8
mediatization of war 70
Meirelles, Fernando 42
memory 8, 10–12; Berlin and remembrance of violence 10–11, 87–106; Lifescape project 11, 107–21; working poor and development in Beijing 11–12, 122–34
memory value 88–90; at Potsdamer Platz 90–7
Mendes da Rocha, Paulo 25–6, 27
mental health services 29
Mercer, Vivian 49
MetaVR 78
Mexico 33
Meyerowitz, Joel 142
middle-class virtue 130–1
Mies van der Rohe, Ludwig 105
migrant workers 122, 125, 126–8, 129, 131, 132–3, 134
Miklos, Paulo 45
military imaginaries, American 10, 67–84
minhocão 24–5
Missing House, The (Boltanski) 101–3
mission rehearsal exercises 77, 80–1
'Mixtacity' (Coates) 2–5
mobile phones 172
money laundering 39
Montmartre 154
monumental memory 11, 88–90, 97; aesthetics of in post-unification Berlin 98–100
monumental photographs 12, 139–43
Moóca, São Paulo 20
Moreton, Margaret 143
motorways 24–5
multiplicity 148
murder and execution density plots 83, 84
Museum of Brazilian Sculpture (MuBE) 25–6, 27
Muybridge, Eadweard 10, 63

Nagl, John 76, 81
narcotics industry 9, 32–48
neoliberalism 152
New National Gallery, Berlin 104–6
new spatial order 109
New Urbanism 27
New York City 17–18, 30–1, 161; cityscape and the Twin Towers 110–13; Lifescape project 11, 107–21; photographs of the homeless 143
New York summit 53–5
Nietzsche, F. 97
non-places 122, 162; Beijing 123, 124–8, 132–3, 138; classing space 124–6
Norfolk, Simon 50
normality, violence and 130–3
Novgorod complex 163–4

Olympic Games 3; China 122, 129
Ônibus 174 19
oppressive city script, poaching on 151, 153
Orientalism 10, 81
Our Lady of the Assassins 9, 33, 40–1, 44, 47

Packer, George 72
Palace of the Republic 103–4
panic urbanism 13
panoramas 64–5
Parallax View, The 161
Paris: *banlieues* 12, 143–5, 150–60; Bourne trilogy 167–8; cinema 12, 150–60
Parra, Miguel 98–9
Pearman, H. 2
Pei, Mr 131–2
peripheries 12, 143–5, 150, 153–4
personal interaction 80
Petraeus, D. 83
Petro, P. 1
photography 43–4; poetics of scale in urban photography 12, 137–49; Spinatsch's photographs of global summits 10, 49–66
physical models 71
Pickles, John 71
planetary pedestrians 145–9
playfulness 2–3
poaching on the oppressive city script 151, 153
point of view, lacking 140
pollution 6, 7
posters for 'Global Cities' exhibition 5–8

postmodern urban walking experiments 145–9
Potsdamer Platz 11, 87, 90–7
Potsdamer Strasse 105
Poundbury, UK 27
poverty 6; working poor in China 11–12, 122–34
Primeiro Comando da Capital (PCC) (First Capital Command) 18–19, 42
prostitution 36–7
'Proyecto Cingapura' 141
pursuit 166

reclamation projects: High Line 115, 116; Lifescape 11, 107–21
Red Command 42
Reichstag 11, 98, 99
Reitz, Edgar 94
repression 28
Revolution in Military Affairs (RMA) 67, 68–9
Ricks, Thomas 72
Riegl, Alois 88, 89, 98
Rio de Janeiro 32–3, 42
Rocha, Glauber 43
Rodrigo D. No futuro 35
Rome 145
Rose Seller, The 33, 36–8, 47
rubble 37
ruined appearance (premature ageing) 21–2

S-Bahn sign 91–2
Sabotage 45
Said, Edward 68, 81
Santo Amaro III (González) 141–2
São Paulo 32–3, 42, 141–2; economy of violence 8–9, 17–31
saturation 148–9
scale, poetics of 12, 137–49
Scales, Robert 72–3, 76
Scheunenviertel 100–1
Schmidt, Leo 93
Schouwburgplein, Rotterdam 66
Schroeder, Barbet 40
screens 157–8
Seattle 161
Second World War 87, 90
secure communities 9, 26–9
security, at global summits 10, 49–66
Shiel, M. 1
shooting at a screen 41
shrinkage 148
siege psychosis 13

signal box 91, 93
Silberman, S. 82
simulations, computer 70–1, 77–80, 81
Sina-YouTube 129
skyline *see* landscape
Sleeper (Wallinger) 104
Smithson, Alison and Peter 22
Soja, E. 3
Sontag, Susan 147
space: classing 124–6; violent 123–4
spectacle 8, 12–13; Bourne trilogy 12–13, 161–71; Paris cinema 12, 150–60; urban photography 12, 137–49
Spectacular City exhibition 139–41
Spinatsch, Jules: 'Heisenberg's Offside' 60–1, 62–3; *Temporary Discomfort* 10, 49–66
'State Britain' (Wallinger) 106
Sternfeld, Joel 52
Steyerl, Hito 11, 96, 97
Stille, A. 51–2
street children 35–7
Struth, Thomas 52
style, architectural 22–6
Sumas y restas (*Addictions and Subtractions*) 33, 38–9, 40, 47
summits, global 10, 49–66
surveillance 28, 29, 30; Bourne trilogy 161–71
Suzhou Qiao underground station tragedy 11, 122, 125, 129, 131, 132–3, 134
symbolic violence 12, 150–60

Tactical Iraqi 80, 81
Tangiers 168
targeting, military 69–70
Tate Modern 'Global Cities' exhibition 2–8, 9
Taxi Driver 157
television 34–5; ethics of production 157
Temperance Street (Collyer) 142
temporal loss 37–8
Temporary Discomfort (Spinatsch) 10, 49–66; 'Corporate Walls' 53–5; 'Oppidum' 51–3; 'Pulver Gut' 56–61; 'Revolution Marketing' 54, 55–6; 'The Valley' 50–1
terrorism of 9/11 107–8, 109, 112; earthwork monument to 11, 108, 114, 118–20
Thames Gateway 2–5
therapeutic discourse 82–4
Three Days of the Condor 161

Thrift, Nigel 13
topographical distinctiveness 168
traffic signal box 91, 93
transitory abodes 125
trees 90, 91
Trespasser, The 33, 45–7
trust 80
Twin Towers 11, 110, 121; earthwork monument 11, 108, 114, 118–20; New York cityscape 110–13; wreckage taken to Fresh Kills Landfill 11, 107–8, 109, 114

uncanny visual disruptions 139–43
United 93 166–7
United States military 10, 67–84
University of São Paulo school of architecture (FAU-USP) 23–4, 25
University of Southern California (USC) 79–80
unmanned aerial vehicles (UAVs) 70, 71
Untitled/Osaka Diptych (Hatakeyama) 142
urban photography 12, 137–49
urban skimming 12, 145–9

Vallejo, Fernando 40
Van der Salm, Frank 139
Van Kempen, Ronald 109
Vendedora de rosas, La (*The Rose Seller*) 33, 36–8, 47
Venice Architecture biennale 2
view *see* landscape
Villes/Cities/Städte (Depardon) 12, 145–9
violence, as normal 130–3
violent space 123–4
Virgen de los sicarios, La (*Our Lady of the Assassins*) 9, 33, 40–1, 44, 47
Virilio, Paul 13
Virtual Reality Scene Generator 78
visual culture 1
visual field, city as 69–72

Wagenburg 90
Wahrmann, Dror 130–1
Waiting for Godot (Beckett) 49, 65–6
Wallinger, Mark 104–6
Walther, Manfred 96
war: late modern war 69–72; mediatization of 70; US military and Iraqi cities 10, 67–84
Washington, DC 161

waste 109; Fresh Kills Landfill 11, 107–21
Waterloo Station, London 168, 169–70
Weinhaus Huth, Potsdamer Platz 90, 91
Wenders, Wim 90
Weschler, Lawrence 64
Wesely, Michael 96
Wigley, Mark 121
Wings of Desire 90
Wisnik, Guilherme 23
working poor 11–12, 122–34
World, The 11, 122, 123, 126–8, 133, 134
World Championship qualifying match 60–1, 62–3
World Economic Forum 10, 49; Davos summit 2001 50–1; Davos summit 2003 56–61; New York summit 53–5
World Trade Center *see* Twin Towers
Wrapped Reichstag (Christo) 11, 99
Writing on the Wall project (Attie) 100–1

Yglesias, Matthew 84–5

Zakaria, Fareed 68
Zhou Jie 122, 134
Zhou Yongqian 122, 134
Zweig, Stefan 21

eBooks – at www.eBookstore.tandf.co.uk

A library at your fingertips!

eBooks are electronic versions of printed books. You can store them on your PC/laptop or browse them online.

They have advantages for anyone needing rapid access to a wide variety of published, copyright information.

eBooks can help your research by enabling you to bookmark chapters, annotate text and use instant searches to find specific words or phrases. Several eBook files would fit on even a small laptop or PDA.

NEW: Save money by eSubscribing: cheap, online access to any eBook for as long as you need it.

Annual subscription packages

We now offer special low-cost bulk subscriptions to packages of eBooks in certain subject areas. These are available to libraries or to individuals.

For more information please contact webmaster.ebooks@tandf.co.uk

We're continually developing the eBook concept, so keep up to date by visiting the website.

www.eBookstore.tandf.co.uk